CONNECTICUT

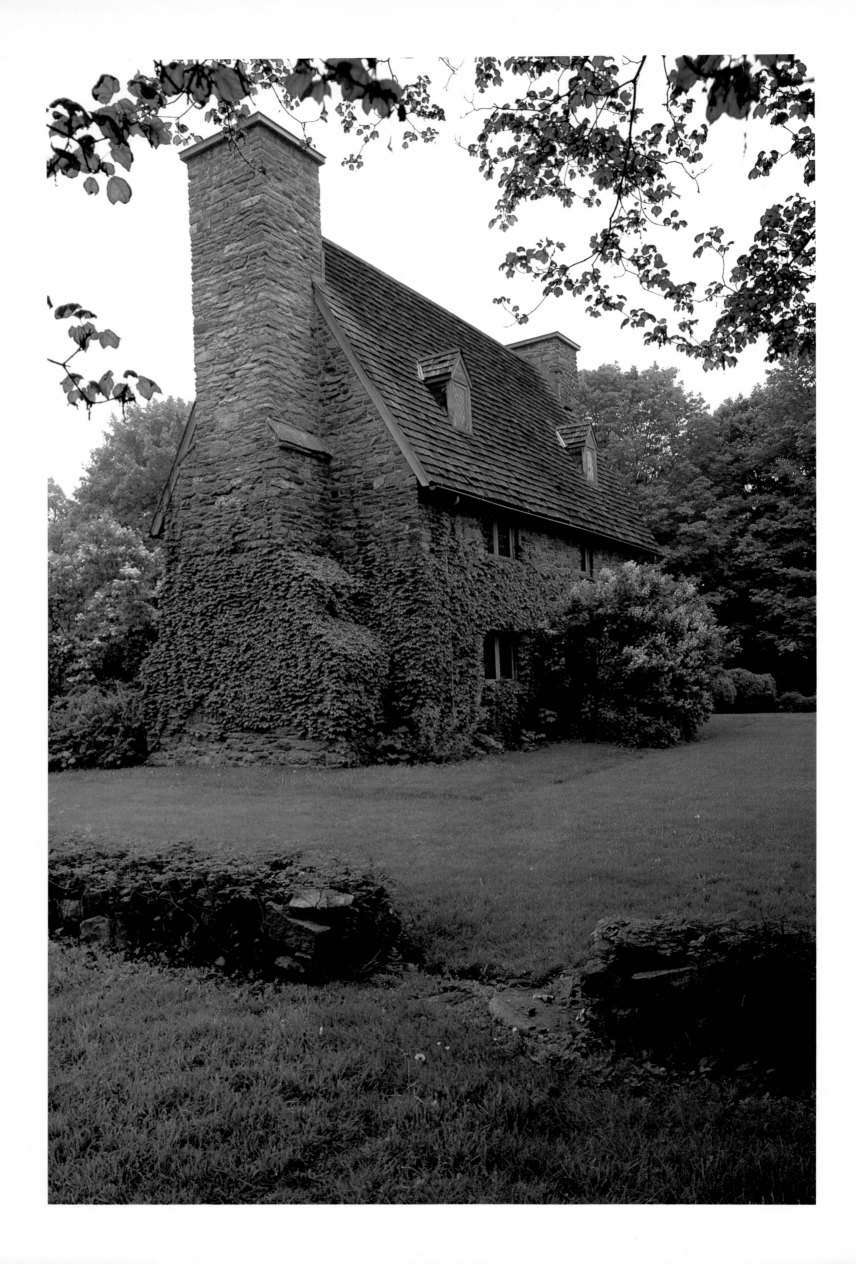

CONNECTICUT

Jerry
Many Thanks
John G Rowland

PHOTOGRAPHY BY WILLIAM HUBBELL

TEXT BY ROGER EDDY

FOREWORD BY HARRISON E. SALISBURY

GRAPHIC ARTS CENTER PUBLISHING®

International Standard Book Number 1-55868-015-2
Library of Congress Catalog Number 89-83844
© MCMLXXXIX by Graphic Arts Center Publishing Company
P.O. Box 10306 • Portland, Oregon 97296-0306 • 503/226-2402
Editor-in-Chief • Douglas A. Pfeiffer
Associate Editor • Jean Andrews
Designer • Robert Reynolds
Book Manufacturing • Lincoln & Allen Company
Printed in the United States of America
Seventh Printing

CONNECTICUT

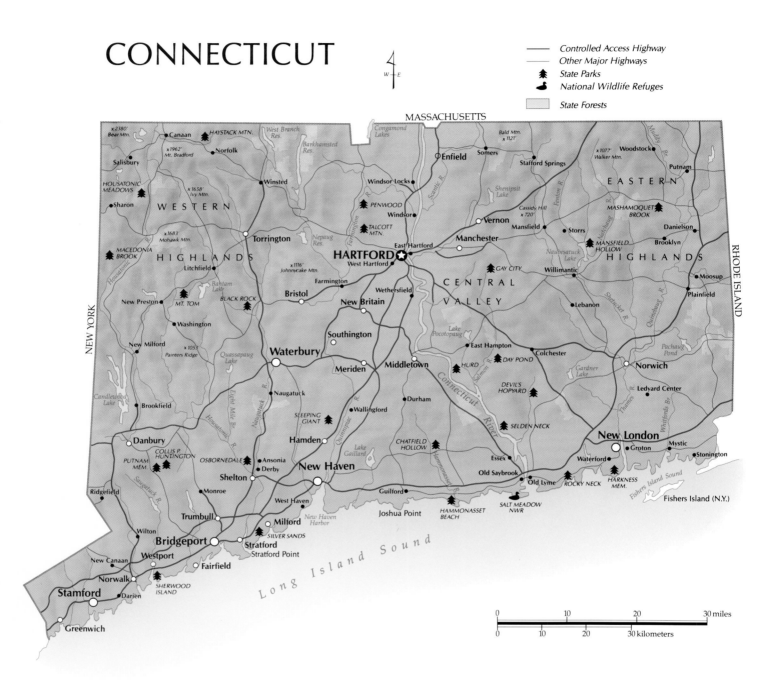

Marian ...
whose vision, enthusiasm, and loving encouragement helped
bring this book from idea to reality.

Bill Hubbell

■ *Frontispiece:* The Whitfield House in Guilford, built in 1639, is Connecticut's oldest house and one of America's oldest stone houses. ■ *Right:* Although two miles upstream from the mouth of the Connecticut River, the Lord's Cove marshes are affected by the tides. They provide habitat for mammals, birds, and shellfish.

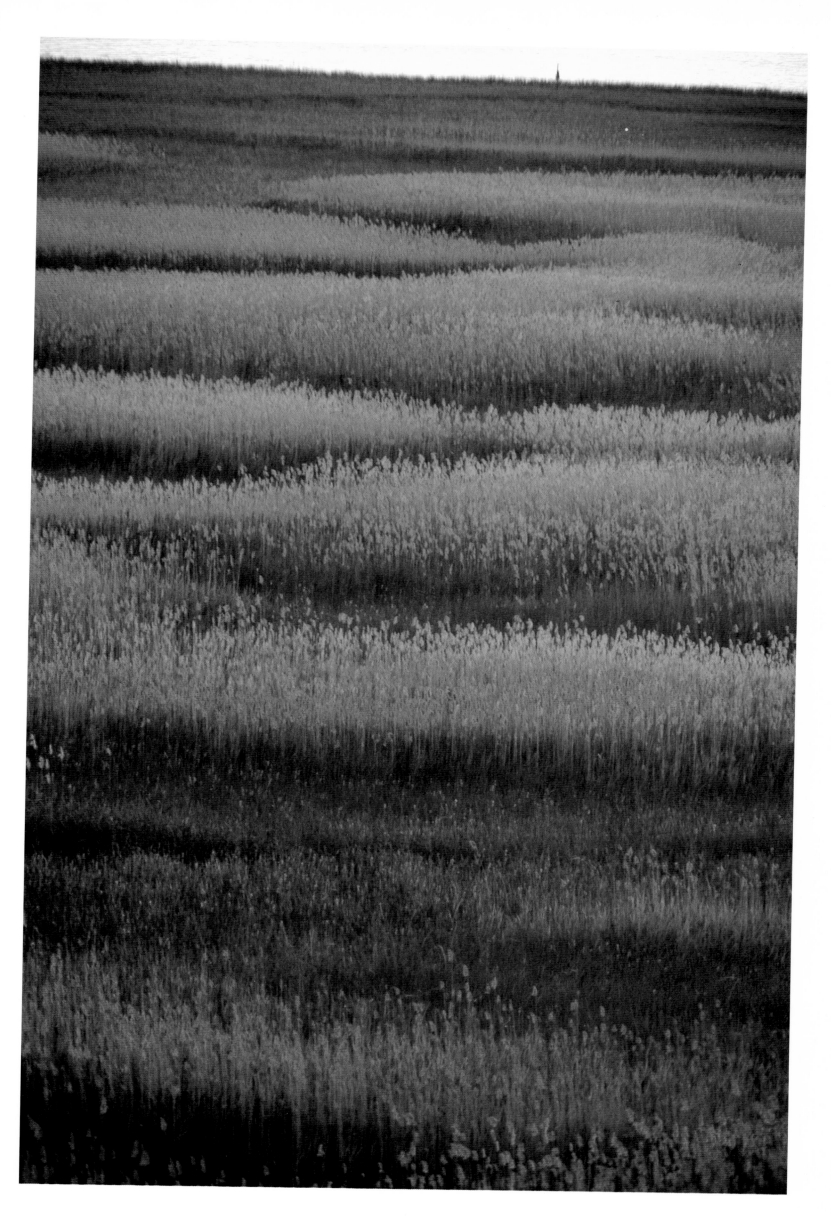

FOREWORD

by Harrison E. Salisbury

I live in northwest Connecticut in a house built the year before the Declaration of Independence. Looking north and west to Mount Riga and the Berkshires, the house stands in a meadow with forest all around. The air is pure, the snow drifts high in the winter, and (usually) it is cooler than the beach in the summer.

This northwest corner of Connecticut has been my home since just after my stint in Moscow for *The New York Times*. It is close enough to New York so I can get there when I want, but far enough away so I have to think twice before dashing to the city.

The scenery is unbeatable—hills to climb, deer and turkeys in the woods. Some say they have seen bear tracks, and there is no doubt about bobcats. But the best thing is the people. They are real, not plastic. Many have been here for a long time, and newcomers try to act like natives.

If I like Litchfield County best, perhaps it is because that is where I live. I like the shore, too, and the sea and the eastern tip where Connecticut jostles Massachusetts and Rhode Island. My ancestors settled just over the line in Rhode Island in the mid-1600s.

The best thing about Connecticut people is that they ignore patterns. They are individualists, which makes it hard for politicians. Some Democrats are a lot more conservative than many Republicans. And some Republicans are as liberal as all get out. I like that. I have lived and worked long enough in places like the Soviet Union to value free-thinkers above almost anything else. Connecticut, like most New England states, has lots of free-thinkers, often cantankerous and opinionated people. And most Connecticut people prize that quality in others. Who would they have to argue with without it?

Connecticut is one of those places where good fences make good neighbors, but everything is not folksy, picture-postcard mottoes. Connecticut is also high-tech industry, great educational institutions, culture—you name it. There is no other place in the world for me to live.

THE LAND

by Roger Eddy

Nearly one hundred fifty years ago, my great-grandfather, who was the youngest son of a large family, received a letter from an older brother, who a decade before had "gone west." The letter cited a number of arguments why my great-grandfather should do the same thing. Among the reasons mentioned were Connecticut's "overpopulation," its lack of a major agricultural crop, its uncertain future, and especially its rapidly dwindling good farmland.

"Out here, where I am," his brother wrote, "a man can plow a level furrow a half-mile long, and never turn over a stone."

Spring ground cover at Caldwell Sanctuary, Cos Cob.

My great-grandfather gave his brother's advice serious thought because, by the standards just prior to the Civil War, Connecticut, the third-smallest state in the Union, was overpopulated. Two-thirds of the land area was already cleared for crops and cattle, and all the good farmland—the river bottomland and the fertile valleys, never in abundant supply—had long since been settled. Even the uplands of eastern Connecticut and the hills and mountainsides of western Connecticut had become pastures and hayfields.

Adding to the pressure, large families were considered to be an economic necessity at that time. From the earliest colonial era, children were the only dependable source of labor. It was hardly unusual for a man of seventy-five, for instance, to have seventy-five grandchildren, each hoping to own a farm one day.

Therefore, beginning after the Revolution and gradually gaining momentum, an out-migration began which caused Connecticut to lose thousands of its most vigorous and talented citizens. In the 1830s, it was recorded that nearly a third of the elected officials in Washington had been born in Connecticut, and a contemporary observer noted in a Connecticut newspaper that "scores of wagons, piled high with possessions, out of which peer many small heads, are to be seen on all roadways, moving to parts unknown."

It was a critical time for Connecticut. To many of its citizens, dependent as they generally were on agriculture, there seemed to be far more reasons to leave the state than there were to remain.

What follows then is my way of thanking this great-grandfather of mine who decided to stay where he was, maintaining his faith in these five thousand square miles of lush, green fields, the rolling hillsides, the lakes, the valleys, and the gleaming coastline. And especially do I wish to thank him for keeping his faith in the inventive genius of Connecticut's citizens, who have made the state what it is today, an astonishing success, a small miracle, a most envied place, three and one-half million people who feel fortunate to be where they are.

Geologists believe that 350 million years ago the area now called Connecticut was in the center of a zone of colliding continents. In a process beginning approximately 450 million years ago and continuing until 250 million years ago, the primitive continents of Eurasia and Africa, moving westward, collided with North America, creating the Appalachian Mountains. For much of that time what is now Connecticut was a mountainous, volcanically active place. While little is known about the area's appearance five hundred million years ago, what little we do know suggests that Cameron's Line in western Connecticut formed the eastern edge of North America, and everything east of that was deep ocean.

About two hundred twenty million years ago, the processes which caused the continental collision reversed and the combined mass of North America, Eurasia, and Africa began to split apart. The Atlantic Ocean began to form along a north-south zone just to the east of Connecticut. This continental rifting process caused a large fault basin to be formed in the area that later became Connecticut. Within this basin, red-brown sediment and basalt, or traprock, lava flows were deposited. The tilted, eroded remains of these rock layers form the north-south ridges that characterize the Central Valley of the state.

The climate was warm and seasonally humid. Ferns, ginkos, and huge conifers abounded, as did dinosaurs. Today—forever embedded in the red-brown and gray silt which gradually hardened at the bottoms of the warm-water streams, ponds, and rivers of a hundred million years ago—there are more known dinosaur footprints in the Connecticut Valley than anywhere else on earth.

More than a century ago, a Connecticut River Valley farmer thought he had found the track of a "big bird" when he struck a dinosaur footprint with his plow. Little was known then about dinosaurs, and this farmer was more enlightened than he knew, since paleontologists now believe our modern-day birds may have evolved from the dinosaur. Today, his descendents sell dinosaur tracks for table tops, terrace paving, and "conversation pieces."

A decade ago, a bulldozer operator, engaged in construction work in Rocky Hill, exposed a ledge covered with several thousand dinosaur footprints. Today, this site is enclosed in a dome, and Dinosaur State Park is visited yearly by thousands of students and

By damming streams, beaver help expand wetlands.

tourists. People in ever-increasing numbers are fascinated by these giant reptiles who ruled the earth—and Connecticut—for millions of years and then mysteriously disappeared.

Just as dinosaurs left their tracks, so also did several glaciers, which buried Connecticut under billions of tons of ice at least two times during the last two million years. The Captain Islands off Greenwich are piles of glacial moraine material, as are the Norwalk and Fulkner islands. The southern extent of these glaciers reached as far south as central Long Island where they left large, east-west piles of moraine debris. It is estimated that what is now New Haven was buried by fifteen hundred feet—and Hartford by two thousand feet—of solid ice. The top of Bear Mountain, the state's highest peak at 2,316 feet, was also under a blanket of ice.

Mastadon bones and evidence of other extinct populations have been found in Connecticut, providing evidence that these animals also once freely roamed the area.

During the Ice Age, the Atlantic Ocean was five to six hundred feet lower than it is today, and Long Island Sound was a vast, freshwater lake. As the ice moved down over the state, it molded and smoothed the land, deepening some valleys, scraping loose debris off the hills, exposing solid bedrock, and forming new hills as deposits of dirt, rock, and other debris. These new hills, known as drumlins, have a north-south streamline shape. The stony debris left by the glaciers provided the rocks for the miles and miles of stone walls built by Connecticut's farmers. As the ice melted back from its southernmost position on Long Island, it created a large freshwater lake in what is now Long Island Sound, and another large glacial lake in the Connecticut Valley, which extended from Middletown, Connecticut, to central New Hampshire and Vermont.

As the ice melted, the ocean rose. Long Island Sound became a tidal extension of the Atlantic. Even today, the ocean continues to rise at a rate of one foot per century, giving the Connecticut coastline its "drowned" appearance and also making it prey to the high tides which arrive with storms and hurricanes.

This decaying, rotting ice block changed the course of the rivers and streams, left depressions in the earth where lakes and ponds would form—Lake Whitney in New Haven being an example— while massive torrents of water flowing down toward the sea eroded the valleys, leaving clay and deposits of fertile loam along the river banks. The marvelously fertile meadowland, north and south of Hartford, along the Connecticut River, was left by the glacial lakes. It was this fertile land which brought the first Puritan settlers overland from Massachusetts, the Bay Colony. These same meadowlands also provided Connecticut with its unique crop of shade-grown tobacco, used as wrappers for cigars. The tobacco is grown under cloth, which still today looms like gray white lakes on all sides of Bradley International Airport in Windsor Locks.

Salem's ledges may come from the Euro-African plate.

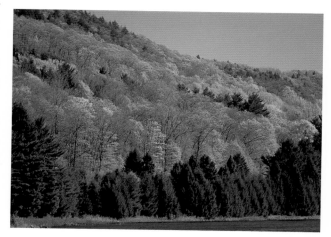

The state's forest is deciduous with a few conifers.

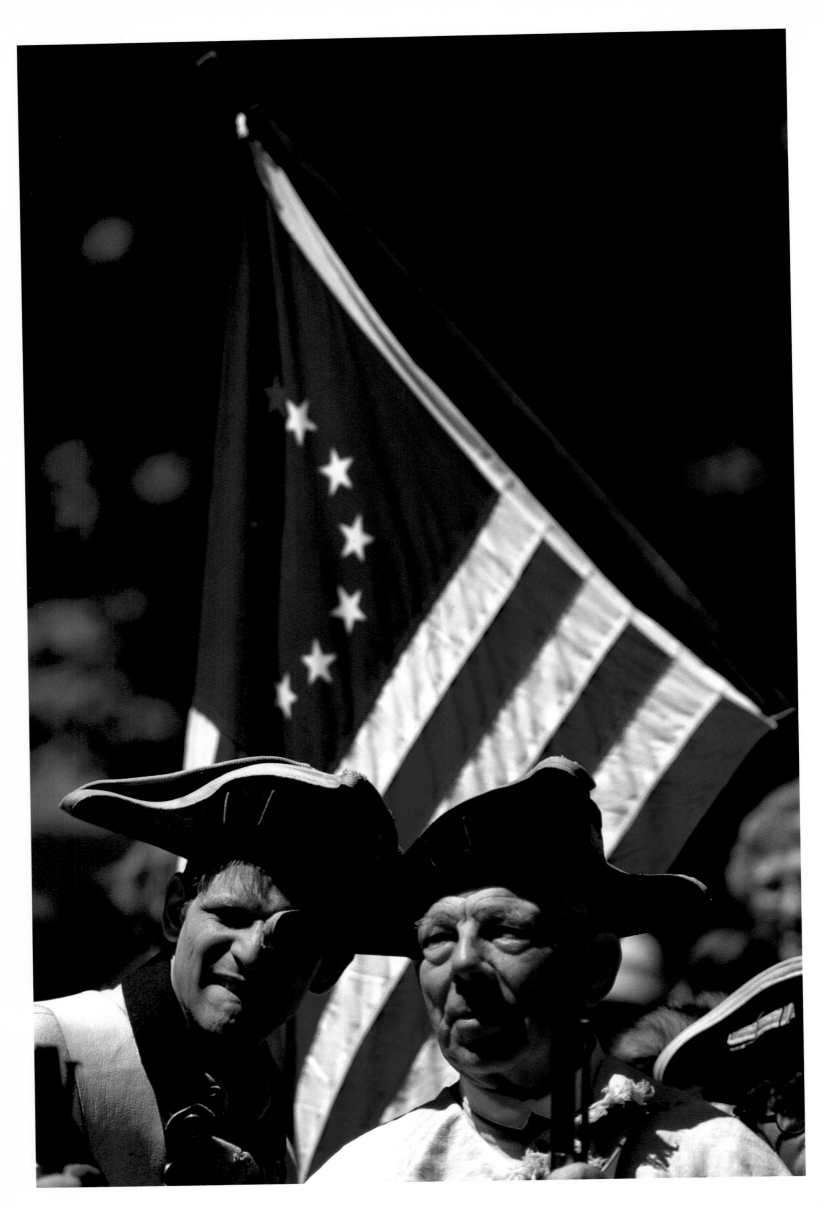

COLONIAL CONNECTICUT

by Roger Eddy

In contrast to the dinosaurs and the glaciers, Connecticut's Native American population, which some claim numbered as high as ten thousand when the first white settlers arrived, has left few traces behind of the thousands of years of living in the area. There is some disagreement as to how long Indians had lived in Connecticut before the arrival of the white man. There is proof that they were here for at least ten thousand years. A few experts believe they were here for possibly forty thousand years. Made up of sixteen tribes, which were part of the Algonquin Federation, they went by such tribal names as Tunxis, Pequot, and Sequin. For the most part, although they engaged in limited cultivation of such crops as corn, beans, and squash, they lived primarily on fish and small game. During the summer months they moved inland. The rivers and streams teemed with fish, the woods with small game. During the winter they settled into camps, or more permanent villages along the coast.

Alien to the Indians' culture, the concept of "owning" land would prove to be the main source of irritation between them and the white man. The land, Indians believed, belonged only to the various gods—the sun, the gods of fire, snow, the river, lightning, etc. For thousands of years, they had lived in total harmony with nature. The Judeo-Christian Puritan ethic, which suggested that nature was man's natural enemy and must be subdued by fire, the ax, and the plow, was incomprehensible to the Indians. In their thousands of years of existence in North America, no Indian had ever built a fence, or marked off a "private" plot of land. According to their beliefs, the land belonged to everyone. Man was merely a part of nature, not its master. Therefore, conflict between the "primitive" Indian and the white man was inevitable.

Because they could not understand the Indians' culture, the Puritan settlers feared and loathed them. The early Puritan settlers considered Indians to be heathens, agents of the devil. Nor did it help when it was discovered that the Indians resisted conversion to

1841 Cornwall United Church of Christ

■ *Left:* At the time of the Revolutionary War, Connecticut was one of the most densely populated colonies, with some 200,000 living mostly along its coast and rivers. Farming was the major occupation. Cloth, clock making, and ship building were early industries. Connecticut Yankees were known as shrewd peddlers.

Christianity, preferring instead their own gods to the Christian God. Therefore, when Captain John Mason, along with a company of men conscripted for the occasion, wiped out the Pequot Nation in a single night of fire, bloodshed, and death at Mystic in 1637, there is no record of any feeling of remorse.

That same lack of understanding of the other's culture caused hard feelings on the Indians' part also. The massacre of the Pequot Nation at Mystic was the result of an Indian raid on Wethersfield, where settlers were murdered as they worked in their fields and two young women were kidnapped and carried off down the river in Indian canoes.

Moreover, just as Indians seldom understood what was involved when they "sold" their land, the white settlers found it difficult to accept the Indians' custom of agreeing to something, such as a land sale or a promise of peace, only to have them renege on the "sale" or break the fragile peace.

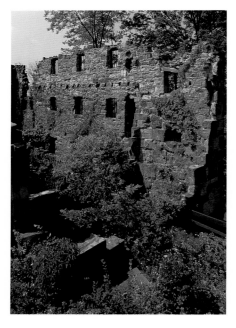

Old Newgate Prison in East Granby

Today, about two hundred fifty Indians still live on Connecticut's five reservations, and, according to the census of 1980, forty-five hundred more, not all of them full blooded, live among the general population. Their stone arrowheads and tools, which even today can be found after spring freshets along riverbanks and occasionally on the surface of a newly plowed field, reside in glass cases in museums or in the toolboxes of farmers' tractors. They are a tenuous reminder of Connecticut's original inhabitants, who, after thousands of years, have been wiped out, leaving few traces behind.

It was "land hunger," not a desire for more religious freedom, which brought Thomas Hooker and his "hardy band of Puritans" overland from Massachusetts in 1633. Dutch traders had sailed up the Connecticut River in 1630 and established a headquarters at a point of land which would later become Hartford. Soon, reports of fertile land north and south along the river filtered back to the Bay Colony. In 1633, two permanent settlements, one in Windsor, the other in Wethersfield—north and south of "Dutch Point," a landmark which still exists in Hartford—had been established. This caused the Dutch, now surrounded and outnumbered, to withdraw, leaving Connecticut once and for all to the English Puritans.

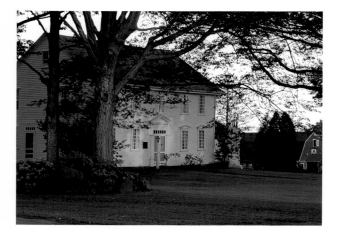

Lebanon's 1740 home of Governor Jonathan Trumbull

From its earliest colonial days, Connecticut's townships, which today number one hundred sixty-nine, benefited from a carefully laid-out plan. As each church congregation moved out to establish its own settlement, a central area was set aside as a common, or green. Surrounding this central area were the house lots of the more prominent settlers, who, with the help of the "elect" and their pastor, were granted tracts of land. Needless to say, facing the green was the church, or, as it was more often called, the "meetinghouse."

Each new town, once it had been granted its charter, considered itself to be totally independent of any central church authority. This has given rise to a saying in Connecticut that the state is made up of

one hundred sixty-nine fiercely independent republics. For nearly two centuries the state was run as a theocracy, dominated by the Congregational Church. Democracy, as we know it today, was unheard of. Only property owners could vote, and even then, the vote was restricted to members of the church. The church elders decided who would represent them at Hartford, and church leaders also decided who would be governor.

From the beginning, the birthrate was high and families extremely large. While a few immigrants, including a number of blacks, came into Connecticut during the seventeenth century, most of the new towns were the result of the rapidly increasing population within the state itself.

Only two of Connecticut's original cities and towns took Indian names. These are Norwalk and Naugatuck. This is a reflection of the way the early settlers felt toward their "primitive" Indian neighbors. The rest of the towns, for the most part, were named after towns left behind in England.

After the Revolution, however, when hatred of Britain flamed, many of Connecticut's "associate towns"—such as Moodus, Mystic, or Poquonock—took Indian names. By that time, since the Indians had been virtually eliminated, they could be regarded with sentimental affection. It was then that feelings of guilt, because of the treatment the Indians had been given, began to surface.

The Puritan ethic, which flourished in Connecticut far longer than it did elsewhere in colonial America, has left a permanent mark on the state's character. The early Puritans believed in work. Idleness was a cardinal sin, a manifestation of the devil. The Puritan goal was to establish a "Zion in the Wilderness," and nothing must stand in the way.

The days were long and hard. It was by no accident that when one of them died, he was "laid to rest," and the cemetery was his "final resting place."

They married young and raised large families. If a wife died—and her chances of survival, especially in childbirth, were not good—they took a second wife and raised a second family.

Universal education was one of the tenets of the Puritan faith. The American public school system, the best in the world, in large measure was born in Connecticut and originally was inspired by Congregationalist Puritan teaching. Ignorance and illiteracy, the early Puritan clergymen believed, provided fertile ground for the "great deluder," the devil. It should be borne in mind, however, that in Puritan eyes, education was never intended to open men's minds to doubt or question about the infallibility of God. Yale College, the bastion of Puritanism, was founded in 1740, not for the enlightenment that it provides today, but to train clergymen to guard and protect the Puritan faith. No skeptic would have remained long at Yale, at least during its first century.

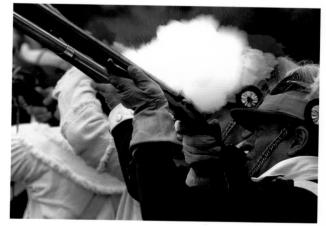

Connecticut Dragoons reenact Revolutionary battle.

That the pursuit of happiness was one of man's inalienable rights would never have occurred to Connecticut's early Puritan settlers. Only an idle man would find the time to ask himself whether or not he was happy.

They expected little from their lives on earth. Their reward, if it were to come at all, would be granted to them in the life hereafter. They did not believe in luck, myth, or mystery. Stained glass in a place of worship to them was a manifestation, not of beauty, but of doubt. They believed in the word, and the word was the stark, naked truth. They built their meetinghouses out of wood, and when they could afford it, they painted them white. The human voice was their only music.

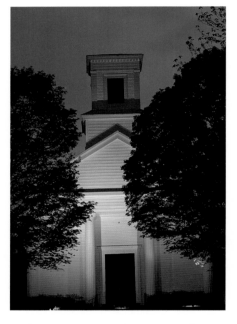

The 1814 Meetinghouse, Hamburg

A devout Puritan believed that he could always do better. He could always work harder, clear more land, pick more stones, raise more cattle and crops, and lead a more perfect life. He put first things first, and—like the dinosaurs and the glaciers—left a permanent mark on Connecticut. Recreation, assuming he ever thought about it, would be allowed only after he had died, after he had picked his last stone, cleared his last forest, and plowed his last field. He did not look forward, as many of his descendents do today, to four-day summer weekends on his boat on the Long Island Sound.

The Puritans came from an English tradition of carpenters, sawyers, and joiners. They were not masons or stonecutters.

Therefore, they built their dwellings, their barns, and their meetinghouses of wood. These simple wooden structures, which still are a feature of Connecticut's countryside, are considered to be among the finest examples of wooden architecture anywhere in the world. They are a lasting monument to the Puritan faith which burned bright in Connecticut for nearly two centuries.

Lebanon's old cemetery provides aid to geneologists.

In the meantime, along with their wives—who worked as hard, or harder, than the men did—they cleared the land, plowed the fields, planted their crops, and tended their cattle. They set tax rates, turned Indian paths into roads and highways, built bridges, provided an education for their swarms of children, and took care of their aging parents. Then they went to church on Sunday to listen to their pastor flay them for their idleness, during sermons which could last as long as two hours.

Occasionally, they drank too much. The men gathered in the cellar around a barrel of hard cider, while their wives gossiped in the kitchen above. If, on Sunday, the early Congregational Puritan meetinghouses tolerated no doubt, now and then, the church members sought relief from God's relentless quest for perfection by getting drunk.

Fire was their tool. Fire cleared most of the land. In the fall, the smoke of burning brush and stumps hung over the land, collecting in the valleys, even obscuring the sun. Fields replaced woods and forests, and cattle appeared on hills and mountainsides.

And always they "picked stones" to clear the land and for use in walls marking their farms and fields. Today, these crumbling relics of the state's colonial past often appear in the middle of dense woods or forests which have recaptured two-thirds of the state. Large trees—oaks, maples, and ash—grow from between moss-covered, gray stones dragged out of fields and built into walls two and a half centuries ago.

"Who built all these walls?" is the question often asked by those who stumble upon them "in the middle of nowhere."

"The boys" built them when "there was nothing else to do." When the hay was in the barn, and the crops harvested, the men and their sons "built wall"—enough to extend around the world at the equator. Using crowbar, stone boat, and oxen, they cleaned up after the glaciers and cleared the land. Stones are embedded in the very character of Connecticut. Stones were "first things first." Stones had to be "done" before a crop could be raised. Today, just as one can fly over England and see long-forgotten, overgrown Roman roads in the fields below, so also can you fly over Connecticut and see the walls marking the overgrown and abandoned back pastures where cattle once grazed, but where today only trees grow.

It seems more than likely that if these Connecticut farmers of the seventeenth and eighteenth centuries returned to the state today, they would observe many changes which would fill them with astonishment. The roads they built over Indian paths are now eight-lane superhighways. Huge steel bridges have replaced ferries. The entire state hums with traffic. The small, quiet villages of two centuries ago—Stamford, Meriden, Wallingford—and the cities—Hartford, New Haven, and Bridgeport—are now gleaming centers of commerce, with glass buildings reaching toward the sky.

All these changes would doubtless fill the early settlers with wonder. However, nothing would surprise them more than the market which today exists for stones. Today, these "cursed stones" are in great demand from suburban dwellers who wish to enclose their yards or to pave their terraces. Landscape gardeners and architects bid for stones at auction. Sculptors arranges these same stones in what they hope are pleasing lines, in public places. These same stones, which nearly broke Connecticut's colonial back and which tested the Puritan will, are today cherished. Look carefully at them. Although the sweat has long since dried, you can still observe the scratches made by plowshears, and the deep grooves made by seventeenth-century crowbars. Connecticut's glacial stones, now resting in walls, are worth approximately two hundred dollars per cubic yard, more hard currency than those farmers who first dug them out would earn in an entire year. This, above all else, the early settlers would find hard to accept.

The lack of a major crop—such as cod, rice, cotton, or tobacco—to trade with the Old World, and the absence of a deep-water port

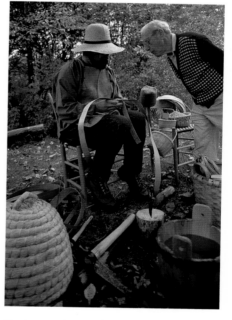

Basket making follows Colonial ways.

caused Connecticut to remain relatively isolated for two centuries. At the same time, its neighbors, New York and Massachusetts, were subjected to the liberalizing influences of the Old World through trade and the resulting exchange of ideas. Connecticut's Puritan-Congregationalist faith remained intact, unchallenged, far longer than elsewhere in the New World. Harvard, the great center of learning in Massachusetts, early became far more "enlightened" than did Yale, which remained essentially a college to train ministers for the Congregational Church.

Because of its relative isolation, Connecticut remained orthodox and conservative, a "theocracy" run by the elect of the church, who saw no reason to amend the state's Fundamental Orders until they were forced to do so in 1818 by political pressure. The result was the Constitutional Convention, which was held in Hartford's Old State House. That convention marked a major turning point in the political history of the state.

At last, even though the Congregational Church would remain politically dominant, the members of other churches—Anglicans, Baptists, and Quakers—were no longer forced to pay taxes to a church to which they did not belong. The new constitution broke the political power of the Congregational Church once and for all, and constitutional democracy, more along the lines we enjoy today, made its appearance for the first time in the "Constitution State," which soon become one of Connecticut's nicknames.

The Puritan influence lingered on, however, as did the power of Connecticut's infamous Puritan "blue laws."

Connecticut's boundaries were not fixed for one hundred eighty-five years. Disputes with Massachusetts, New York, and Rhode Island persisted, each state claiming that their charters entitled them to land and townships claimed by another.

Those original charters granted by England were often vague. Connecticut, according to its charter, might well have extended all the way to the Pacific Ocean. In fact, at one time, the state did own a considerable portion of what eventually became Ohio. Many of Ohio's original settlers came from Connecticut, laying out towns which even today bear a remarkable resemblance to the towns they left behind in Connecticut, with their neat, central greens, and their white, wooden meetinghouses.

In all the boundary disputes with its neighbors, Connecticut held a trump card. The state's low taxes, still a feature today of this "land of steady habits," caused those who resided in the contested townships to prefer the jurisdiction of Connecticut.

Nor was Hartford always the undisputed capital of the colony. For a time New Haven clung to its ambition of remaining an independent political entity. In 1665, however, facing the loss of its towns and therefore bankruptcy, New Haven finally allowed itself to be "absorbed," and Hartford became dominant.

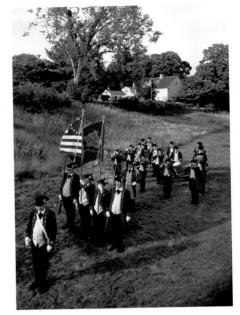

Chester Fife and Drum Corps

Putnam Cottage, 1692, on the Post Road in Greenwich

■ *Right:* Located across part of Lebanon's mile-long village common is the War Office that was used by Governor Trumbull, Washington, Franklin, Lafayette, and Rochambeau. In early 1781, five regiments of French troops under Rochambeau camped here on this green before joining the Continental troops at Yorktown.

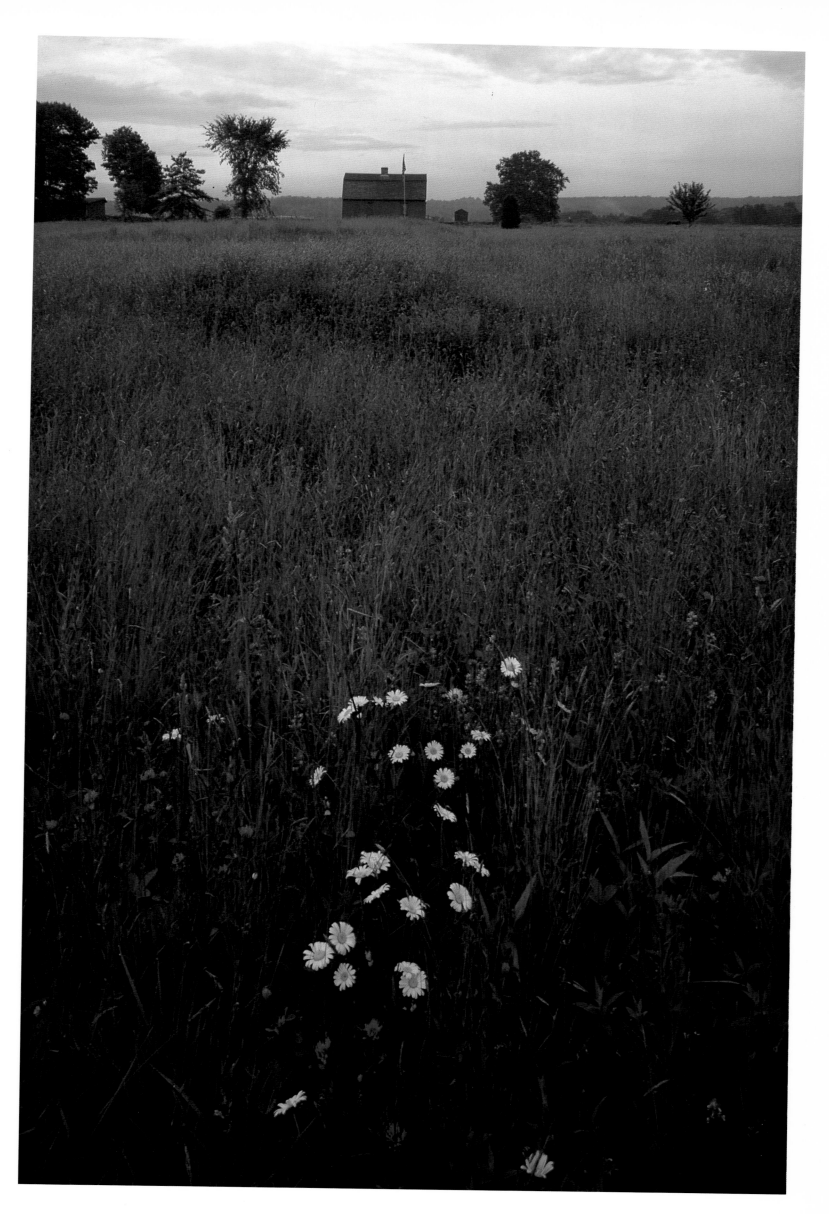

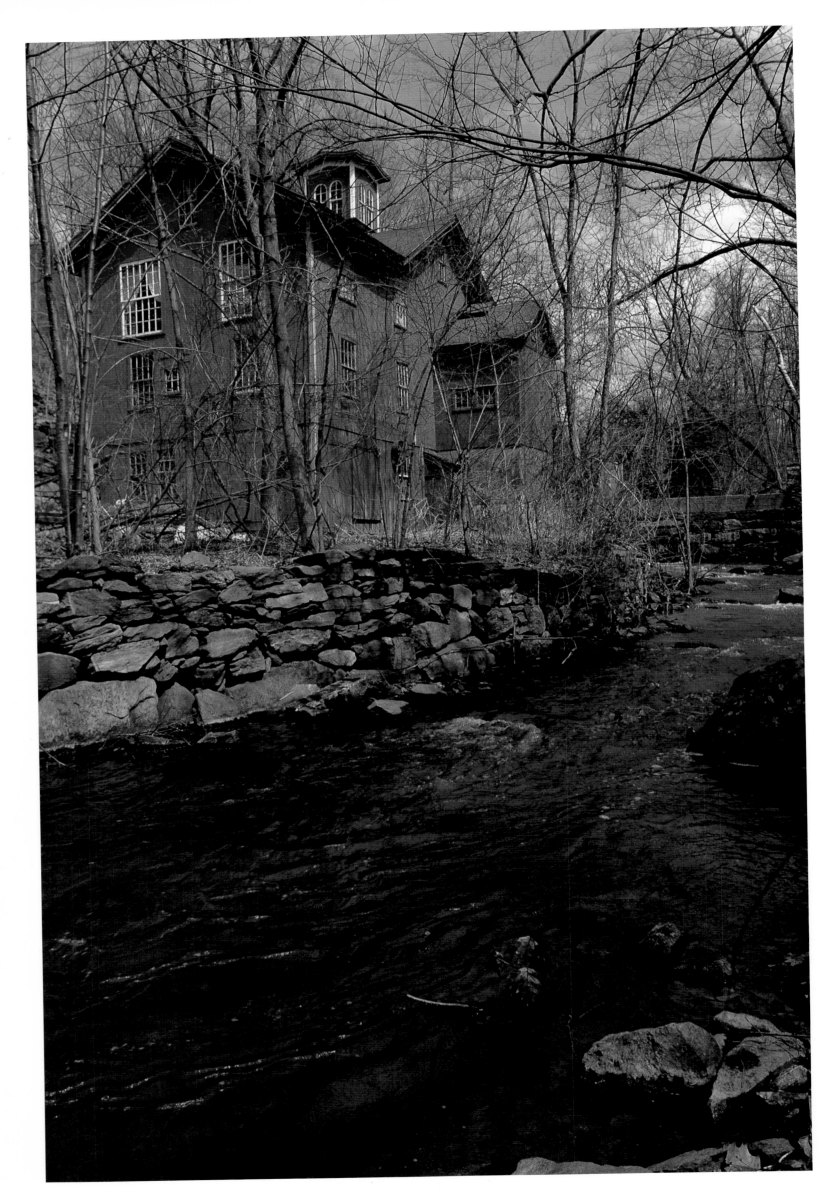

THE INDUSTRIAL REVOLUTION

by Roger Eddy

More than anything else, it was Connecticut's abundant water power, its streams and rivers, which started the state on the road to industrial wealth and power. Lacking a great port or an important agricultural commodity to trade with the Old World, the more enterprising citizens recognized early that Connecticut was a case of "manufacture or perish." They realized that to survive, the state must import raw material, make it into things that people in the New World wanted and needed, and then fan out across the land, selling what they made.

An 1881 mill in Glenville, now an advertising agency

Connecticut's status today of being a leading exporter of manufactured goods began early, when the "Yankee traders" became famous far beyond the state's boundaries. These sharp salesmen, who traveled the roads with wagons loaded with pots and pans, tools, nails, pins, clocks, and—if reports can be believed—wooden nutmegs, helped build Connecticut's industry. Those peddlers also gave Connecticut another nickname, the "Nutmeg State," which has clung despite efforts of state officials to eliminate it.

Gradually, the state emerged as a major manufacturing power in the New World. Mills appeared along nearly every fast-water stream in the state—brass mills, metalworking shops, and firearm factories. Connecticut's industry received its first great boost as a result of the penalties imposed by Britain after the Revolutionary War, when England declared its former colonies to be an enemy nation. The tariffs which were then levied against manufactured goods from England enabled Connecticut's fledgling industries to thrive and prosper. Capital from Rhode Island and Massachusetts flowed into the state. The eastern Connecticut city of Norwich, with its excellent waterway, exploded with growth as its thread mills brought in great wealth.

Also, as has always been the case in Connecticut, those of its citizens who made money reinvested it in Connecticut. Absentee ownership has never been the tradition in the state. Mill and factory owners felt obligated to "live within earshot of the same whistle

■ *Left:* Since 1875 when Oscar Beeman built this water-powered mill in New Preston to power machinery in his carriage shop, it has been used as a cider mill, saw mill, grist mill, and machine shop. It is the only remaining mill structure along this stretch of the Aspetuck River where a number of mills once clustered.

which called their employees to work." While great fortunes have been made in Connecticut—in everything from insurance to horseshoe nails—those who made those fortunes did not forget the source of their wealth.

Following the Revolutionary War and gathering momentum all through the nineteenth century, the list of Connecticut's inventors and the products which resulted from their Yankee ingenuity seems endless. Firearms, clocks, corsets, knives, axes, hardware, hats, rubber goods, sewing machines, textiles, machine tools, insurance, ball bearings, postage meters, jet engines, helicopters, submarines, and soap—all brought prosperity to Connecticut.

Lockwood Mansion, Norwalk, 1865

The state's zeal in promoting and selling its products became legendary. Hartford's early insurance executives dispensed funds on the sidewalks while the fires still burned in Chicago, San Francisco, and New York. This unheard of promptness caused the stability of Hartford's insurance industry to gain world renown and allowed the city to call itself the "Insurance Capital of the World." The J. B. Williams Company in Glastonbury designed a soap which revolutionized shaving, and then promoted and sold it. Singer sold his sewing machines to just about everyone, including Eskimos. The Collins Company in Collinsville, with its supply of water power, made machetes, which they exported to South America in boxes which could also be used for coffins!

Connecticut, with no great natural resources except a seemingly endless supply of water power and crushed rock, learned early that, most of all, it needed to make things and then promote and sell them. This spirit still pervades the state today. It has kept the average income of Connecticut's citizens at, or near, the highest level of the nation, and even the world.

No matter how brief, the story of Connecticut's industrial miracle and its emergence as the arsenal of the nation could not be complete without a specific mention of Eli Whitney. He was certainly Connecticut's greatest inventor and possibly one of the greatest mechanical geniuses ever born in America. He is best known for his invention of the cotton gin, which brought explosive growth to the cotton plantations of the South, as well as great wealth to their owners, but which brought only heartbreak and endless litigation to Whitney, as his patents were ignored.

However, Eli Whitney's greatest contribution to the industrial process was his development of the concept of machine-tooled, identical, interchangeable parts. This meant that, at last, products such as rifles or clocks could be mass produced.

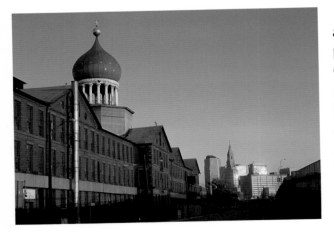

Hartford's Colt firearms factory, now multi-tenant

Later, Abraham Lincoln would receive most of the credit for preserving the Union. However, it was Eli Whitney, whose "modern" factories near New Haven turned out the tens of thousands of firearms carried by the Union troops, who made the preservation of the Union possible.

It was Whitney's invention that brought the machine-tool industry to Connecticut. And it was machine tools which allowed Gilbert of Winsted, Seth Thomas of Thomaston, and Eli Terry of Terryville to produce their inexpensive, accurate, and long-lasting clocks. These clocks, many of them still keeping time today, spread across the country, made Connecticut famous, and also brought wealth into the state.

Whitney's concept of interchangeable parts allowed Samuel Colt of Hartford to produce the famous Colt 45, "The Peacemaker," which also was known by such names as *the gun which won the West* and *the cowboy's friend.*

It was Whitney who made it possible for Singer to mass-produce his sewing machines. And it was Whitney's "Yankee ingenuity" that turned the Naugatuck Valley, with its brass mills, spring factories, and machine-tool factories, into one of the great industrial centers of the nation and the world.

Had Eli Whitney been born elsewhere than Connecticut, or had he lost faith in Connecticut's future and done his "tinkering" somewhere else, it is unlikely that Connecticut would have become the center of the machine-tool industry. Therefore, the state's subsequent development into the industrial juggernaut it now is might never have taken place.

Today, thanks in great measure to Eli Whitney's genius, it is possible to manufacture anything in Connecticut from a submarine to a pin—and a box small or large enough to put them both in—merely by consulting the Yellow Pages of a telephone directory. Per capita, thanks to Whitney, Connecticut has a larger pool of all types of skilled labor than does anywhere else in the nation. This skilled labor force joined with the abundant water supply and the crushed stones to become one of the state's greatest assets.

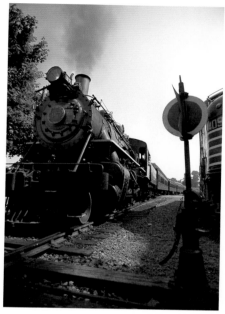

A Valley Railroad steam engine, Essex

The cities of Hartford and New Haven were first linked by rail in 1837, and the ever-growing system of rail transport which soon followed made Connecticut less dependent upon the seaports of Boston and New York. With the development of the railroad, goods manufactured in the state could be efficiently and inexpensively transported overland around the nation. Nearly every town in the state put in its bid for rail terminals, well aware that without one their town or city would remain stagnant. The railroad transformed the quiet Naugatuck Valley into a center of industry. Railroads not only transported manufactured goods out but also imported the workers needed to create more goods.

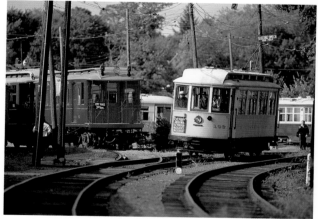

East Haven's Shoreline Trolley is America's oldest line.

Many of these workers also came from Europe, lured by the promise of good jobs and attractive wages. Bridgeport, New Haven, Meriden, Wallingford, New Britain, and Hartford all became prosperous centers of industry, in large measure thanks to the railroad. Across the state, the grand station houses which appeared—such as Hartford's Union Station made of brownstone, and Waterbury's

exquisite station with its strikingly graceful tower, a copy of Sienna's City Hall in Italy—reflected optimism. Today, these station houses, most of them in a sad state of disrepair, stand as a reminder that nothing lasts forever, not even the era of the railroad.

Also in Connecticut are mute reminders that canals were once believed to be the wave of the future. The waterless trench in Unionville, if the dreams of investors had come true, would have been part of a vast, interconnecting system of water transport, able to move manufactured goods from the Atlantic to the Pacific. This weed-choked ditch is a reminder that while great fortunes were made in railroads, fortunes were also lost by those who invested heavily in canals.

Along Route 2 in Lebanon, there is a sign which might seem strangely out of place to those who know nothing about the role played by Connecticut during the Revolutionary War. The sign says, "War Office," and it refers to the Army headquarters maintained by Governor Jonathan Trumbull during the colonies' struggle for independence. While Connecticut is famous for no Revolutionary War battlefield, it was during this war that the state earned its reputation as the "Provision State."

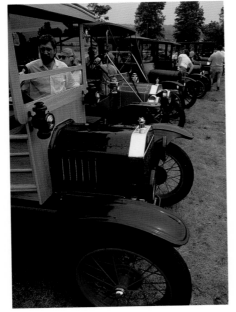

Antique car rallies attract history buffs.

A successful merchant from the eastern part of the state who was elected governor at a critical time, Trumbull was fiercely anti-British, as was most of the state east of the river. It was soon evident that George Washington and the Continental Army had no more loyal or steadfast supporter than this tireless, energetic patriot. While others grumbled and grew weary of the war, mouthing sentiments of possible compromise, Trumbull, from his private headquarters in Lebanon, never wavered. Trumbull may well be the one who should receive credit for saving Washington's army from total starvation at Valley Forge. It was Trumbull who arranged for two hundred head of cattle to be driven overland to feed the troops. The French, ever quick to express their contempt for the American colonials, soon learned to respect this short, unassuming, merchant governor from Connecticut.

Connecticut's citizens have played an active role in every war fought throughout the nation's history, from the French and Indian War of 1740, the Revolutionary War, the War of 1812, the Civil War—where thousands of Connecticut boys served and where hundreds died—and on through both World Wars.

Not only have thousands of Connecticut men served, but the state has also turned out a massive amount of war material, from fuses, to shell casings, to engines, rifles, machine guns, and submarines. From its earliest days, patriotism has always burned bright in the state. Nathan Hale, Connecticut's great Revolutionary War hero who was hung by the British as a spy, best summed up the state's patriotic spirit, when he said, "My only regret is that I have but one life to lose for my country."

■ *Right:* The living Mystic Seaport Museum recreates the life of the nineteenth century. During the gold rush days, the port hummed with activity. Among the ships that were built in Mystic was the *Andrew Jackson* which held the record in 1860 for the best average time to San Francisco—eighty-nine days, four hours.

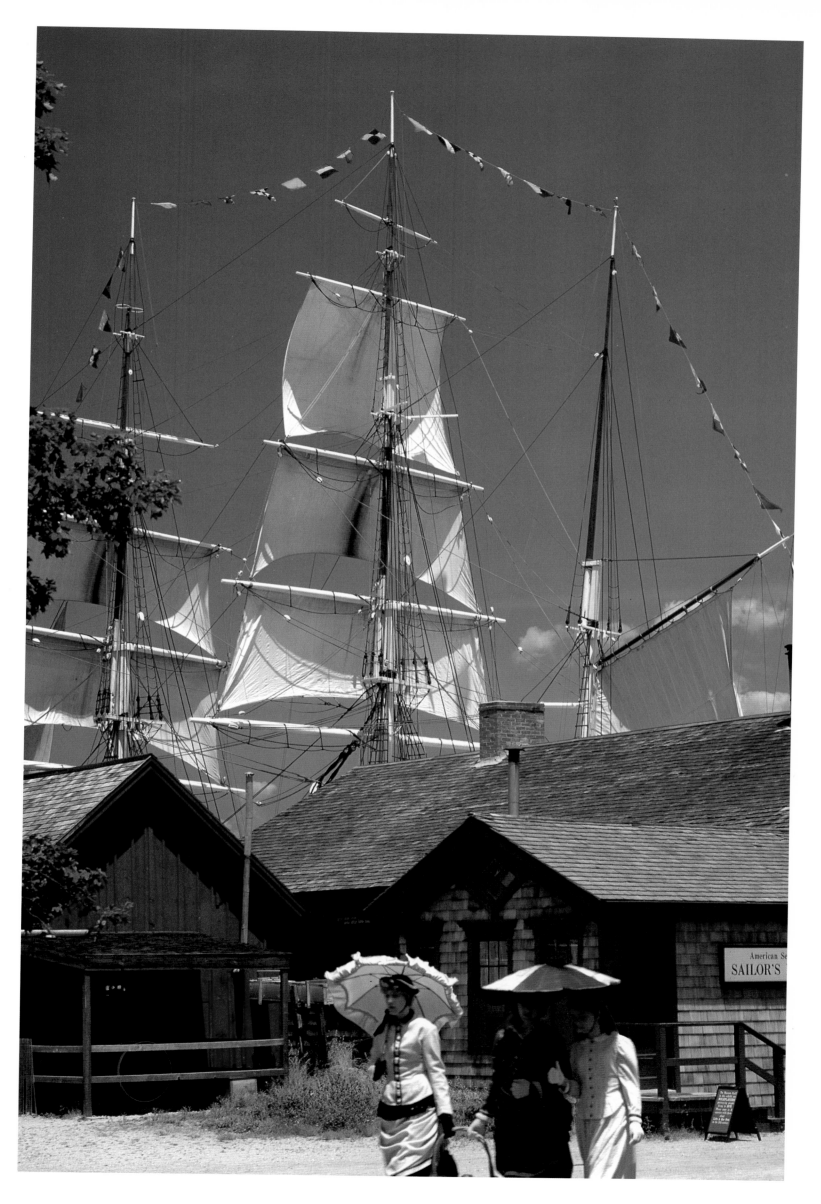

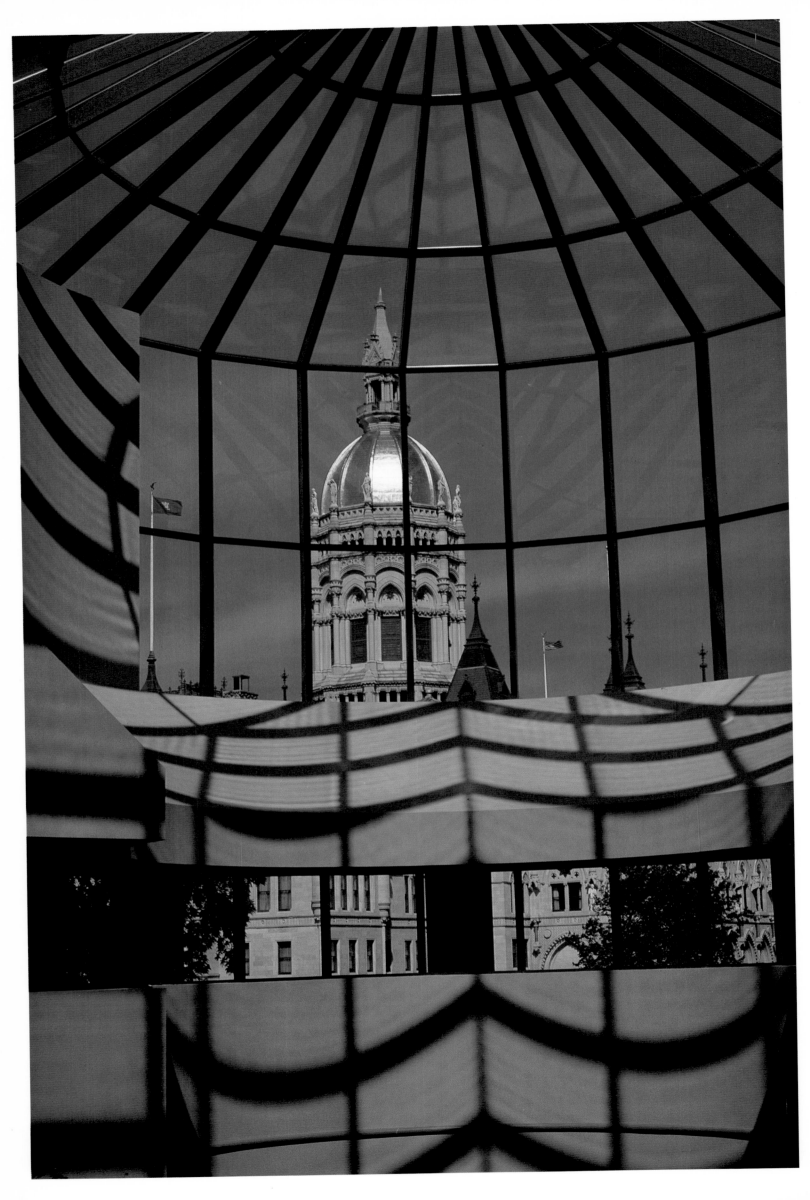

MODERN-DAY CONNECTICUT

by Roger Eddy

Connecticut's lack of a major port, and the resulting isolation, not only kept the Puritan faith intact longer than in neighboring states, but it also kept the state's population more homogeneous. Until its industry began to expand and grow, until Connecticut hung out its "Help Wanted" sign, immigration from Europe—including Ireland, Germany, and the Scandanavian countries—generally flowed into Boston and New York, rather than into Connecticut. Jews had reached Connecticut as early as the Revolution, and most of them became highly successful traders and businessmen. As many as six thousand blacks lived in Connecticut by 1780, most of them descendents of slaves who, for the most part, had been freed. However, the population remained largely of English descent until the need for factory labor became pressing. Then the railroads arrived to transport the work force to such growing industrial centers as Hartford, Waterbury, New Haven, and Bridgeport.

By the time of the Civil War, there were many citizens of Irish descent in both Hartford and New Haven. Connecticut, along with the rest of the nation, was swept up into "the know nothing" movement, a blatantly anti-Catholic outburst, which, among other factors, helped sweep Abraham Lincoln into office.

However, since the Irish are not a people who are easily cowed—particularly by the English, as they considered the Connecticut Yankees to be—a confrontation was inevitable. A Catholic church was burned in Hartford, for instance, and there were near-riots elsewhere. Soon, however, with their genius for political organization, the Irish became a political power in the state, turning the Democratic Party into the party of opposition. The newly powerful party confronted those "original" Americans, the descendents of those who had built their "Zion in the wilderness" and who considered the New World in general, and Connecticut in particular, to be theirs. Whatever were their strengths, and they possessed many, those whose ancestors had tamed the Connecticut wilderness were not noted for tolerance. The Sign of the Cross, according to one

Polo matches are social events in Greenwich.

■ *Left:* Connecticut's State Capitol, costing two and one-half million dollars, was built in Hartford in 1872. Its dome is seen through the State Office Building's atrium. The capitol combines High Victorian and Second Empire styles. In place of a tower, a dome, which signifies "supremacy of law," crowns the structure.

early Puritan spiritual leader, was the "Mark of the Beast," and the "Sign of the Devil." Nineteenth-century Connecticut Yankees, a phrase soon to be made famous by Mark Twain in his book, *A Connecticut Yankee at King Arthur's Court,* had a great deal to learn about tolerance. In the Irish they had found a formidable teacher.

It was the Irish who blazed the trail for the other immigrants, the Italians and the Poles who would soon follow them from Europe, and the French-Canadians who would move down from Canada. Their dream was no different from the dream which had brought everyone else to the New World—a longing for a good job, a place of one's own, and freedom. New Britain became one of the country's largest Polish centers. New Haven, Bridgeport, Waterbury, and Middletown, among others, became Italian towns.

Each immigrant group has made its own contribution to the state. President Howard Taft, observing the Italian truck gardens outside New Haven, remarked that, "they can make a wasteland bloom." The fruit orchards in Glastonbury recruited workers from Italy. Today, descendents of these same immigrants own most of the orchards where their grandfathers were employed. They are also responsible for the state becoming a major exporter of fruit. Those of Irish descent are now totally integrated into all segments of Connecticut society and are prominent in all fields, business as well as politics. "Italian" construction companies build most of the state's roads and buildings, and Italian names appear more and more often among political office holders.

Jews, who arrived in large numbers just before and after World War II, are today highly prosperous and successful wherever they have settled. In eastern Connecticut, Jews have been responsible for Connecticut becoming a major producer of eggs.

There is hardly a national group which has not achieved prominence in Connecticut, and it is this wide variety of backgrounds and cultures which has given the state one of its greatest charms.

Following World War II, thousands of blacks, seeking work and a better life, moved into Connecticut from the south. They now constitute a majority of the population of many of the state's large cities, as they do elsewhere in the nation. Bridgeport is today the home of thousands of Hispanics, as is Hartford.

No discussion of Connecticut can be complete without mentioning the state's weather. Just as Connecticut is the "gateway to the Northeast," it can also be the battleground between three large national weather systems. The first one spreads in from the west. Another, warmer system, flows up along the East Coast, often bringing with it Bermuda lows, tropical storms, and hurricanes. Finally, Connecticut weather is often influenced by drafts of cold, clear air from Canada, which can hold weather fronts over the state for days, occasionally resulting in torrential rainfall. Mark Twain, who lived and wrote in Hartford much of his adult life, certainly

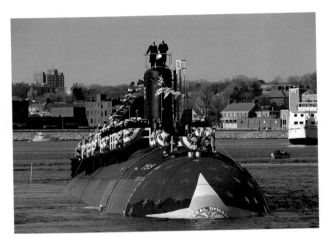

Nuclear attack submarine, USS Miami, *Groton*

must have had Connecticut in mind when he said, "If you don't like New England weather, just wait a minute. It will change."

In 1816, there was near-famine in Connecticut when a killing frost destroyed crops during every month of the growing season.

Connecticut's great "Blizzard of '88," which dropped as much as four feet of snow in thirty-six hours, has achieved the status of a legend in Connecticut, spawning books and exhibits of old photographs, along with numerous tall stories, such as snowdrifts fifty feet high! For years, just as veterans of the Civil War gathered their grandchildren about their knees and told them stories of the war, so also did veterans of the Great Blizzard hold their grandchildren spellbound with stories of tunnels from house to barn, horses with only their nostrils visible above the drifts, and derailed trains. Those who survived the Great Blizzard have all passed from the scene. However, the snow of 1888 grows ever deeper.

Connecticut is often in the path of hurricanes which sweep up the coast like immense, runaway trains. The most famous of these was the hurricane of 1938, which flattened forests as though they were fields of wheat and smashed the state's coastline, leaving destruction which can still be observed today. Those who live in the state fear the occasional hurricane. When the warning arrives, houses are shut tight, and the highways are suddenly deserted. If the wind is gentle, the state breathes a collective sigh of relief. However, when a great wind does blow, it is as though the state has become a child in the grasp of an angry parent, held by the shoulders, and shaken. The wind blasts in across the Long Island Sound, smashes against the coastline, and then sweeps inland, often leaving great destruction in its wake. The two-day rainstorm of 1955, the side effect of a hurricane, flooded Connecticut with as much as twenty-two inches of rain within a twenty-four-hour period. Small brooks became lethal torrents. Entire cities, such as Winsted and Unionville, were devastated. The state was paralyzed for days.

Many will never forget the ice storm of January 1973. In the early morning, the silence was broken only by the cracking of tree branches as they crashed to the ground. Sparks from downed electric wires lit the sky. As the rain continued and froze and the ice grew thicker, trees snapped at the trunk, blocking roads and highways. Firewood sold at a premium. Houses became cold and gloomy. Those with wells had no water. Linemen who arrived from all over the East, worked until they dropped from exhaustion. It was modern civilization in the grip of a nightmare. Many woodlands still show the effects of this two-inch blanket of ice which froze the state to a standstill.

But that is the bad news about Connecticut weather. There is good news as well—lots of it. Nowhere in the world are the four seasons more clearly defined than in Connecticut. Spring moves softly into Fairfield County. Dogwood and apple trees blossom. The

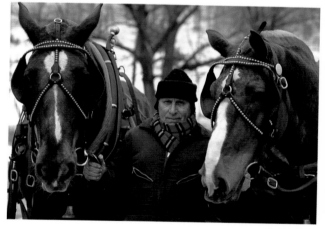

Belgian draft horses are now used for competition.

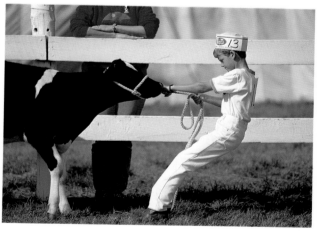

At a 4-H competition, not all goes as planned.

air is laden with the nostalgic smell of lilacs in bloom. Grass turns a brilliant green along the Merritt Parkway, the world's most beautiful highway. Warblers flash through the woods, heading north. Soon, all over the state, wildflowers carpet the woods with a display of fragile color—yellow, white, pink, and blue. Buds swell, and leaves appear overhead. Native to this beautiful, sun drenched, "semi-tropical" New England state are as many varieties of trees and plants as are found anywhere else in the world. It is spring again, and all those who live in Connecticut know it.

In Connecticut, summer flows up the rivers. Warmth, sometimes humid and heavy, rolls up the valleys, up the Housatonic, the Naugatuck, the Thames—and especially up "the long tidal river," the Connecticut, the great, unspoiled waterway, once called by the Indians, *Quinnetukut*, which gave the state its name. Long Island Sound comes alive with thousands and thousands of boats appearing suddenly, like butterflies. The water is warm. The beaches revive with music, laughter, and people. Summer nights in Connecticut vibrate with the songs of katydids and crickets. Corn, tobacco, and hay grow lush. Above all, summer in Connecticut is a time to be young, or, if that is no longer possible, to remember when you were.

Fall in northwestern Connecticut—in Litchfield, or Salisbury, or Sharon—is more than merely a season. It is a moment etched in time. No other section in the country can equal it. Healthy and tan from the summer, the children play touch football on the town greens. In the distance, on the hills and mountainsides, the maples, ash, and oaks each gradually turn their own favorite color. The valleys compete with each other. Overhead, tens of thousands of geese fly south, just as they have for tens of thousands of years before. Everything in Connecticut has changed in three hundred fifty years, but then nothing has changed.

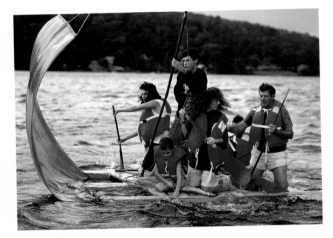

Lake Waramaug hosts the annual Huck Finn raft race.

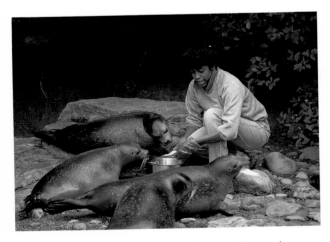

Mystic's Marinelife Aquarium has 6,000 specimens.

Winter comes suddenly with a rattle of brown leaves and a cruel wind. Snow falls. In Connecticut, people believe that nothing good can ever happen where snow never falls. The world contracts in the winter, making it possible for dreams to survive.

The many great colleges and universities are not in Connecticut by accident. Yale, Trinity, Wesleyan, along with the scores of excellent state institutions of higher learning, are part of the Connecticut tradition. The schools—including Hotchkiss, Taft, Choate, Loomis, Westminster, Miss Porters, Ethel Walker—educate the young from all over the world.

A while back I visited the state capitol in Hartford. It was a perfect May day with cool, clean air flowing down from Canada. The sky was a brilliant blue. The grass around this ancient pile of granite and marble had been freshly mowed. The building, recently sanded and cleaned, gleamed as though built the day before. As a former legislator—and to bring myself luck—I touched the bronze foot of Nathan Hale, who stands proudly at the capitol's east entrance.

At the far west end of the capitol, I observed again the banks of Civil War regimental colors displayed in glass cases. Also in its own glass case was Lafayette's canvas cot, a souvenir of his stay in Hartford during the Revolutionary War. At the north entrance was the dusty tree trunk with the Civil War cannon ball embedded in it. Connecticut's capitol, among other things, is the state's attic, filled with objects from the past, not quite good enough for a museum, but still too good to hide.

There is supposed to be a precise spot, directly beneath the capitol's golden dome, where, if one stands silently, every word ever uttered by those who have served the state can be heard. I failed to find this spot, nor have I heard of anyone who has. But the rumor persists. Connecticut has become what soon the entire nation will be. It is a successful mixture of the peoples of the world, living in harmony, led variously by governors whose ancestors came from Ireland or Italy, and cities with black mayors or those whose forebears once lived in Italy. Connecticut is living proof that America's future remains bright.

The hall of the House, that fractious, noisy chamber, where, through some magic known only to those who live in Connecticut, first things are always done first—like removing stones before the crop is planted—today was silent, as was the senate chamber.

This wonderful building inspires awe in all who are chosen to serve in it. It makes us better than we are. Cool, steady, solid, and permanent, it remains a symbol of both old and new, of the past and of what will come. A changing river of people flows through this capitol, just as a changing river of people flows through the state itself. But the building and the state were both built to last.

Near the top of the capitol, there is an outside ledge where one can stand and see almost the entire state. To the north are the hills of Massachusetts. Far to the west is New York. To the east is Rhode Island. The great river, the Connecticut, unspoiled and unchanged, flows down toward the coastline and the sea. Spread out around the capitol is the glittering glass-and-steel, brand-new—and old—city of Hartford, prosperous and solid, like the state itself.

I was soon joined on the ledge by a man who seemed anxious to explain why he was there. He said, "My great-grandfather was a stonecutter from Ireland. They recruited him to help build this capitol. He stayed on in Connecticut after it was finished, and that's why I'm here. I come up here every once in a while, just to look at this magnificent view and to remind myself how fortunate I am."

I told him that my story was similar and related the episode of the letter my great-grandfather had received from a brother who had urged him to go west. I said, "My great-grandfather wrote back, and said, 'Dear Brother, I have given your advice my most serious consideration. However, I have decided that there could be no finer place to live than Connecticut, and best of all, I am still here.'"

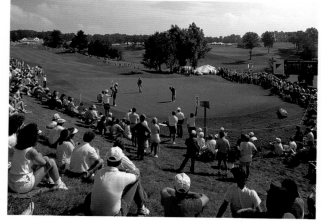

The Sammy Davis Jr. GHO draws golf's largest crowds.

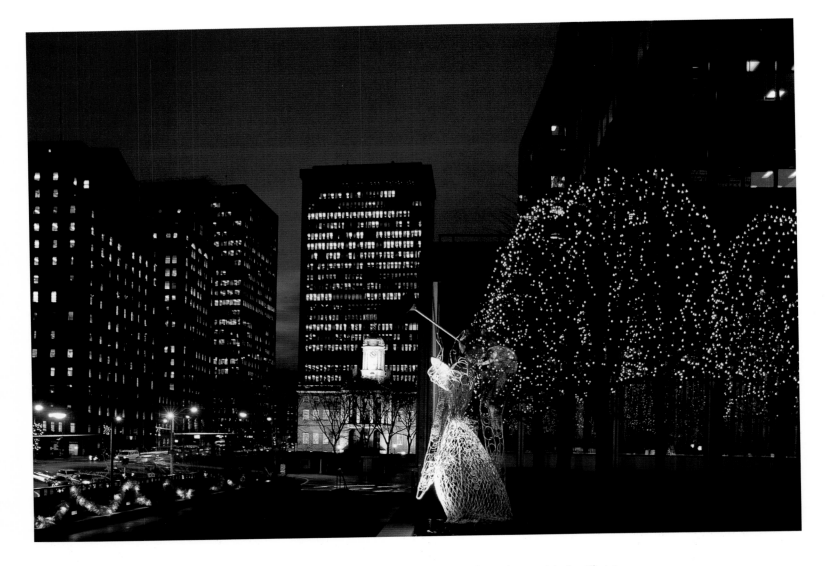

■ *Above:* Hartford's Old State House, America's oldest, glows with the Christmastime illuminations of Constitution Plaza. ■ *Right:* Until the 1970s, Stamford was a quiet colonial town but now has become home to multinational corporations. The value of commercial real estate has grown nine times in the past decade.

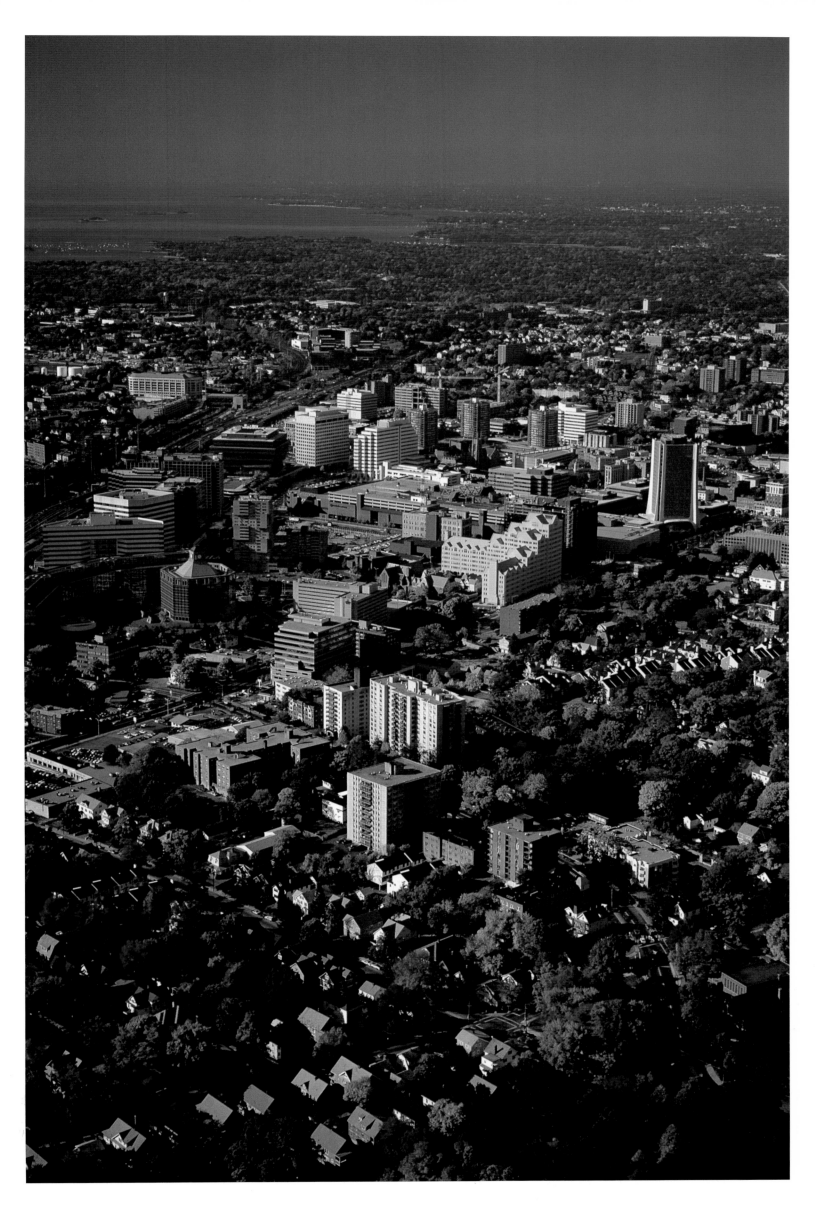

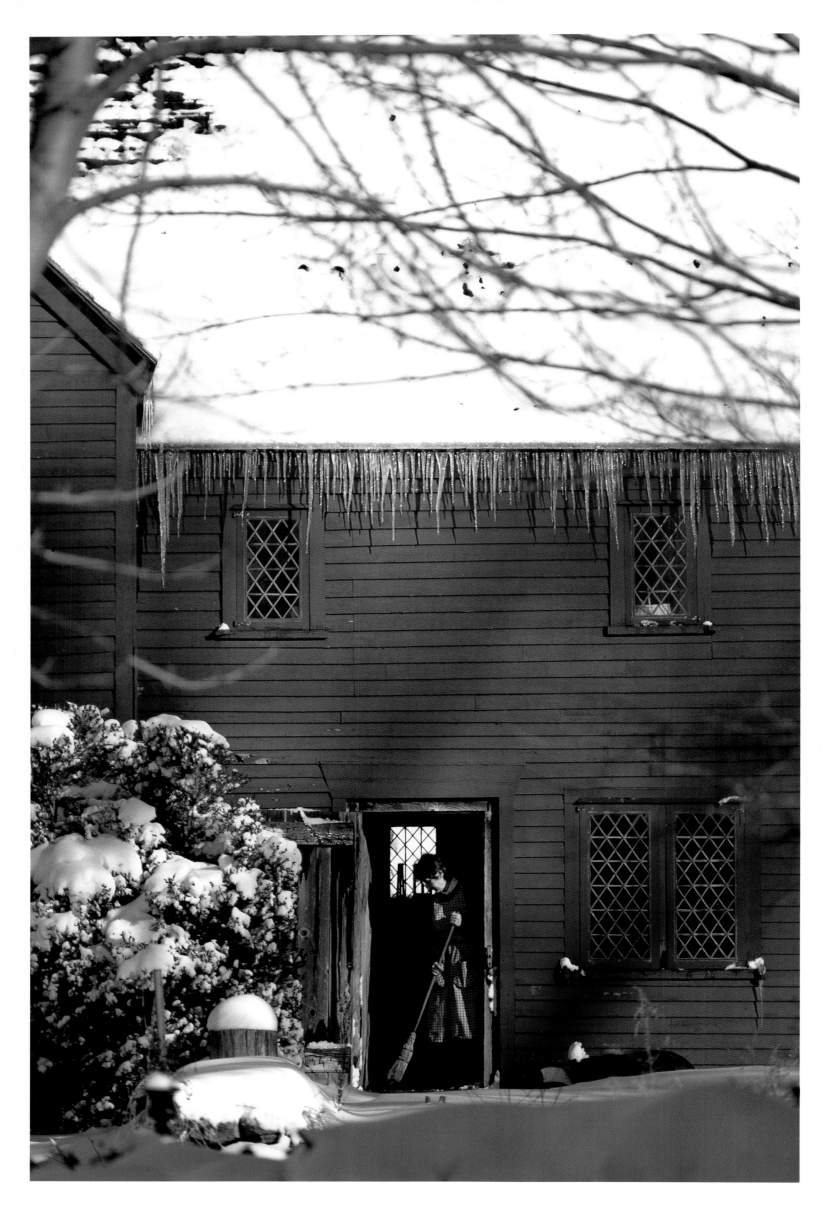

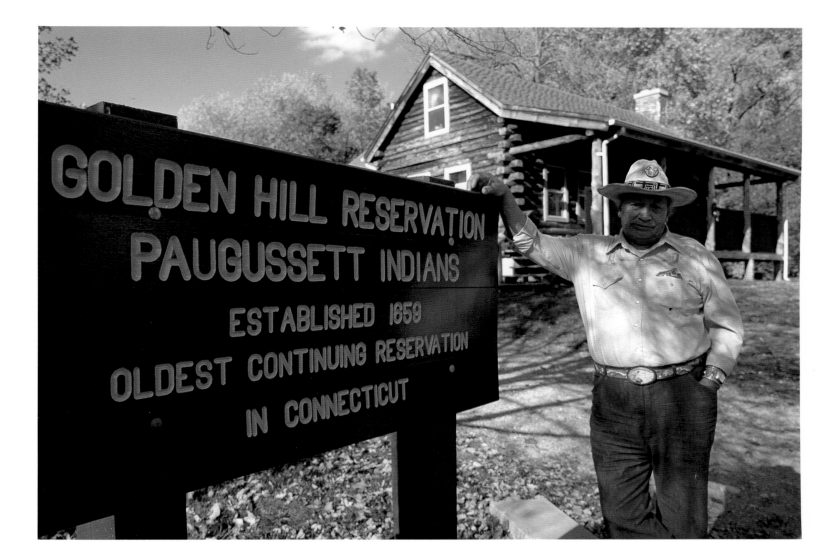

■ *Left:* Originally built in Old Saybrook in the mid-eighteenth century, Mystic Seaport's Buckingham House has a huge kitchen fireplace where visitors can watch colonial-style cooking. ■ *Above:* Only one-quarter of an acre in size, the smallest Indian reservation in America is in Trumbull. When the first settlers arrived, an estimated seven thousand Indians lived in what is now Connecticut. Currently, approximately forty-five hundred Native Americans live in the state.

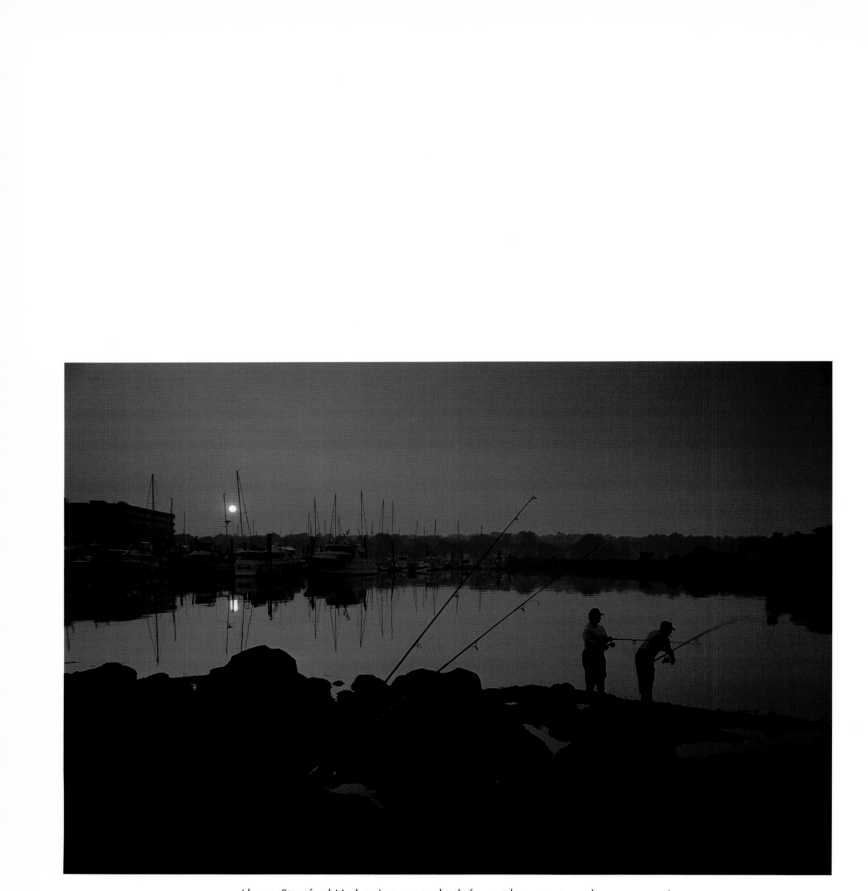

■ *Above:* Stamford Harbor is a center both for outdoor sports and commerce. A Connecticut Yankee from Bristol invented the telescoping steel fishing rod, easily concealed for Sunday fishing. ■ *Right:* The home port for the Coast Guard Barque *Eagle* is New London, also home of the United States Coast Guard Academy.

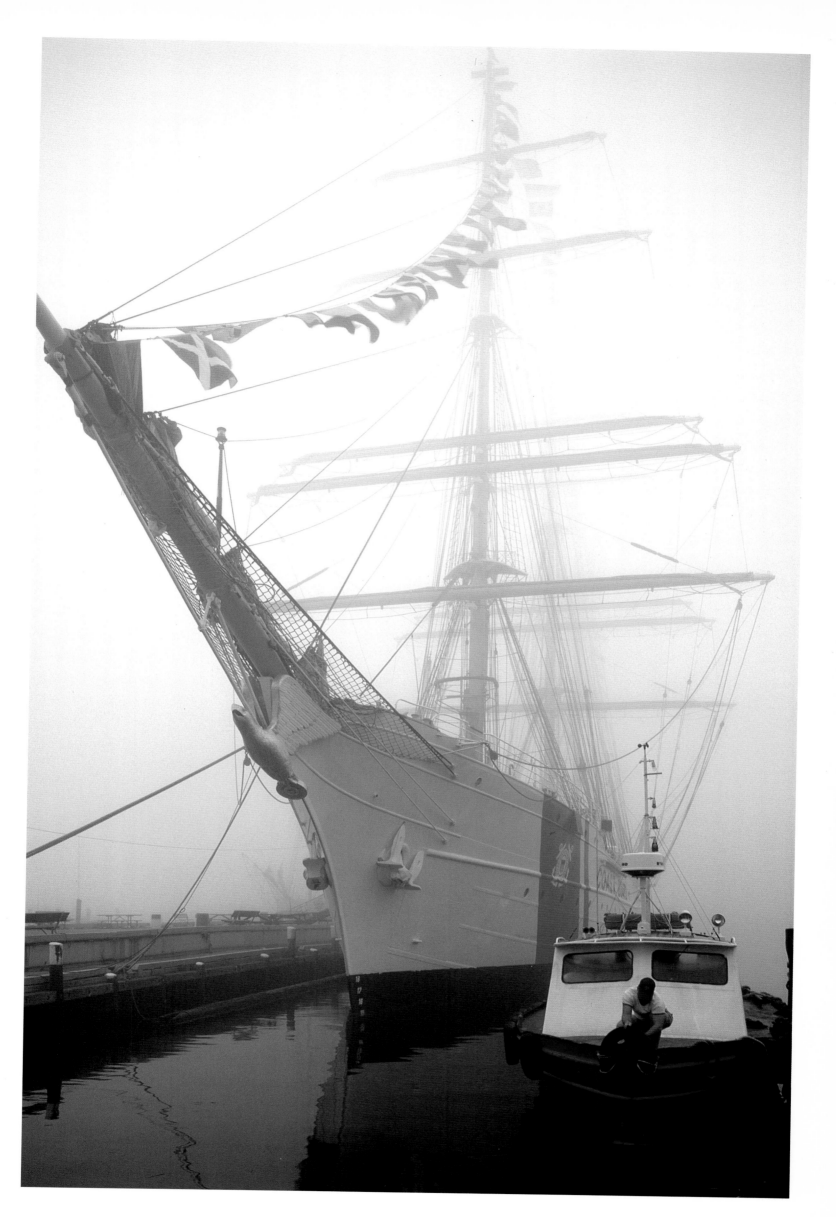

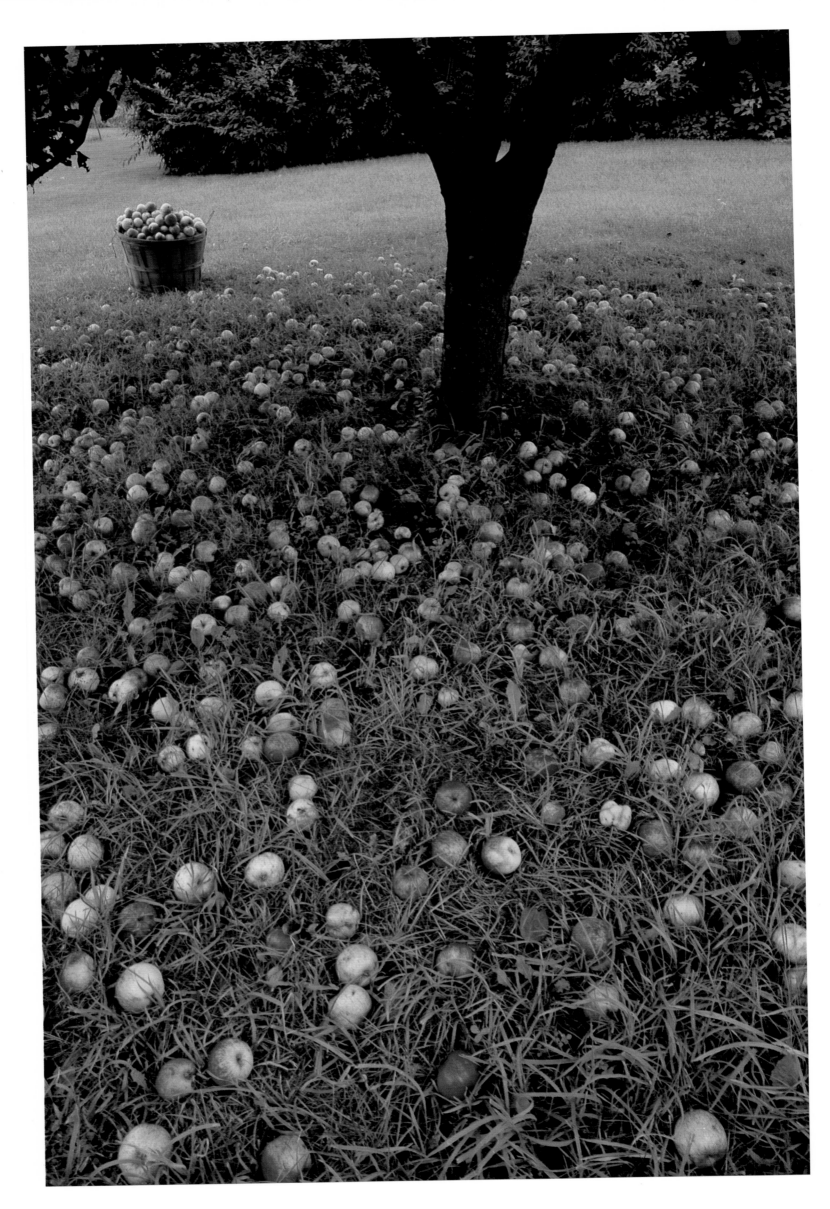

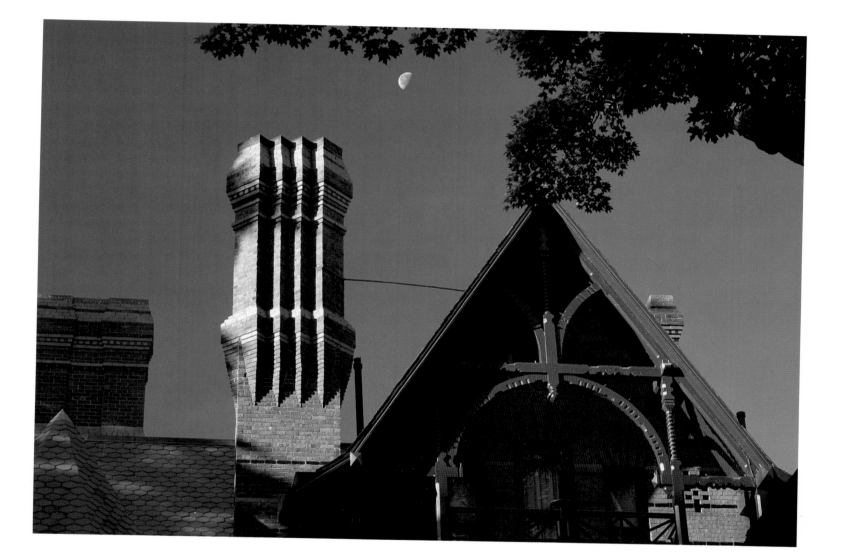

■ *Left:* In the fall, Connecticut is transformed into a land of bounty. These windfalls will become apple sauce and cider. ■ *Above:* Now a national landmark, Mark Twain built his exhuberant twenty-four-room mansion in Hartford in 1874. Rumor says that because of its ornate chimneys, elaborate woodwork, and carved balconies, it was designed to resemble Mississippi steamboats. Twain wrote many of his famous books here, including *The Adventures of Huckleberry Finn*.

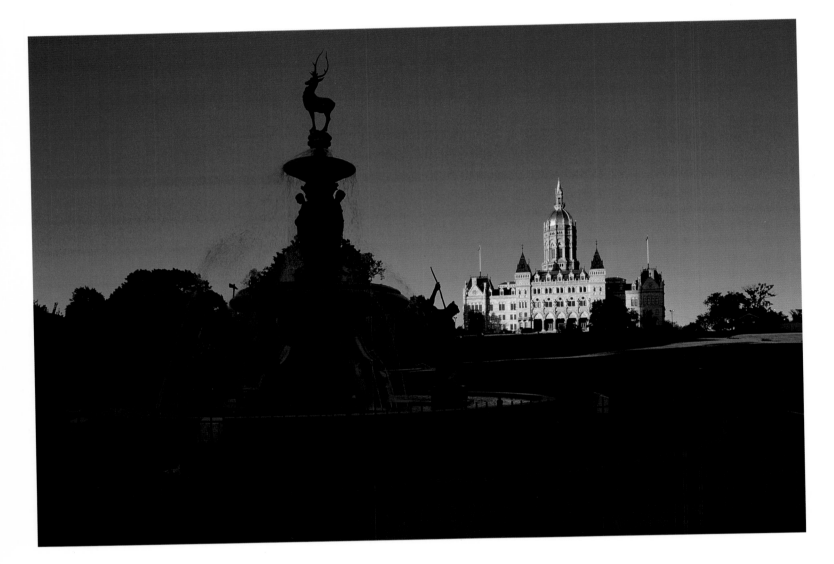

■ *Above:* The State Capitol, built of Connecticut marble, overlooks the city of Hartford from a rise in Bushnell Park. ■ *Right:* Ice sheets melting as recently as seventeen thousand years ago left massive boulders, called erratics. ■ *Following page:* Spring, a short-lived but distinct season, lasts from April to mid-May.

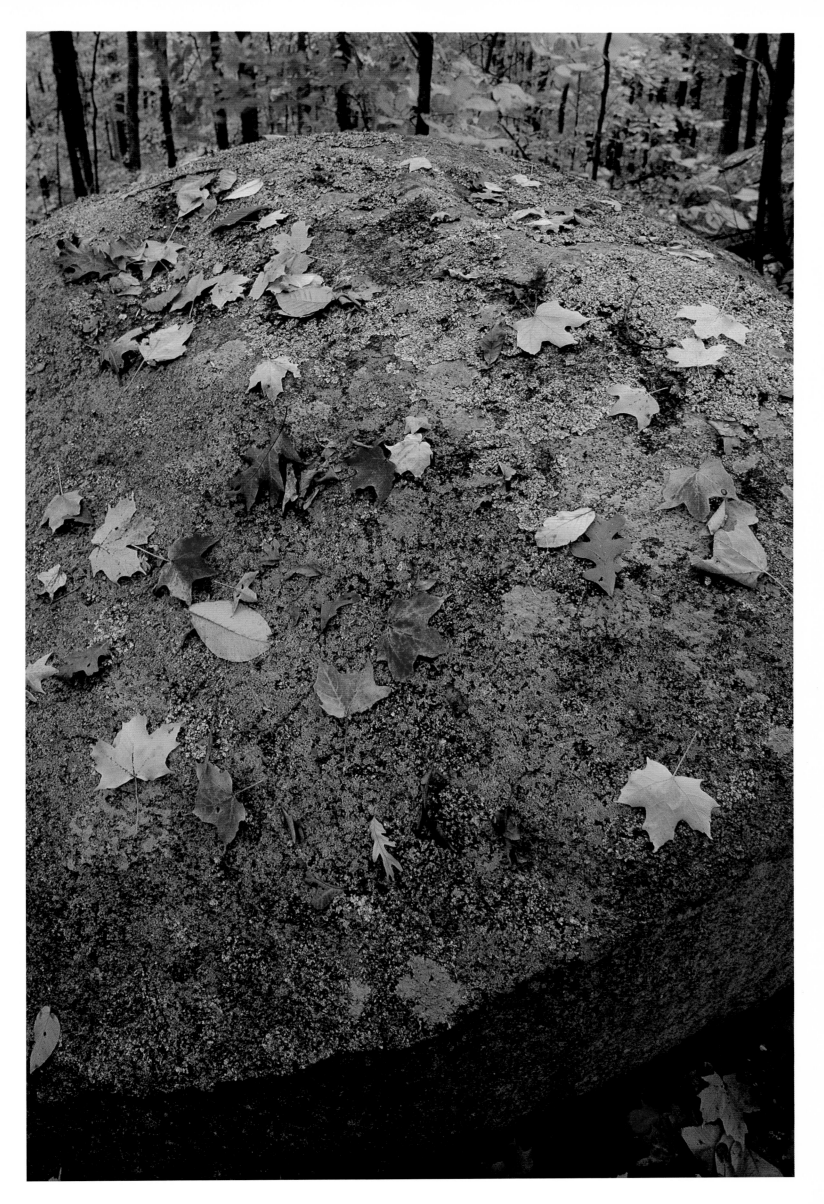

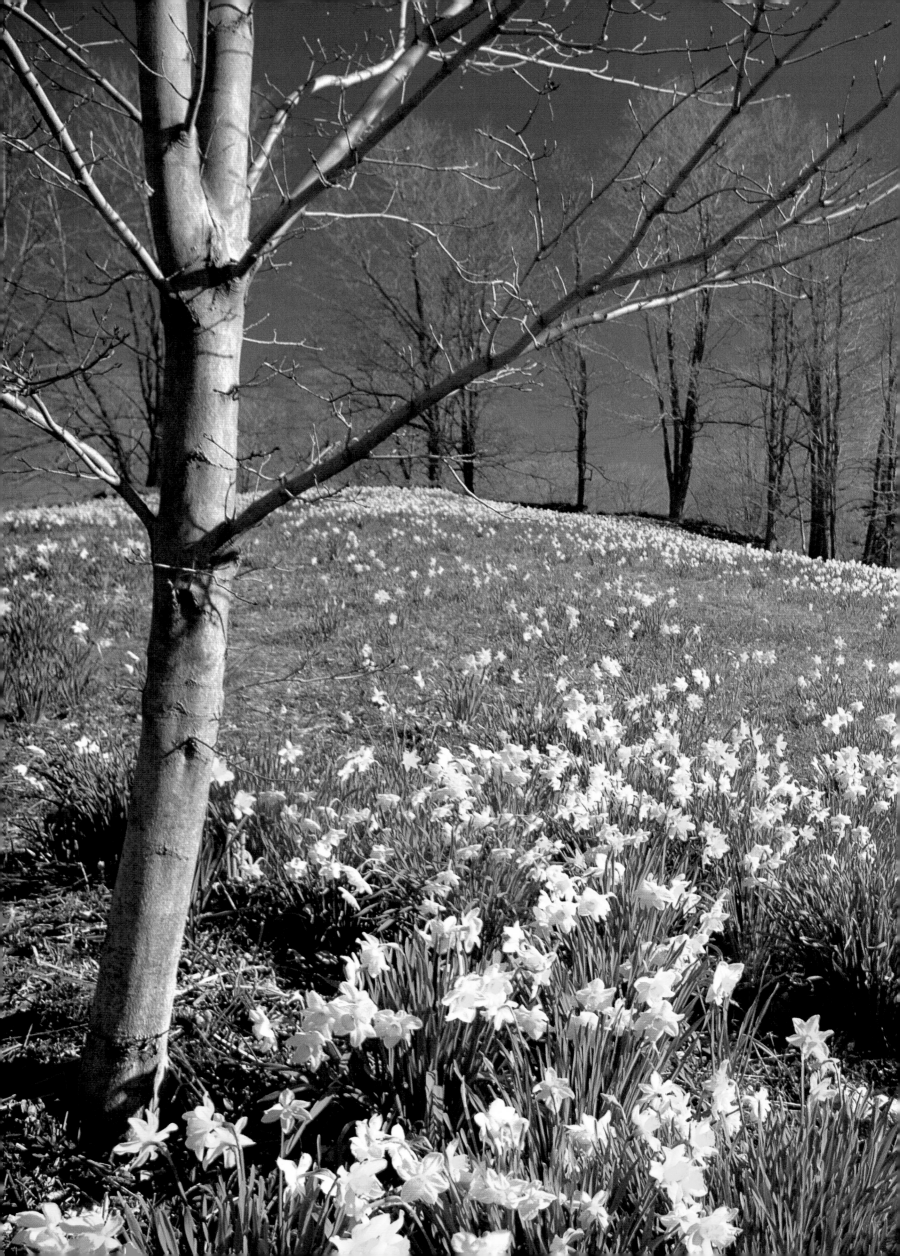

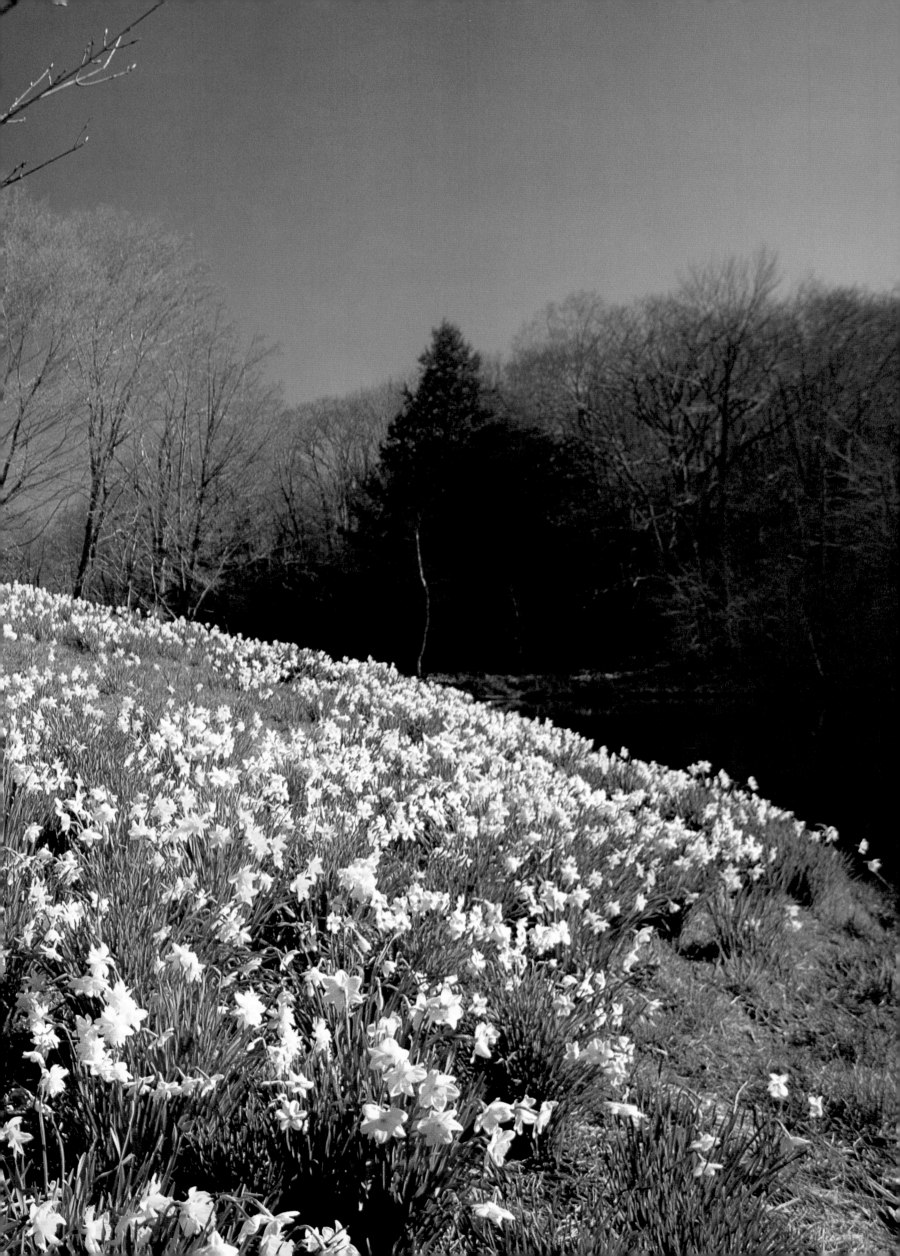

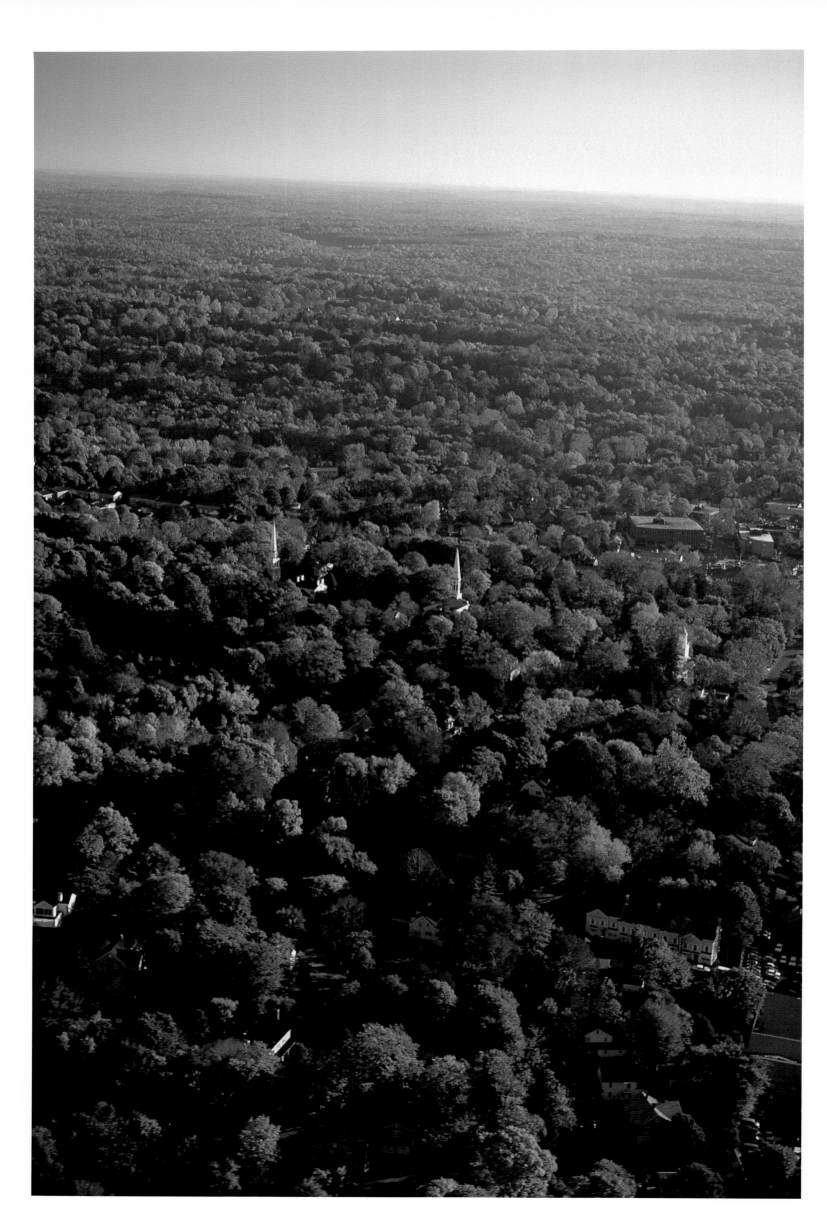

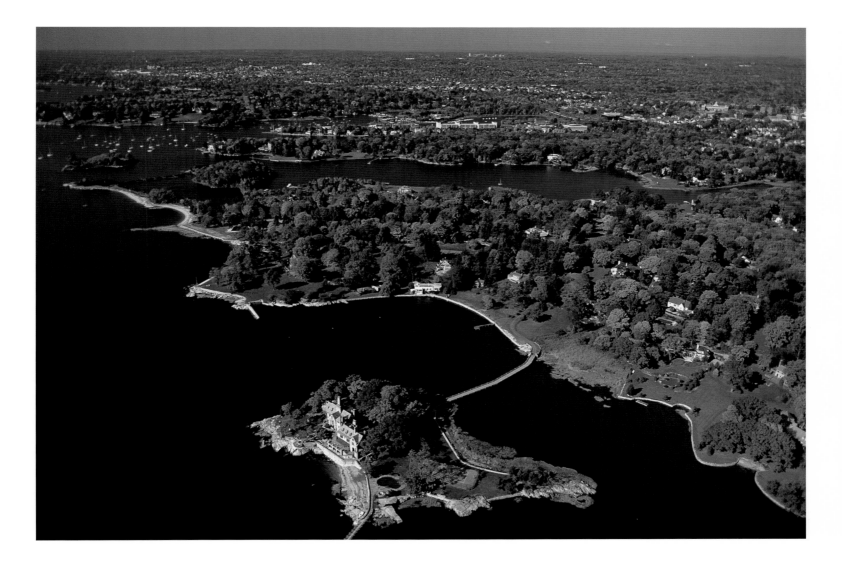

■ *Left:* Beneath a canopy of trees, three church spires mark "God's Acre" in New Canaan, a town of nineteen thousand, one of the most affluent communities in the nation. ■ *Above:* Greenwich, bordered by Long Island Sound on one side and New York State on another, is known as the "Gateway to New England."

■ *Above:* Autumn in Connecticut is a time for brisk leaf-kicking walks, pumpkins, rural fairs, apple cider, and an appreciation of the glorious fall colors. ■ *Right:* From Mount Tom, west of Litchfield and 1,325 feet above sea level, sunlight and a passing shower add glory to the countryside of northwestern Connecticut.

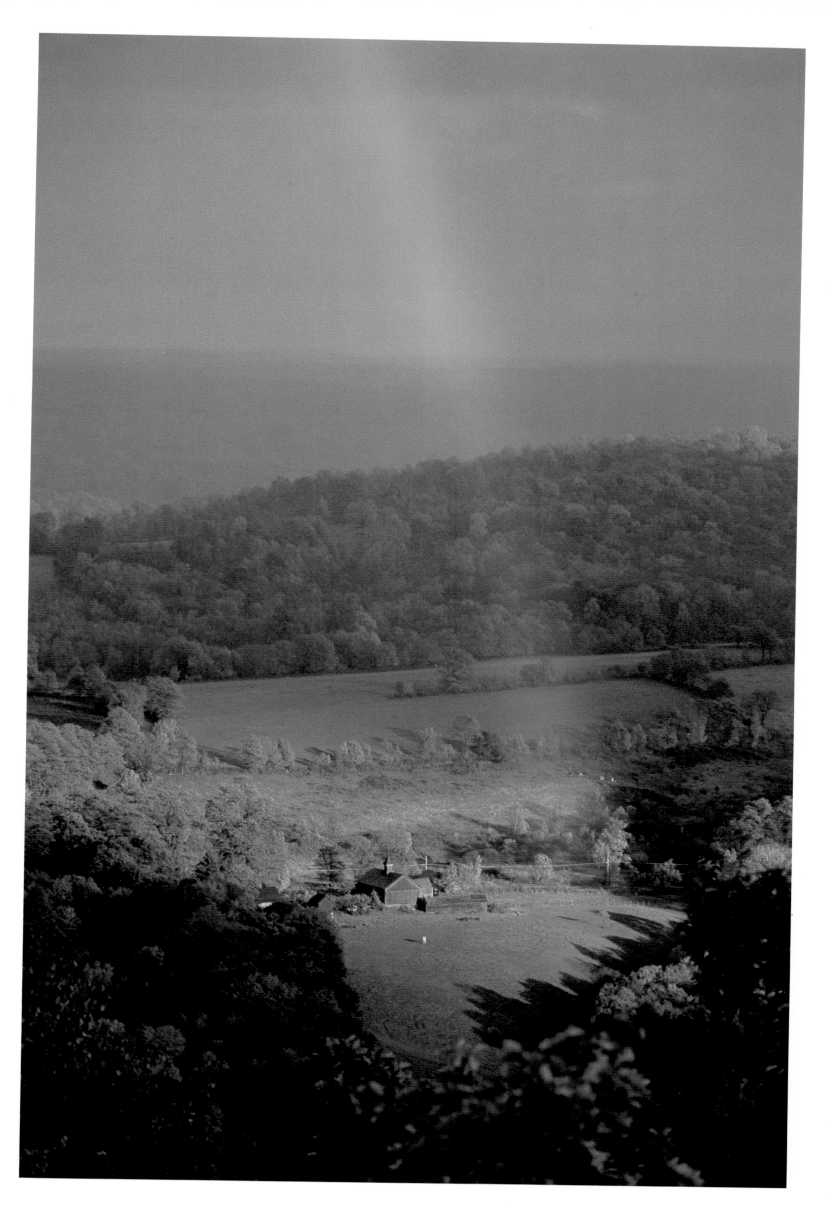

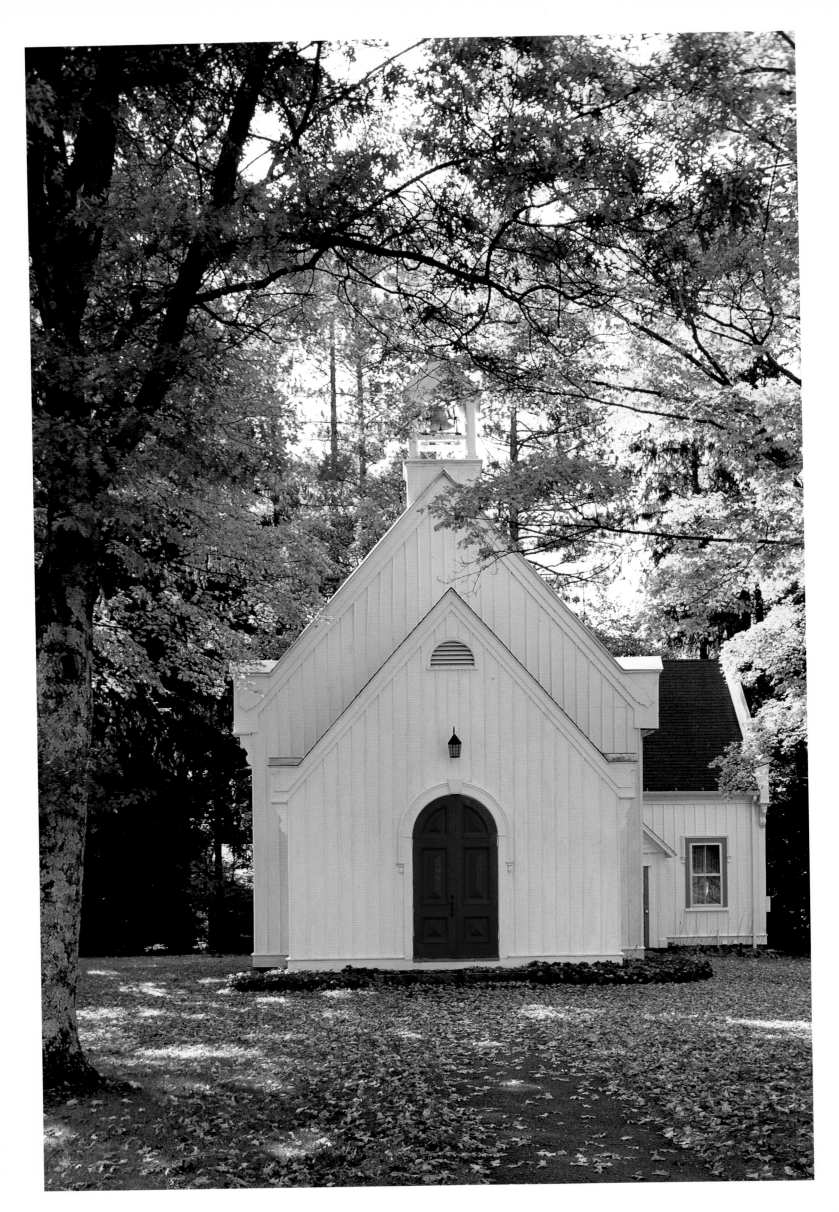

■ *Left:* Between 1810 and 1826, Christian missionaries were sent to Hawaii and the South Pacific from this church and its small village of Cornwall. ■ *Above:* Connecticut's climate helps create a very resilient forest floor. In each cubic foot of healthy soil are millions of organisms building more soil from debris that falls.

■ *Above:* Native Americans were living in Connecticut some nine thousand years ago. They supplemented their diet with cultivated crops of pumpkins and other squash, beans, and corn. ■ *Right:* Occasionally one finds a pair of venerable sugar maples, traditionally planted by the bride and groom in front of their new home.

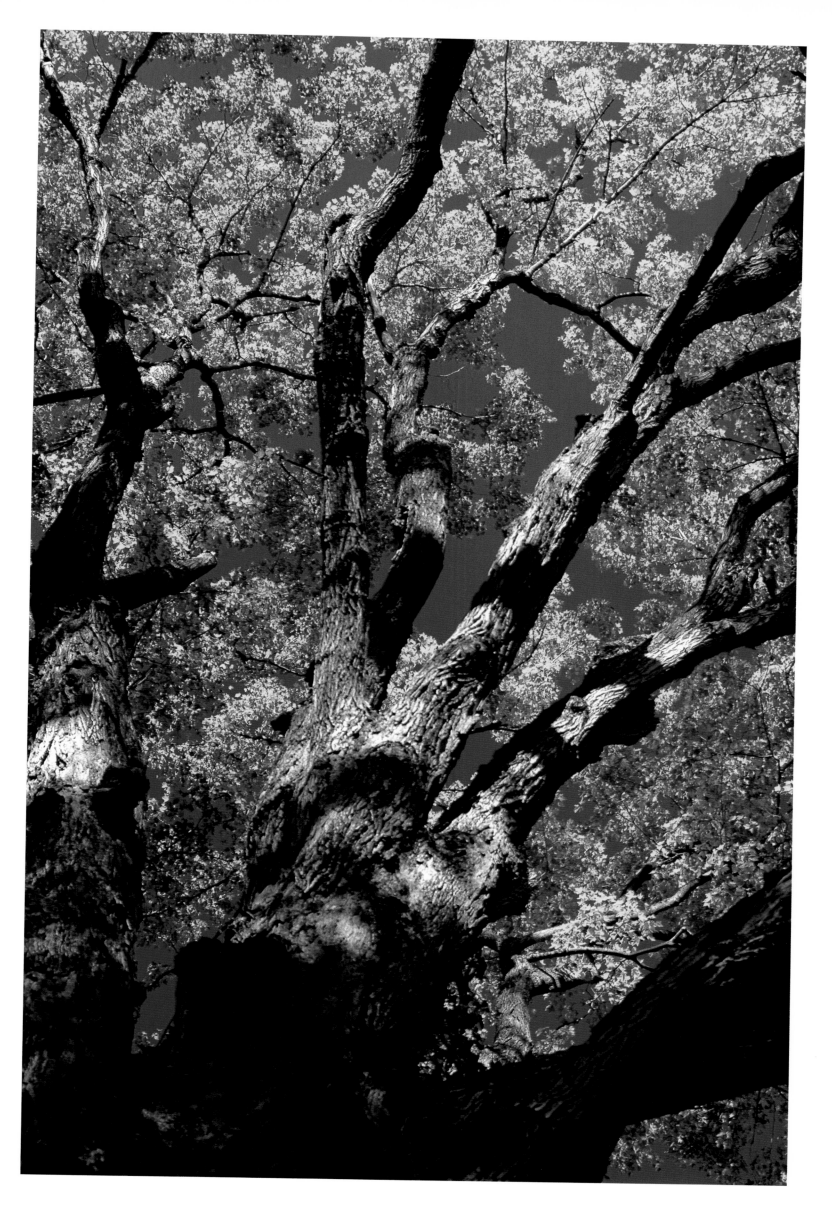

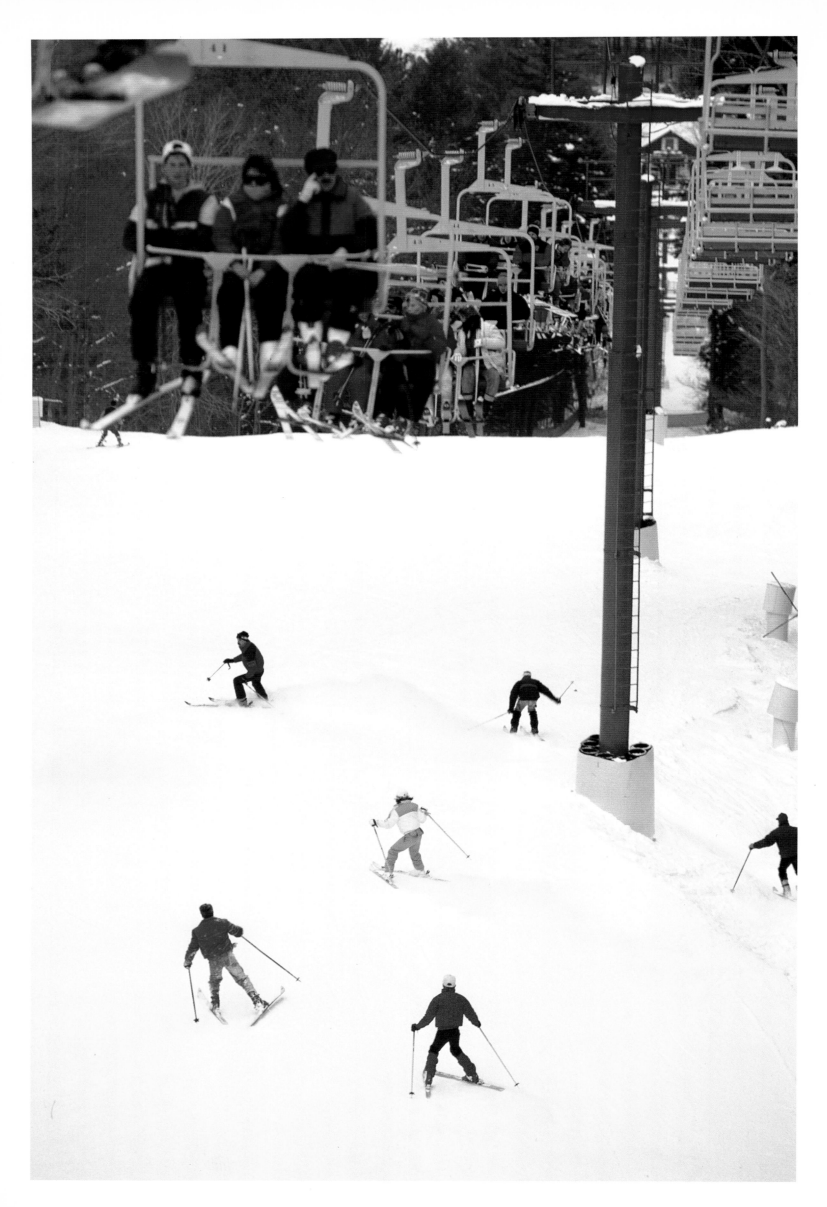

■ *Left:* This chairlift at Mohawk Mountain is one of fifteen lifts located in six popular ski areas in the state. Taking advantage of Connecticut's average annual snowfall of forty-nine inches, innumerable trails criss-crossing the state parks and forests are available for cross-country skiing. ■ *Above:* Winter in Connecticut is a time when the landscape turns soft and serene, a time to store the energy necessary to push up a profusion of meadow flowers and lush spring grasses.

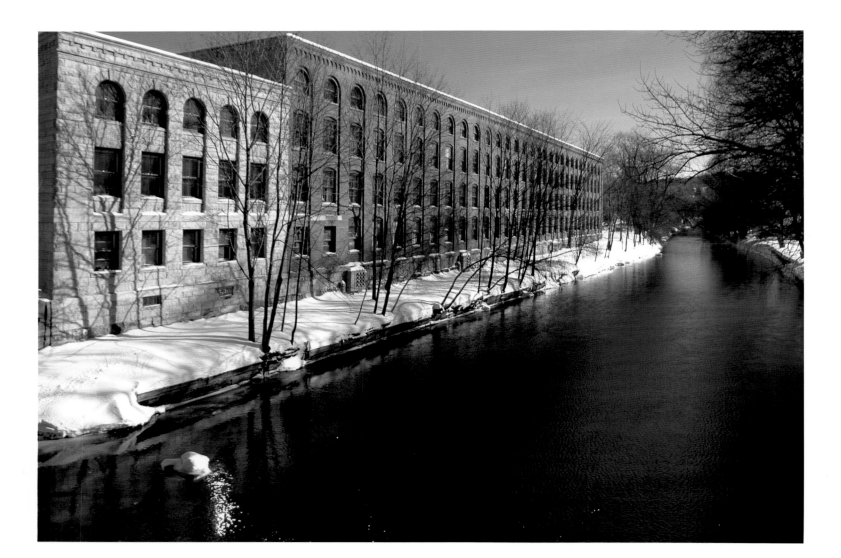

■ *Above:* Now cozy condominiums along the Still River in Winstead, these buildings once housed the Gilbert Clock Factory. Using Eli Whitney's mass production techniques, the state's clock industry became the largest in the country. ■ *Right:* Carved in 1827, the Statue of Justice, crowning Hartford's Old State House, gazes across the Connecticut River. Within five hundred miles of Hartford lies about 30 percent of the population of the United States.

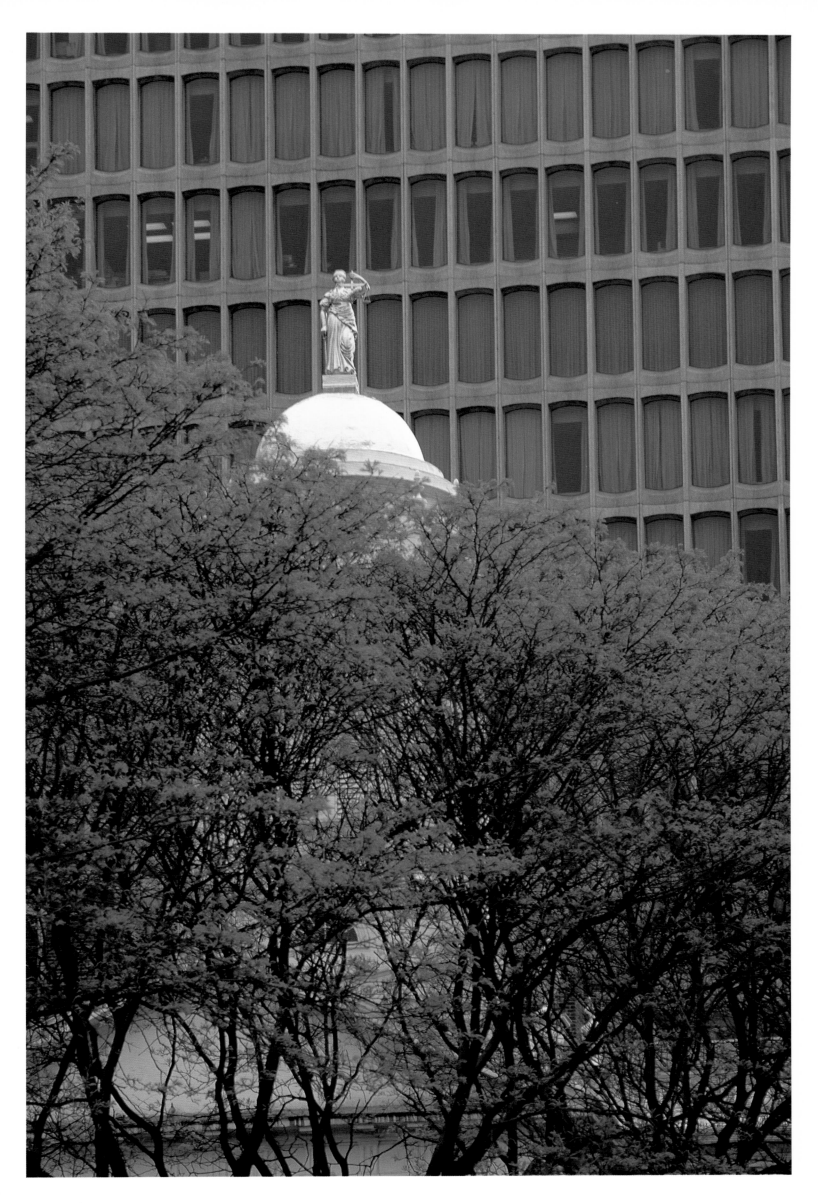

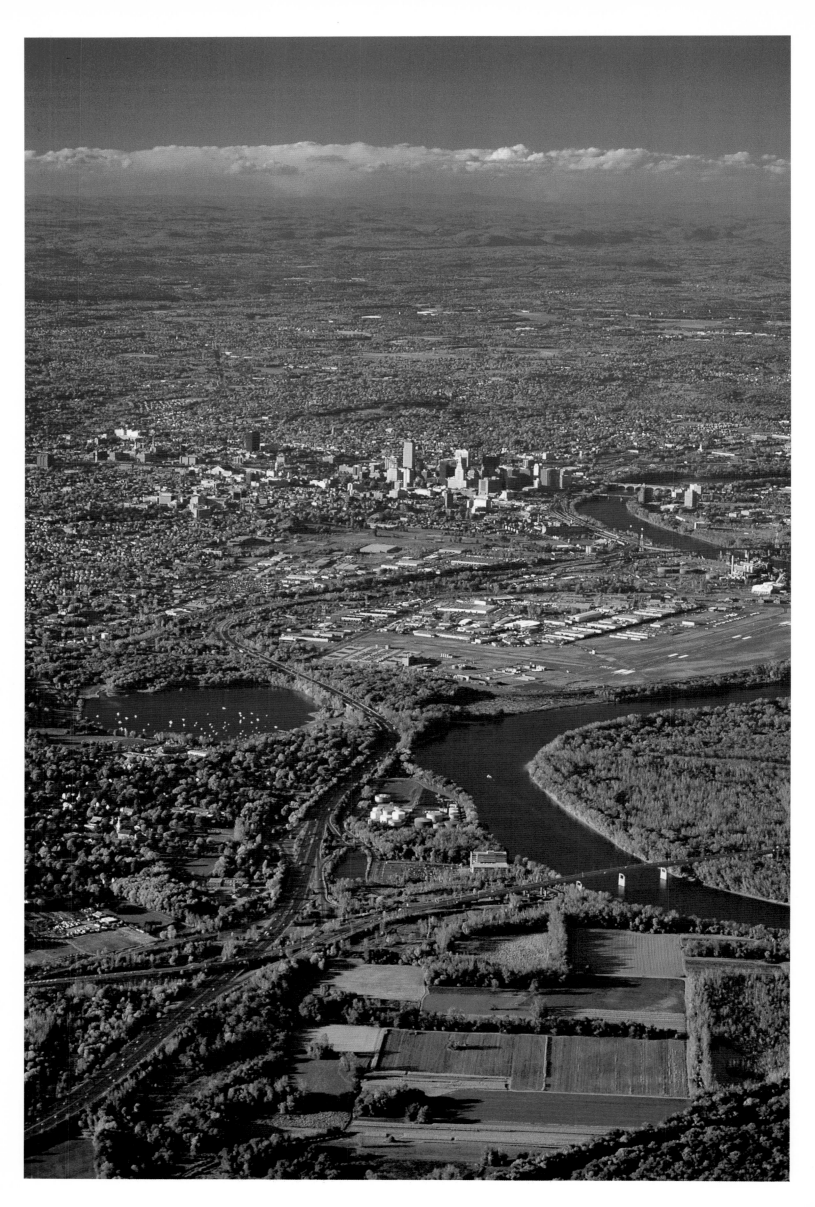

■ *Left:* From the distant Massachusetts hills, the Connecticut River winds past Hartford, the "Insurance Capital of the World"—then Wethersfield, the state's first settlement—en route to the Sound. ■ *Above:* Connecticut's fall foliage is a major attraction in October. Not all trees change colors at once. The normal progression is first swamp (red) maple, then birch, ash, other maples, hickory, and finally, oak. ■ *Overleaf:* Hartford's skyscrapers rise beyond the ancient Connecticut River.

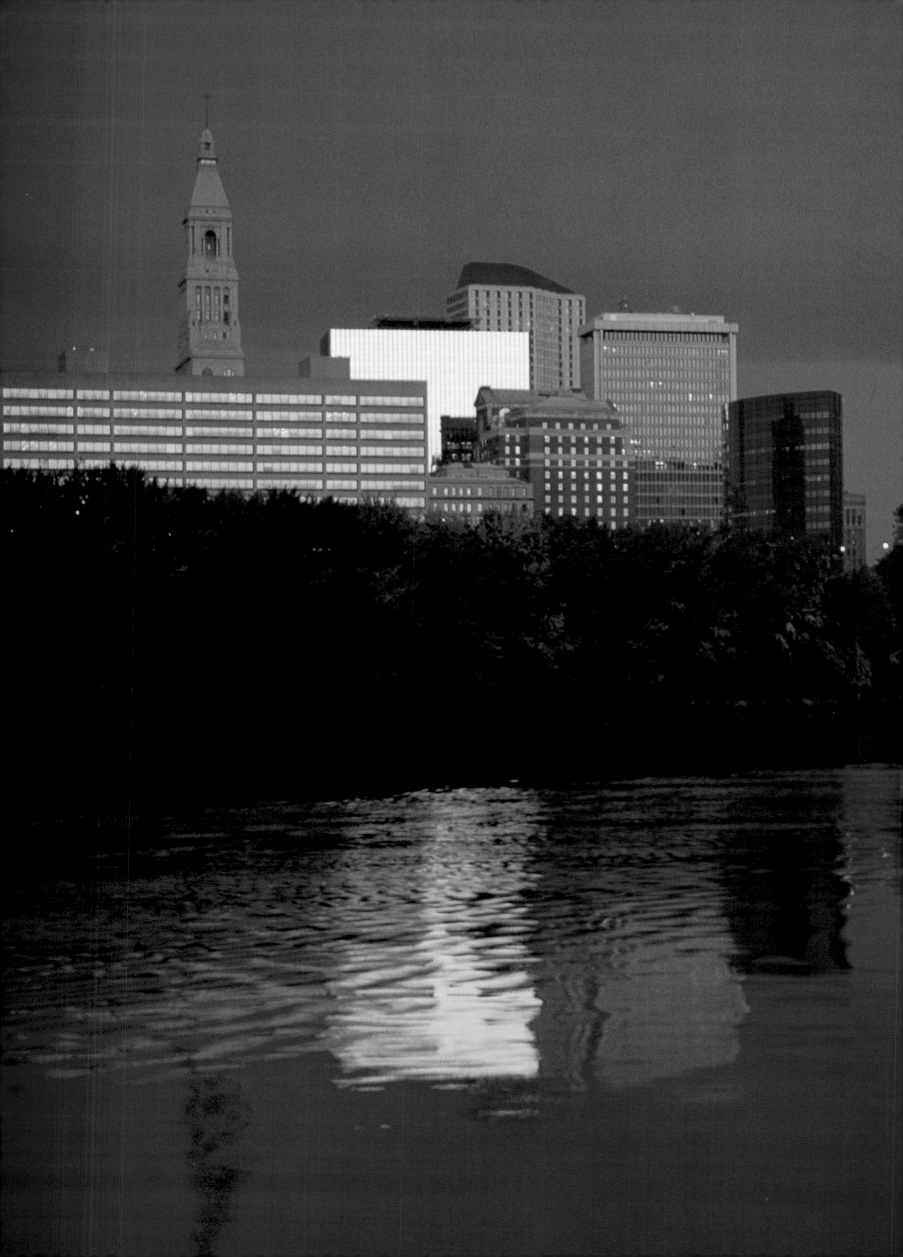

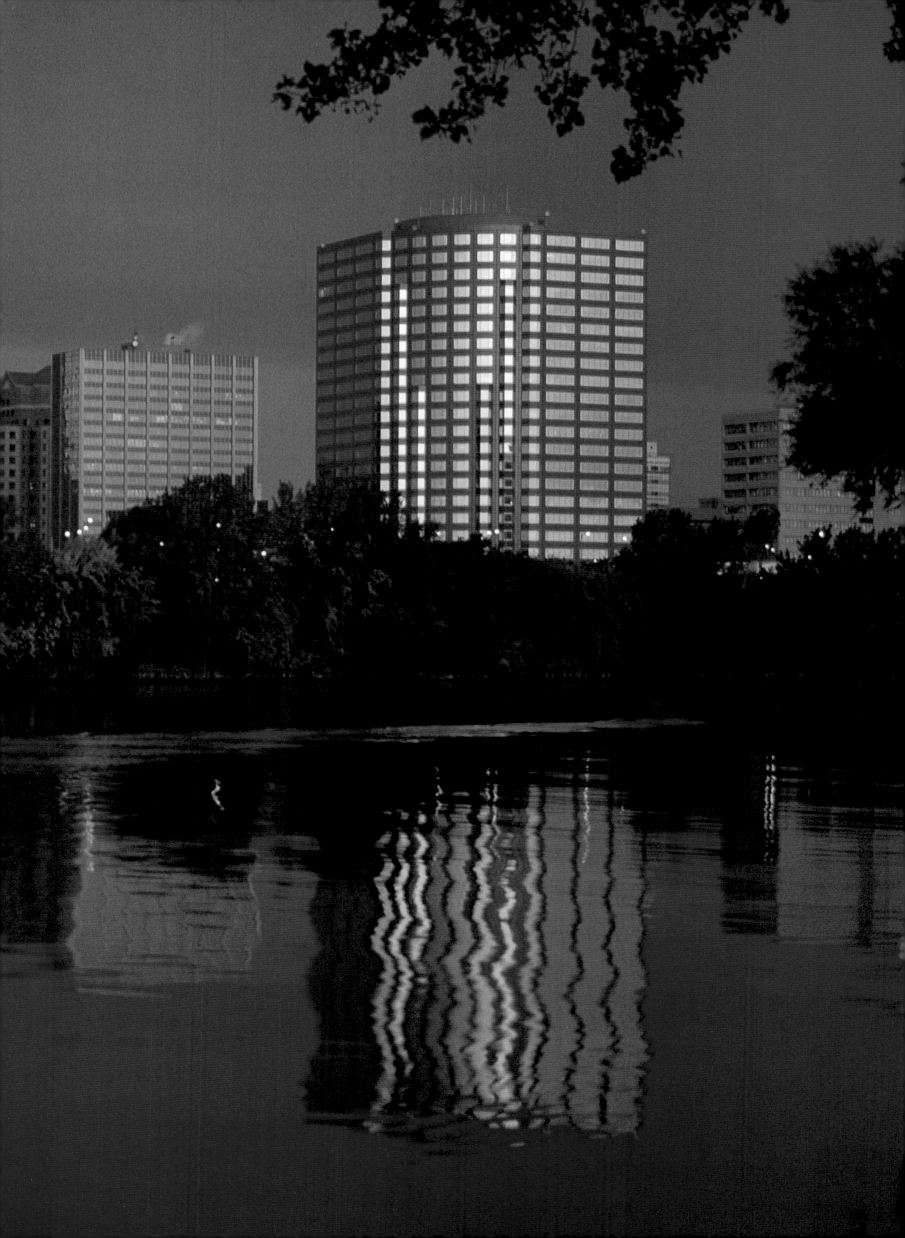

■ *Above:* With the advent of paint in the eighteenth century, red barns came into vogue. "Indian red" paint, often made of local materials—iron oxide or even buttermilk—was common. ■ *Right:* At the Westbrook Fife and Drum Muster, the second largest in America, all ages participate in preserving their colonial past.

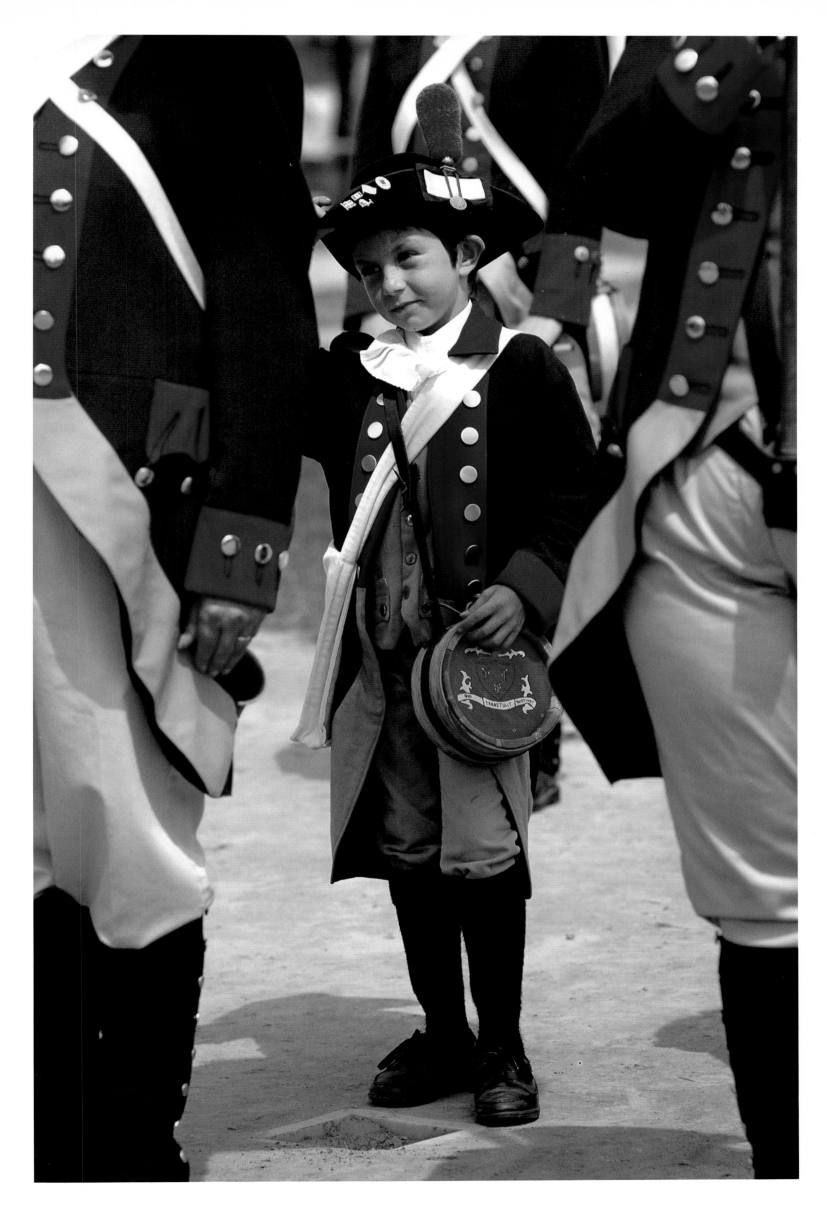

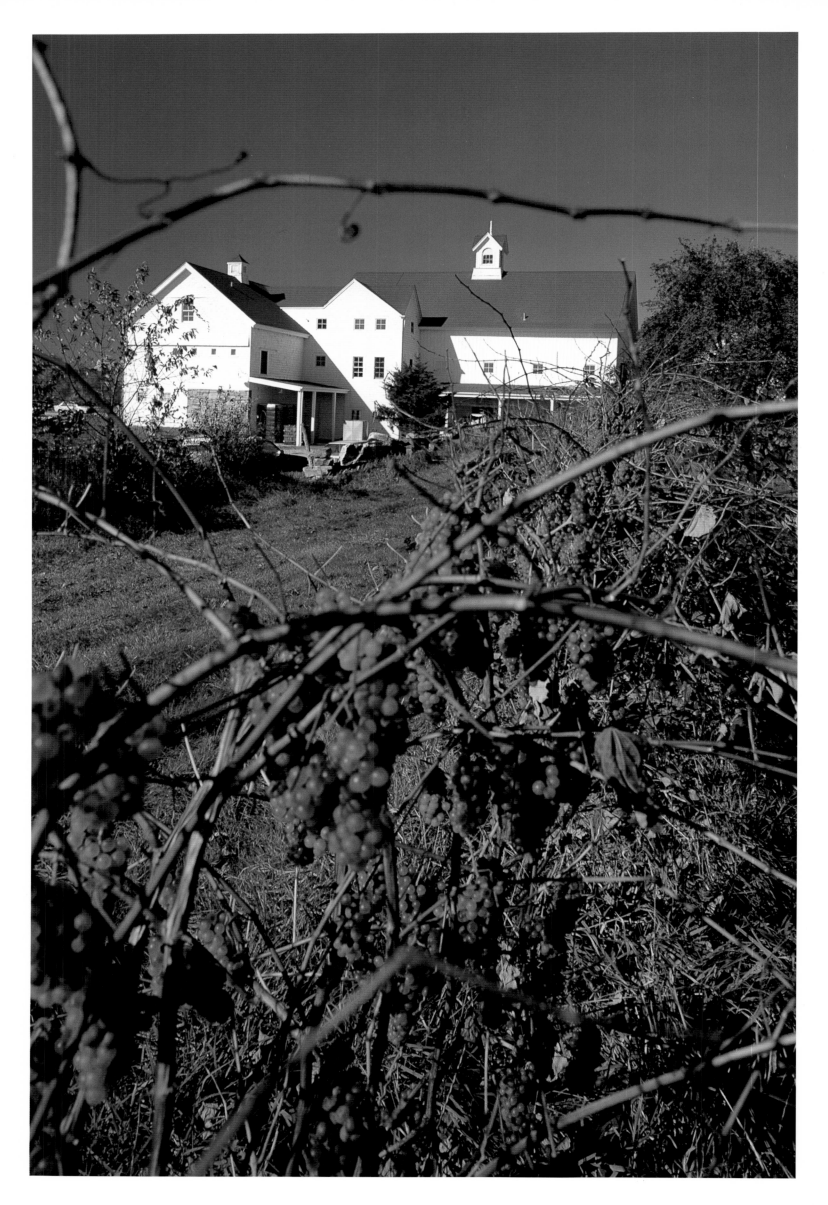

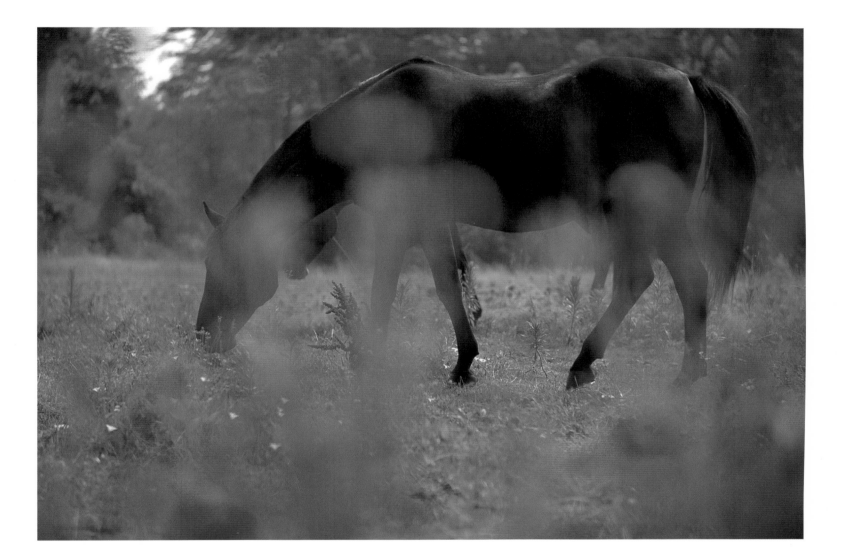

■ *Left:* The Crosswoods Vineyard is one of the twelve licensed winemakers in the state. All told, Connecticut's vineyards produce approximately three hundred thousand gallons of wine per year. The varied micro climates and rocky soils have produced fine and diverse wines for Connecticut's fastest growing agricultural industry, which is spread throughout the state. ■ *Above:* Connecticut supports approximately fifty thousand horses, more than ever before in the state's history.

■ *Above:* Much of the marginal land was abandoned after the Civil War when farmers sought the fertile, stoneless soil of the Midwest and West. ■ *Right:* The ramparts of the Revolutionary War's Fort Griswold on the Thames River make a good viewing point for Fourth of July fireworks over New London and Groton.

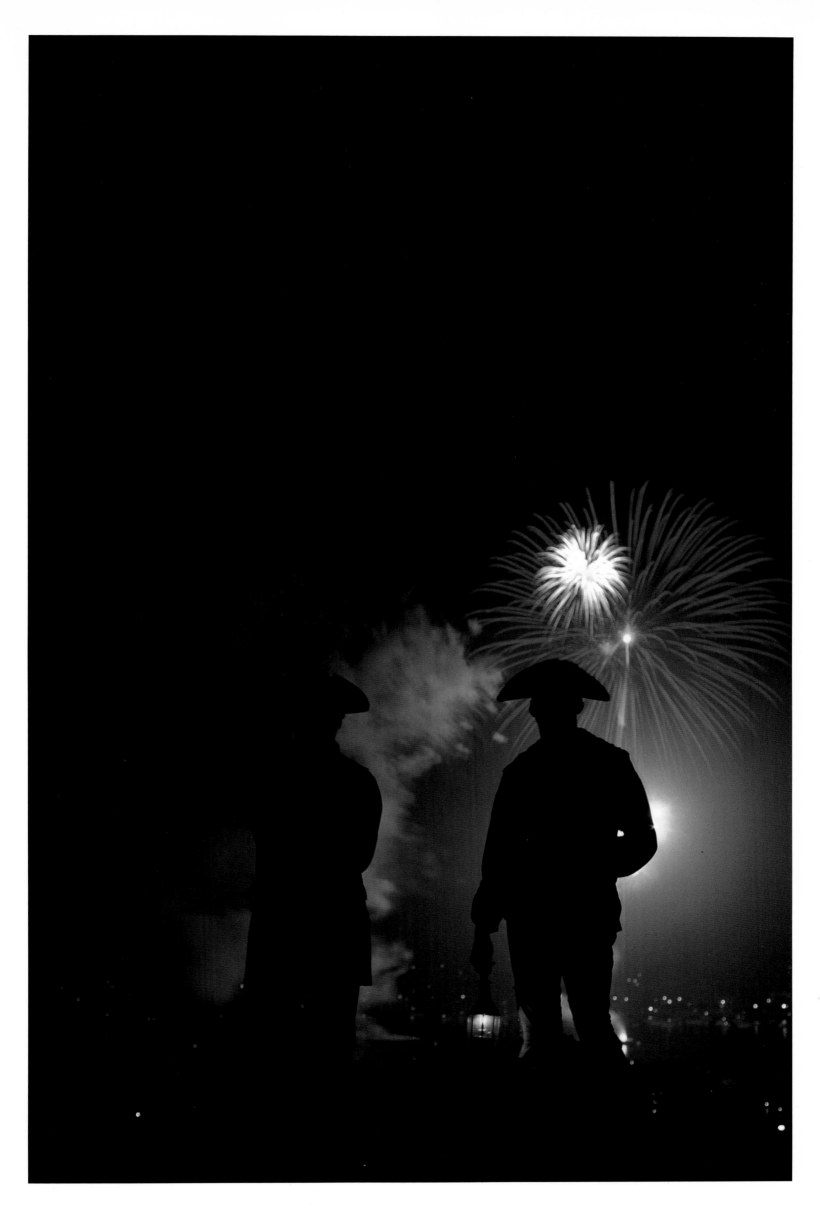

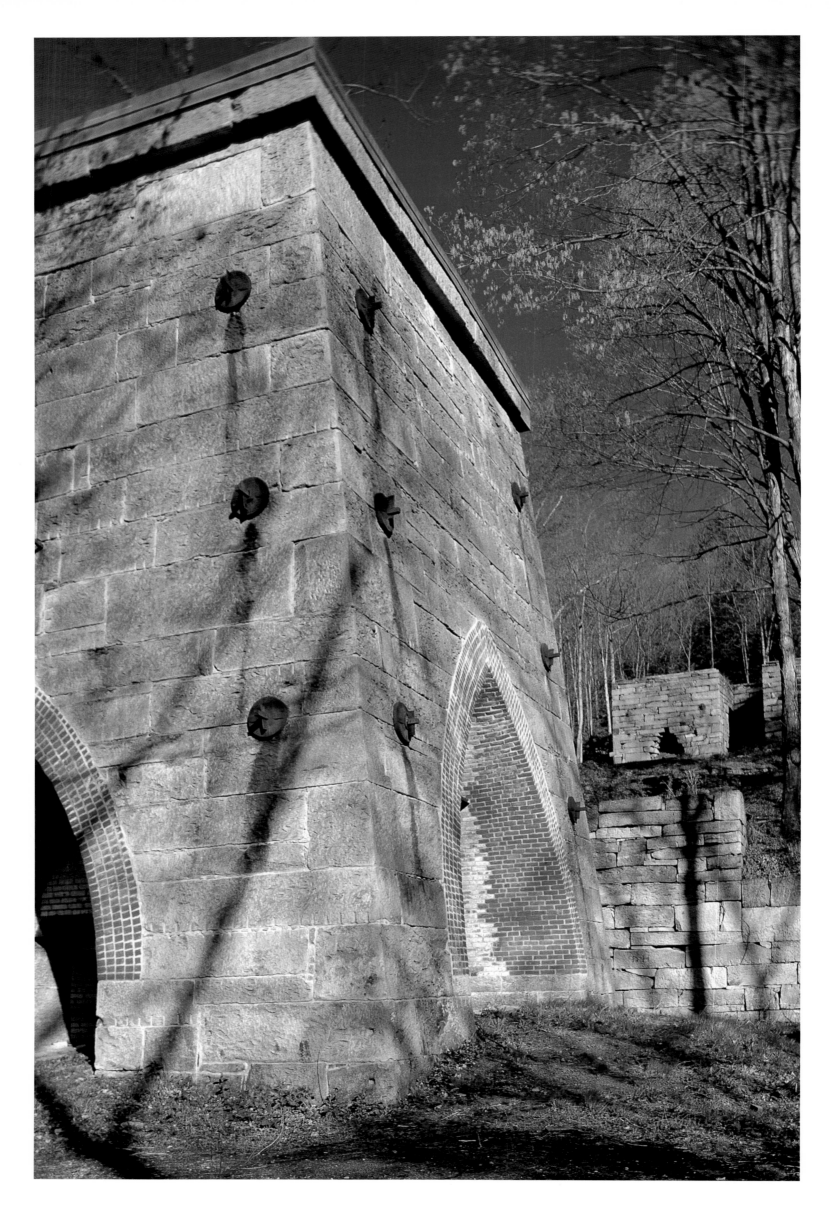

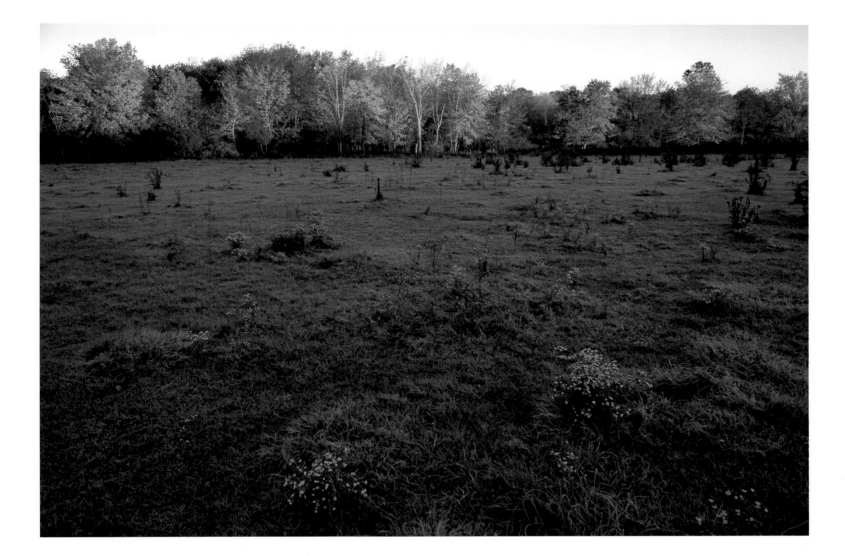

■ *Left:* Built in the 1860s to smelt iron ore from the nearby mines, these granite blast furnaces in Roxbury Station were fired by charcoal. The project failed after five years, which was a long enough period of time for extensive deforestation to occur because of the need for wood to convert to charcoal. ■ *Above:* Left to itself, this frost-covered field will soon revert to woods—first to cedar and juniper, and then in about a century, to a mature forest composed of oak, maple, and hickory.

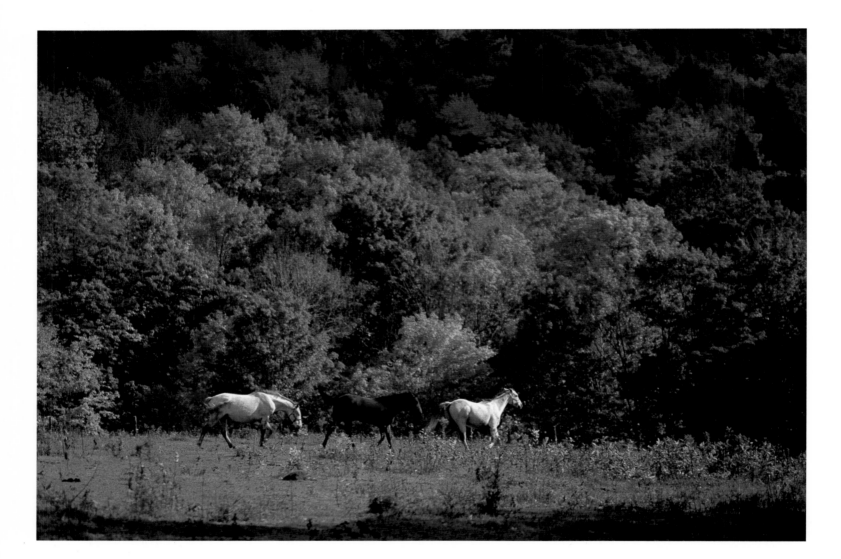

■ *Above:* A horse farm in the lee of Canaan Mountain is one of many in the state. With 9.8 horses per square mile, Connecticut leads the nation in horse density. The industry comes to a third of a billion dollars annually. ■ *Right:* Here the Connecticut—in the Indian language, *Quinnetukut,* meaning "long tidal river"— ends its four-hundred-mile journey to the Sound. Blocked by a sandbar, the river is unnavigable to deep keeled vessels, so the area never developed a large port.

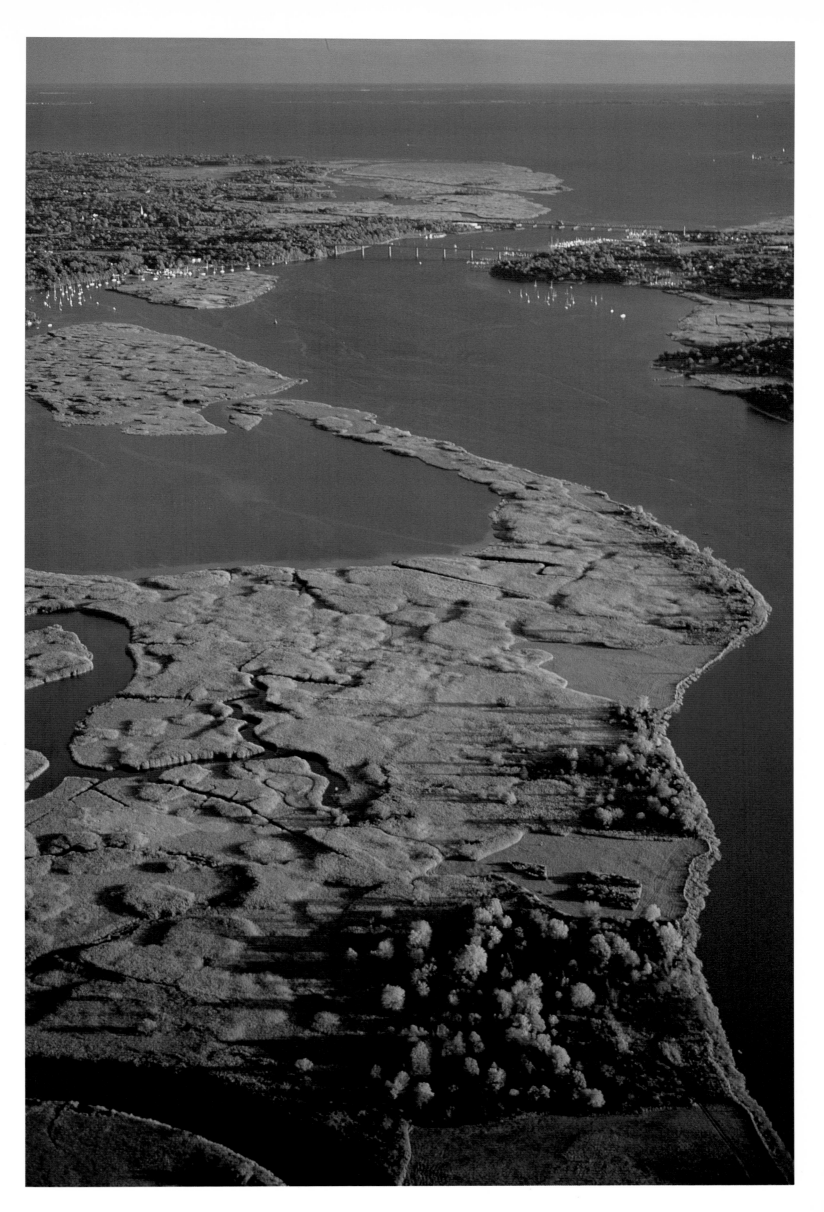

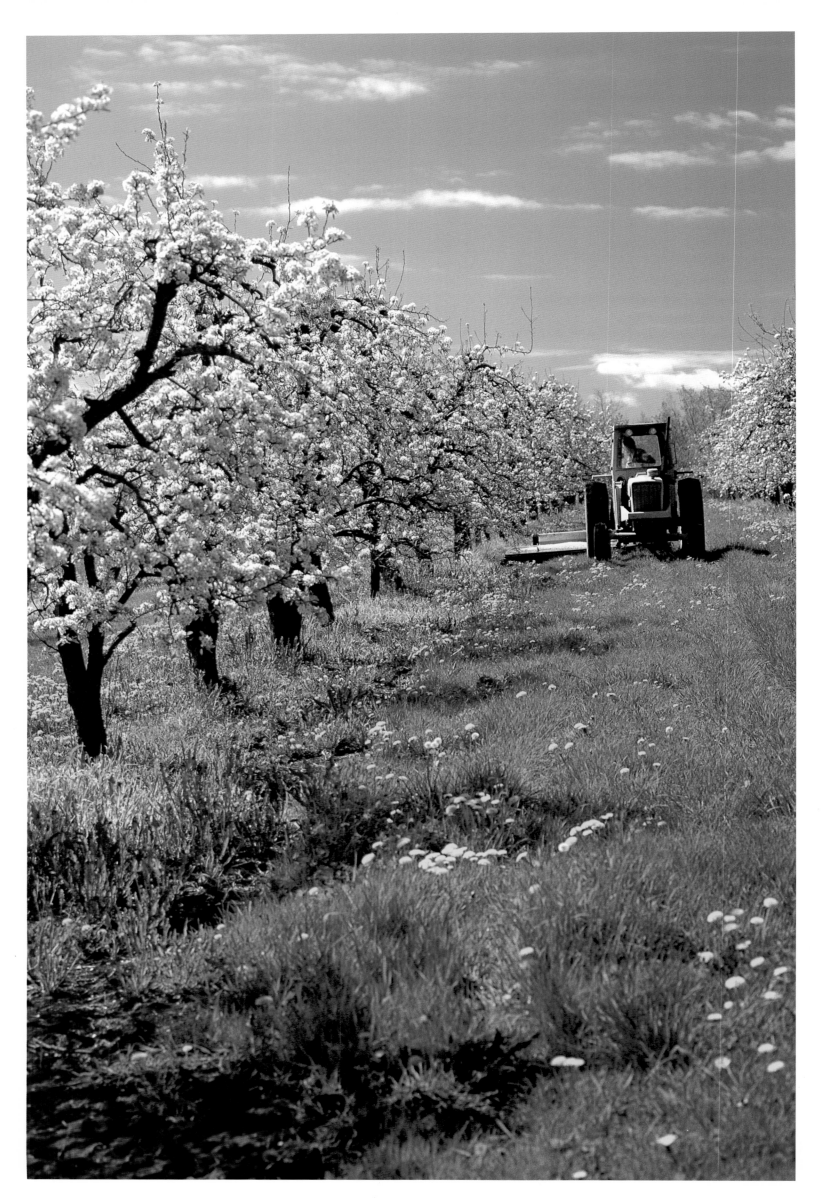

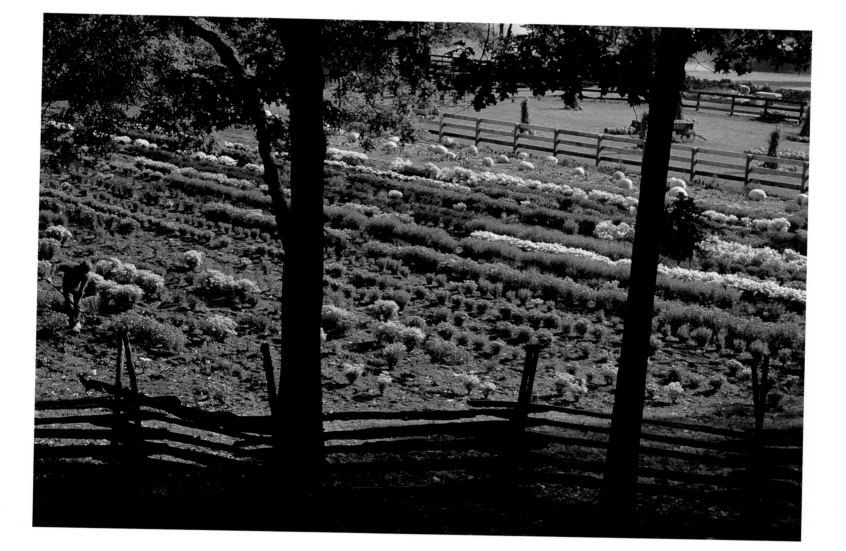

■ *Left:* Orchards, primarily apple followed by pear and peach, crown many hilltops across the width of central and northern Connecticut. Fruit is the state's fourth most important agricultural crop. ■ *Above:* Small farms will fill roadside stands with their fall offerings—perhaps chrysanthemums and pumpkins.

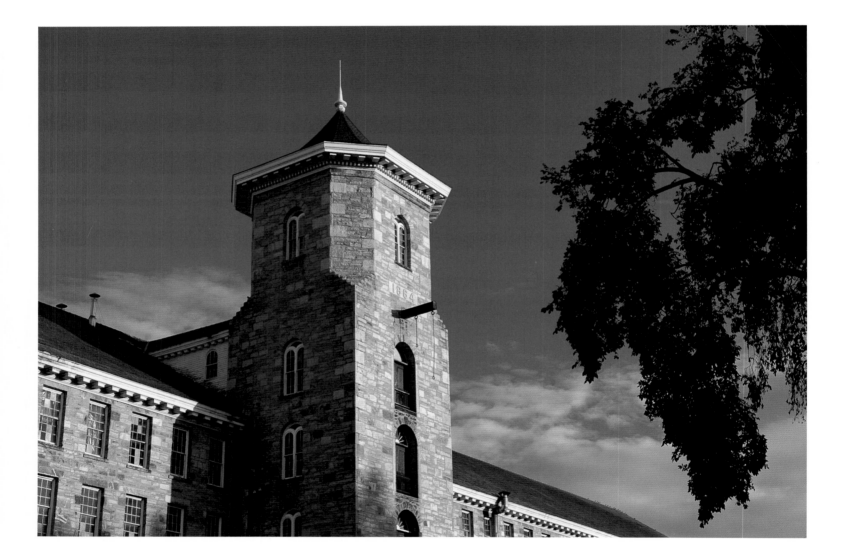

■ *Above:* In the late nineteenth century, cavernous thread mills were built in Willimantic, where thread was first successfully manufactured in the United States. ■ *Right:* Benefitting from the state's average forty-four inches of rain, spring apple blossoms will produce over one million bushels of fruit across the state. ■ *Following page:* Stonington, first settled in 1649, was a "nursery for seamen" during colonial days and is now one of the state's few remaining fishing ports.

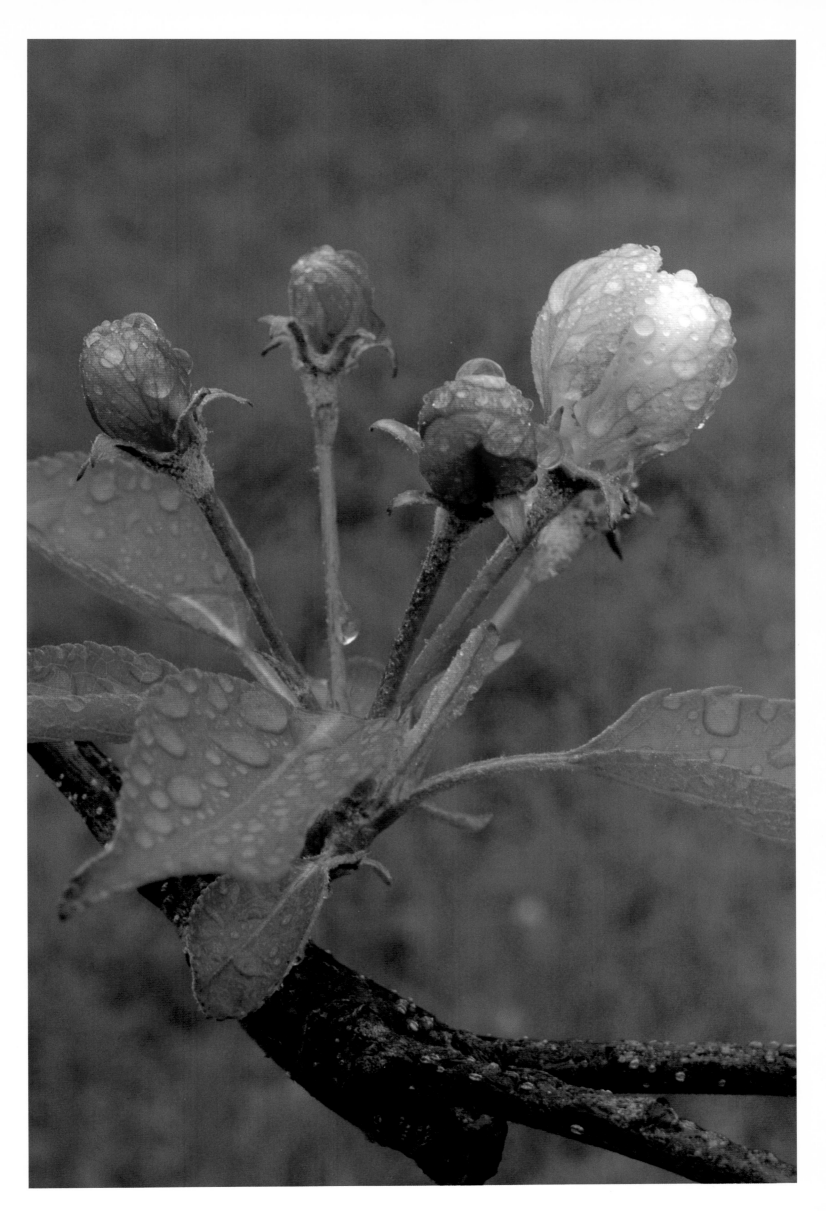

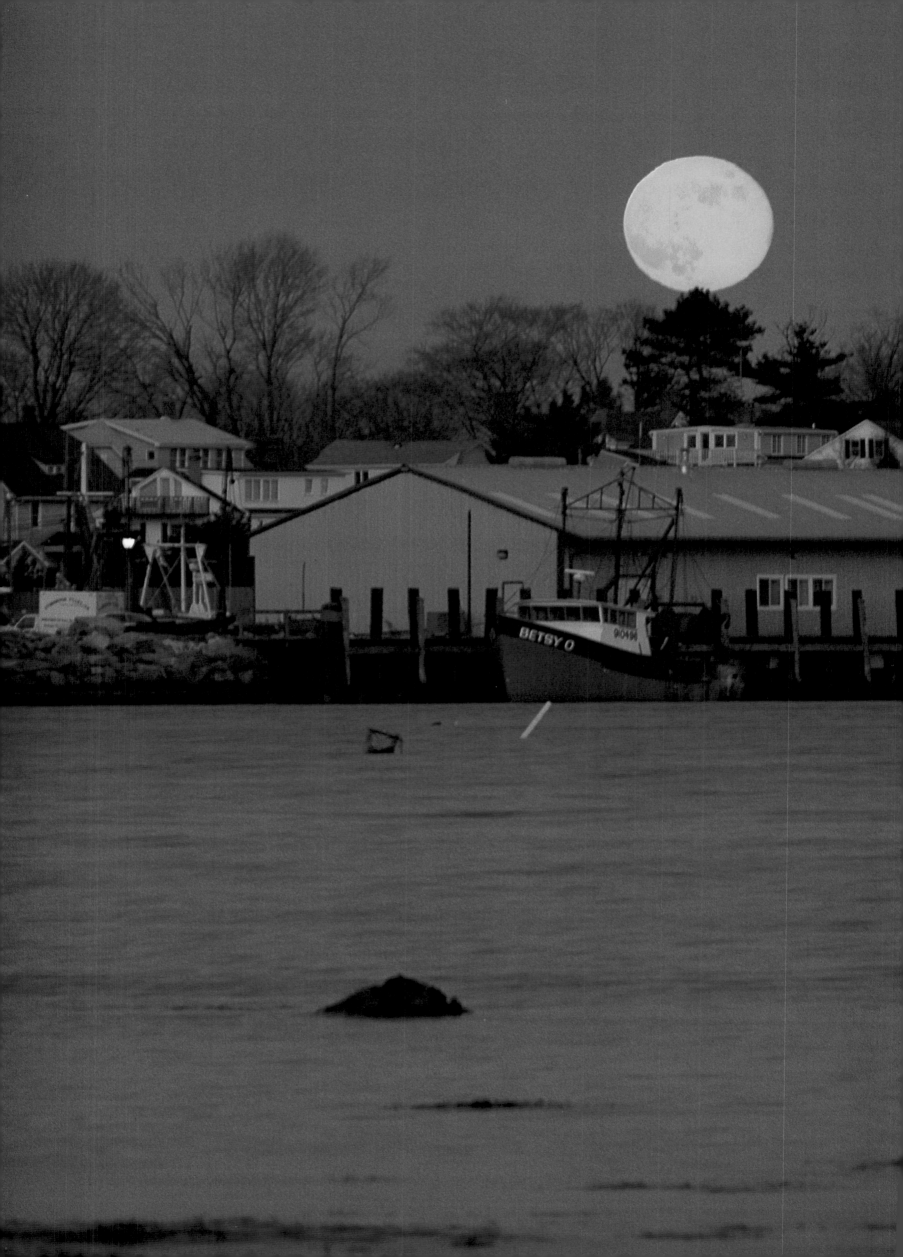

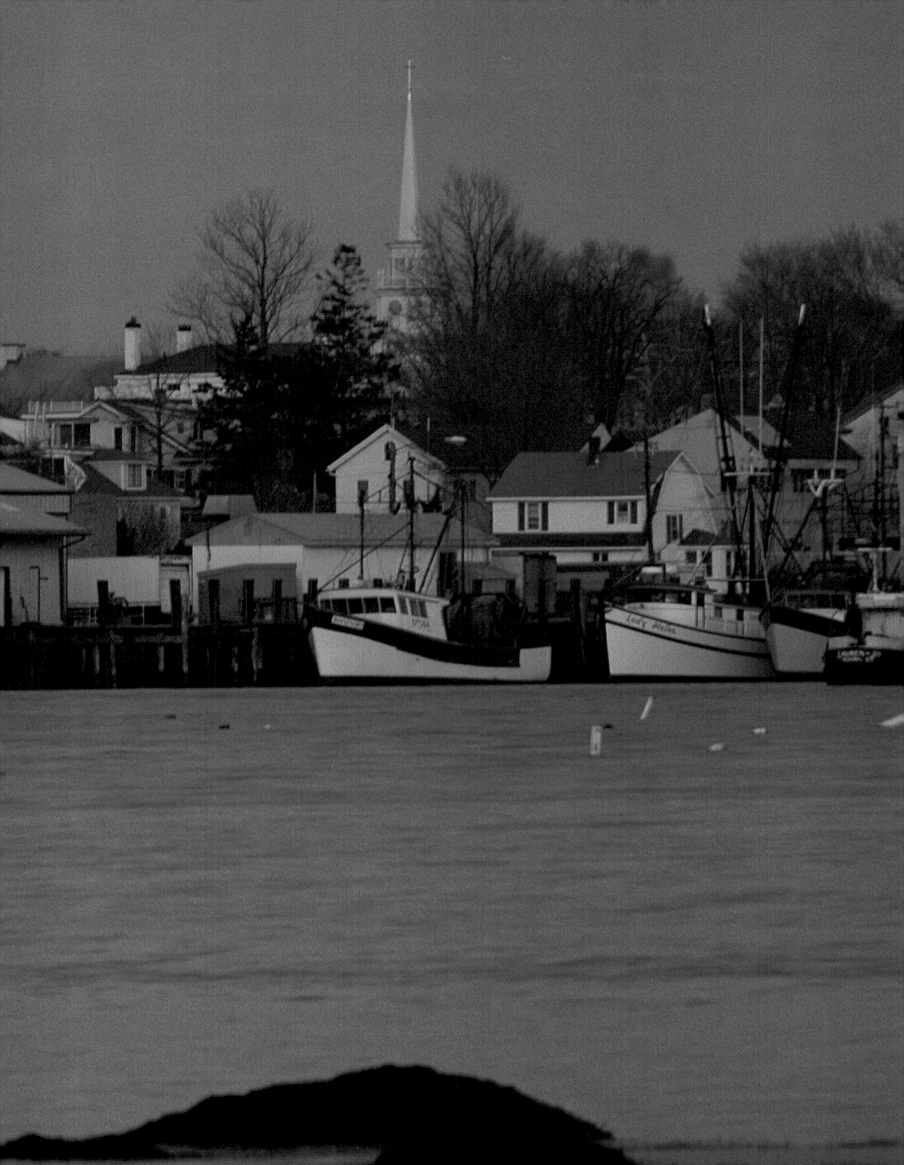

■ *Above:* At the mouth of the Connecticut River, two lighthouses in Old Saybrook reach above the horizon where the river meets Long Island Sound. The sheltered coastline, protected from the fury of the Atlantic by Long Island, makes it a much-sought-after location for homes and marinas. ■ *Right:* At Taftsville near Norwich, the Ponemah Cotton Mill, at fourteen hundred feet long once the world's largest cotton mill, was a victim of the industry's shift to the south after World War II.

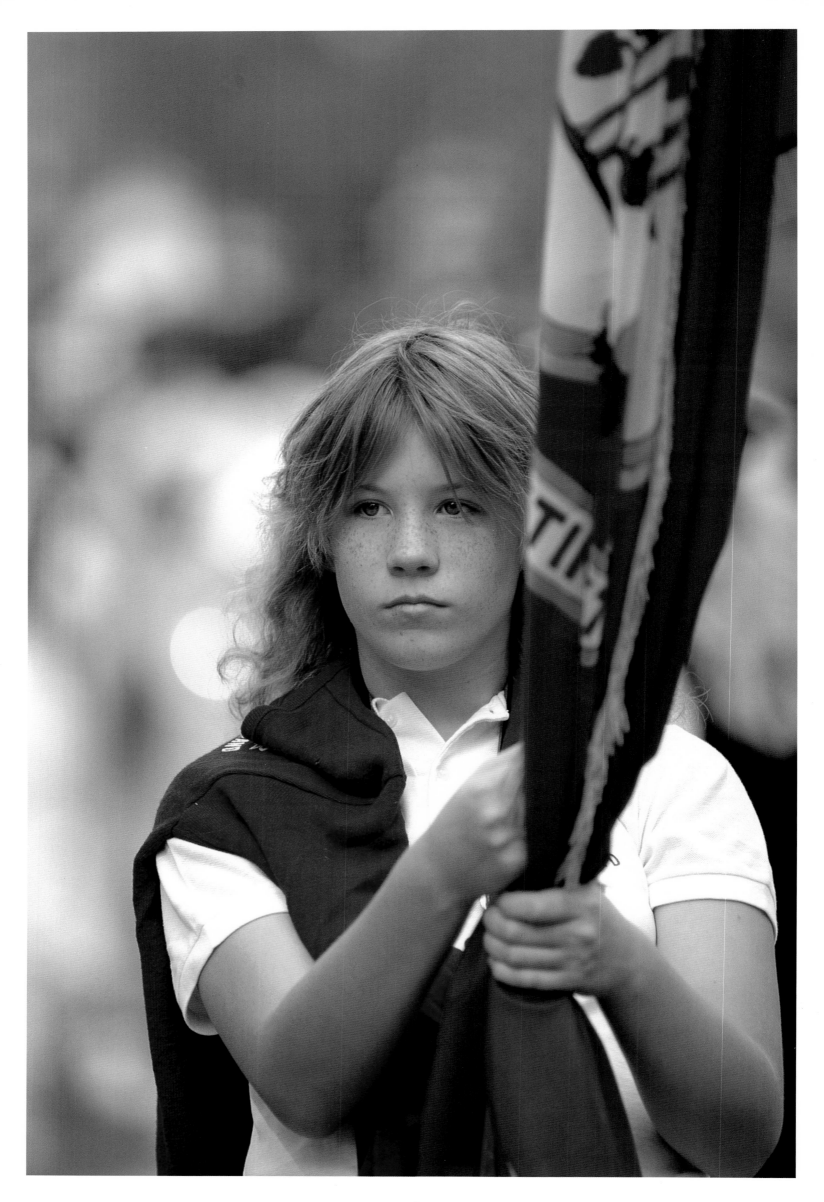

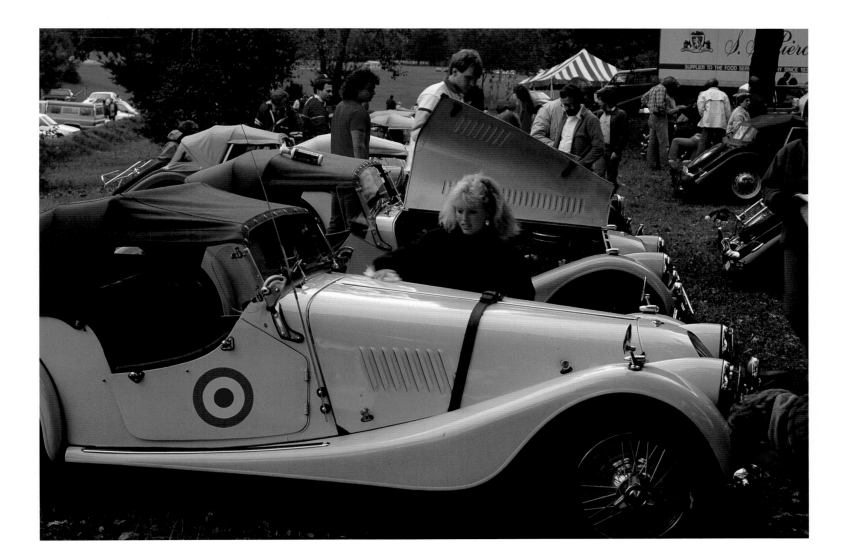

■ *Left:* Carrying the state flag, this girl is one of the thousands of people who come each year to march or to watch the parade at the Apple Harvest Festival in Southington. ■ *Above:* At Lime Rock Park, Connecticut's only sports car road-racing track, owners get their cars ready for the Vintage Fall Festival judging.

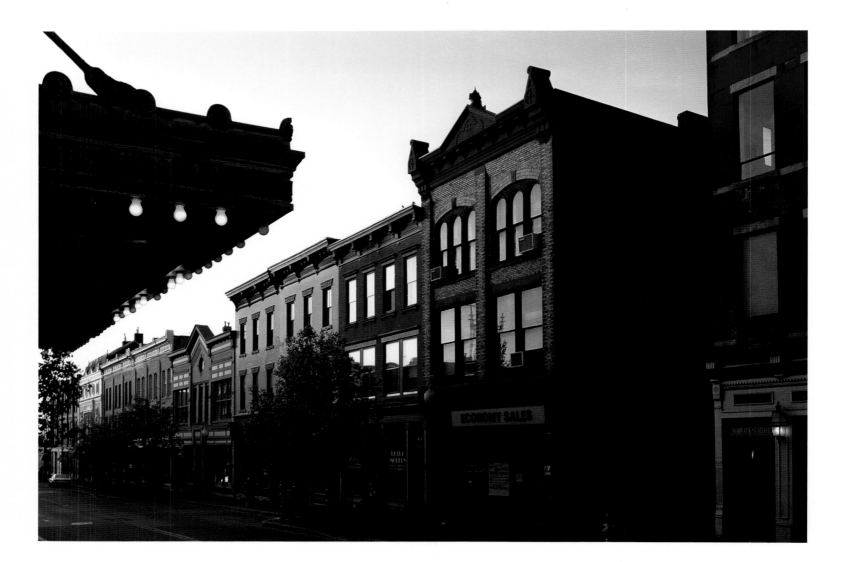

■ *Above:* Saved from the wreckers ball, Washington Street in South Norwalk has a wonderful blend of modern business in century-old storefronts. ■ *Right:* In luxurient contrast to the stark wood clapboards of colonial homes and the quiet brick facades of nineteenth-century architecture, this office entrance in Hartford glories in such materials as chrome, iridescent glass, and neon. It was inspired in part by the work of L. C. Tiffany, the Connecticut-born artist and designer.

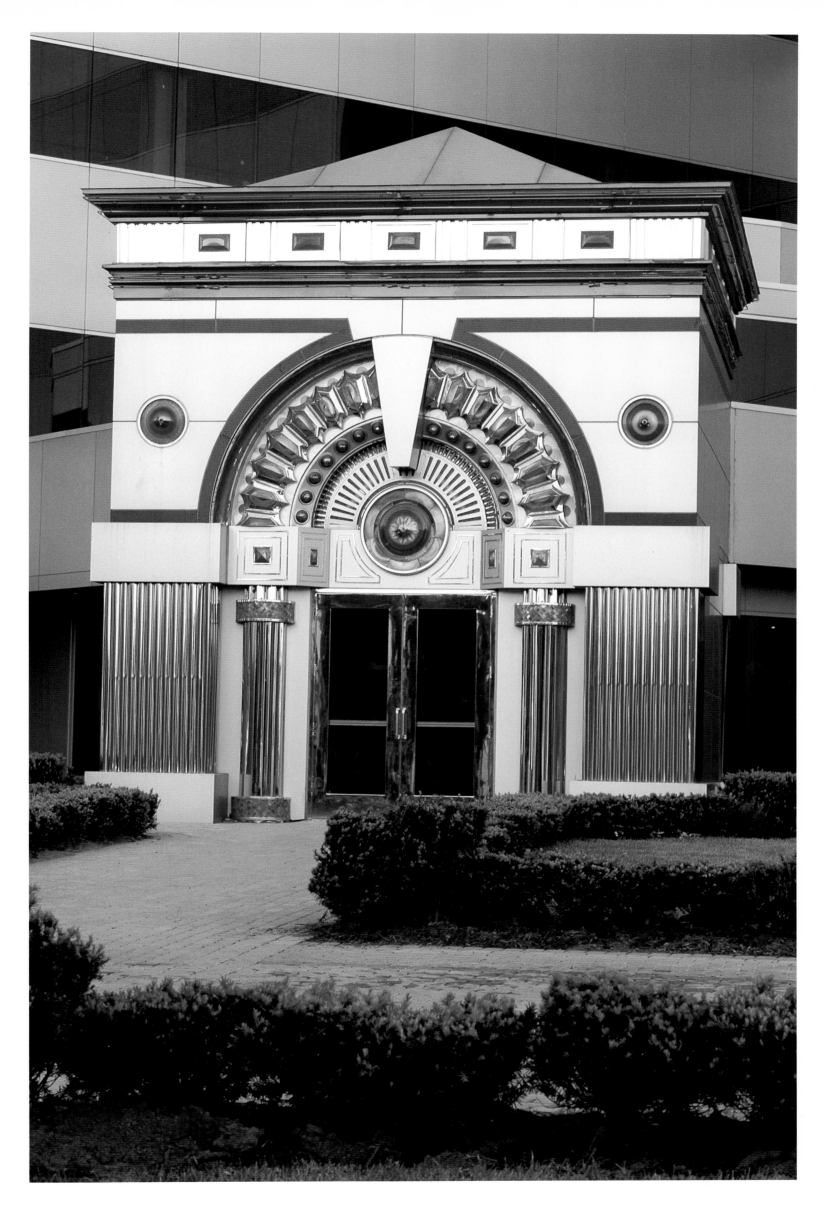

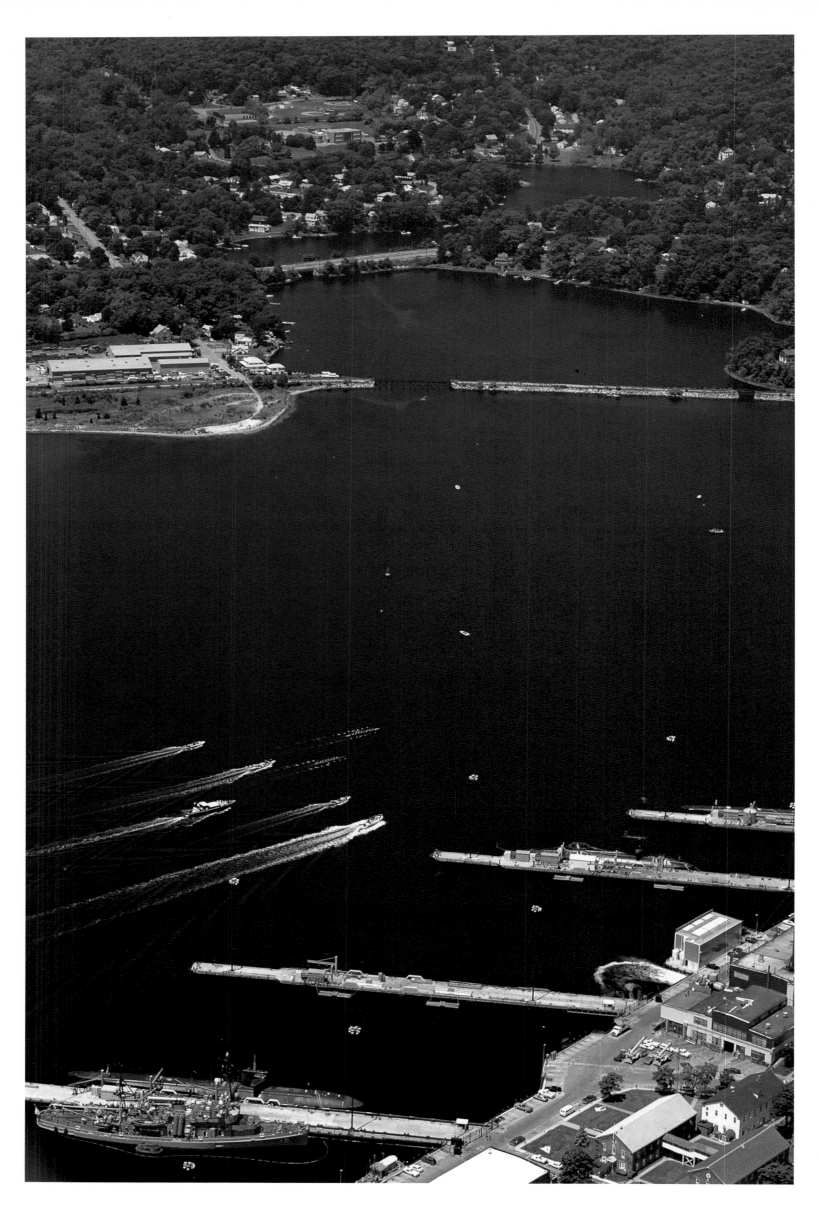

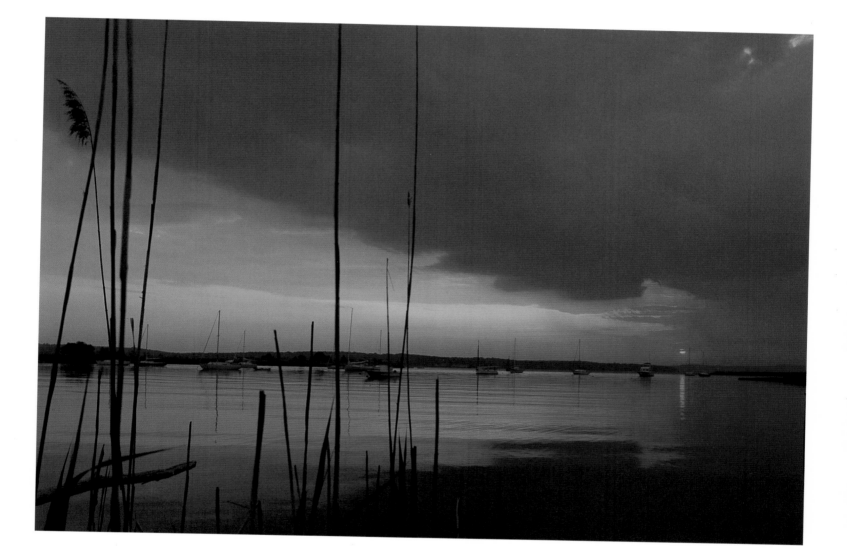

■ *Left:* Followed by power boats, the crews of Yale and Harvard universities toil up the Thames River in the nation's oldest continuously held intercollegiate athletic event, which began in 1852. On the four-mile upstream course, they pass the U.S. Coast Guard Academy, Connecticut College, and the U.S. Navy Submarine Base in Groton. ■ *Above:* Giving shelter to many of the state's eighty-five thousand pleasure craft, numerous marinas line the banks of the Connecticut River.

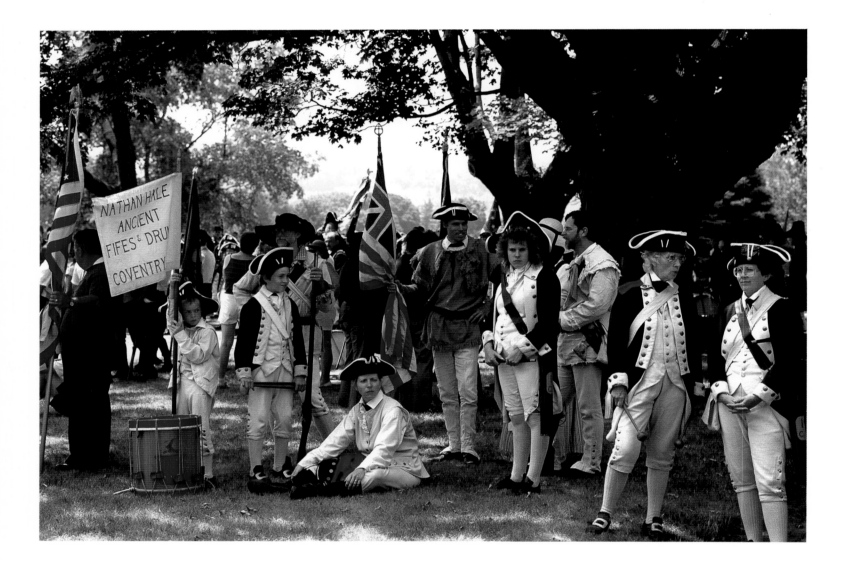

■ *Above:* Begun early in the twentieth century, the Deep River Ancient Fife and Drum Muster attracts over fifty units each year from all over the United States and as far away as Europe. All clothing and instruments are true replicas from the colonial period. ■ *Right:* Downtown Hartford is decorated for the spring Taste of Hartford Festival. In the background is the first two-sided office building in the world, the Phoenix Mutual Life Insurance Building, which was erected in 1963.

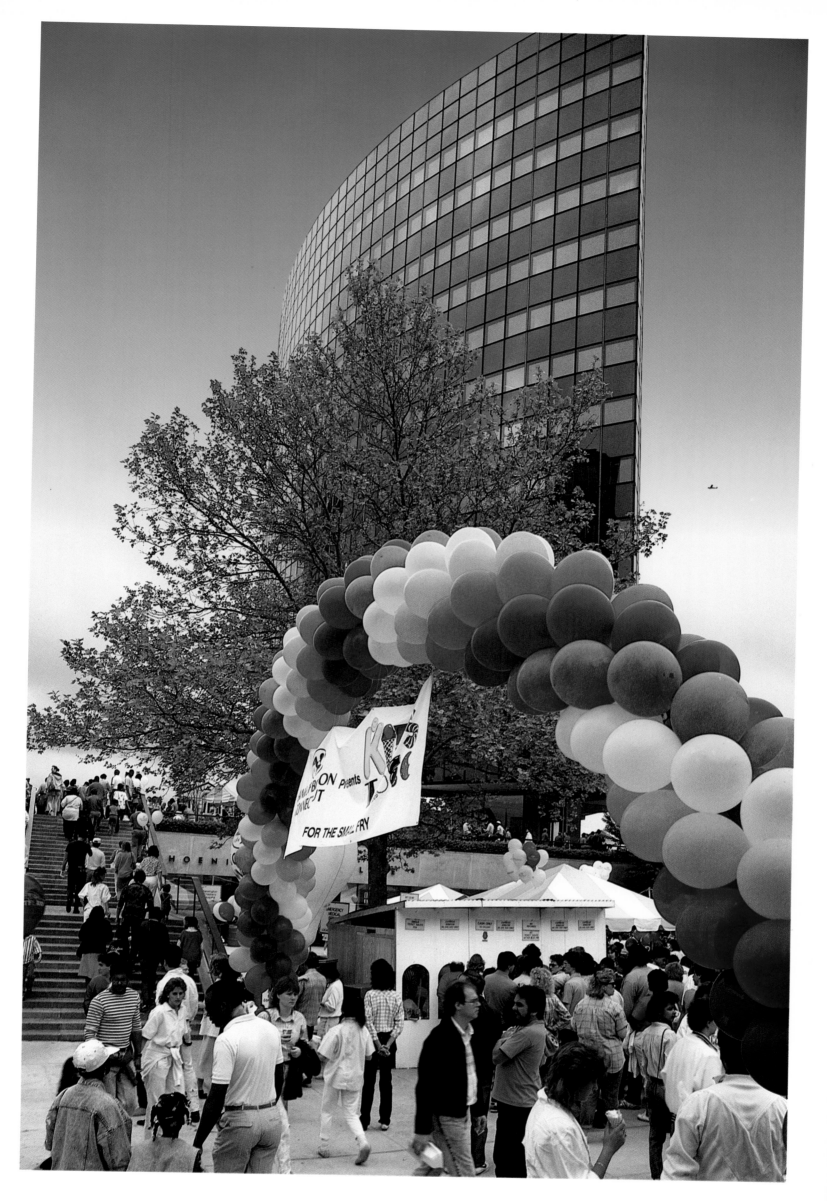

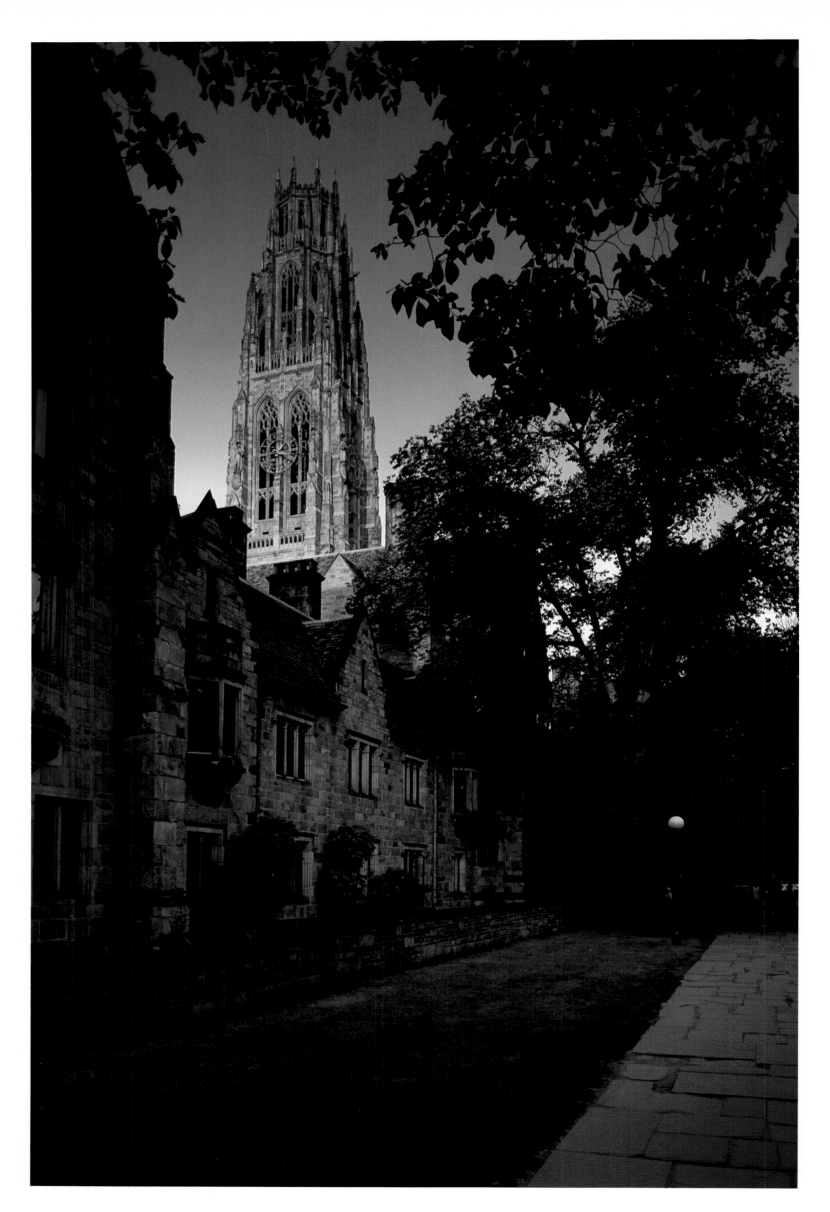

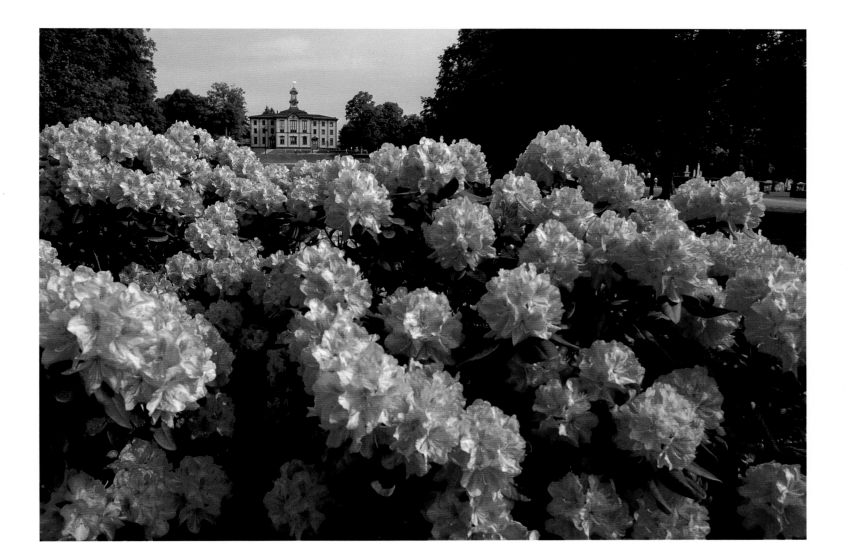

■ *Left:* Patterned after Cambridge and Oxford, Yale's Harkness Tower and Branford College bring old-world charm and tradition to New Haven. ■ *Above:* Properly Victorian, the Academy Building presides over Woodstock's village green. The town caps the crest of a hill in the northeast, the "quiet corner" of the state.

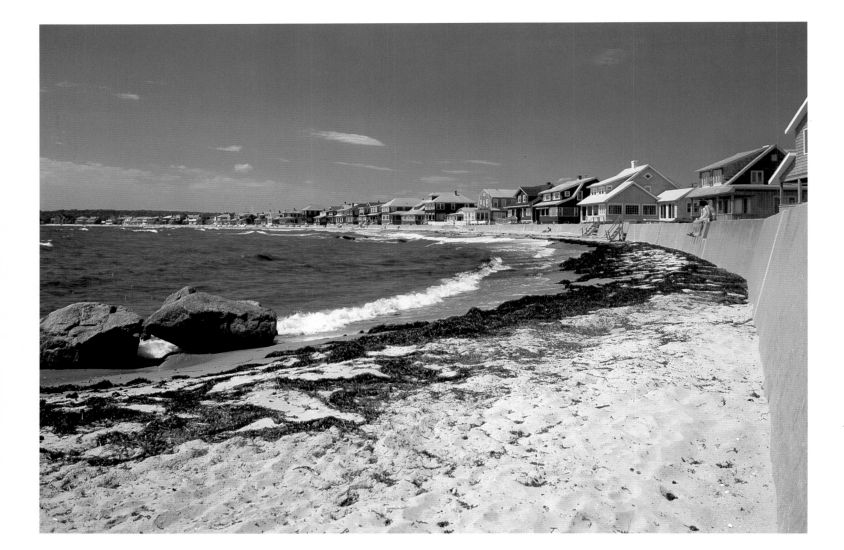

■ *Above:* Summer cottages, converted for year-round living, line the western-facing sea wall on Groton Long Point, one of the many barrier beaches along the Connecticut coast that have been developed for housing. ■ *Right:* The North Atlantic Sailboats Show on Stamford's waterfront is the second-largest in-water boat show in the nation. ■ *Following page:* Once considered rare, a raft of Canadian geese rests and feeds in a pond at McLean Wildlife Refuge in Granby.

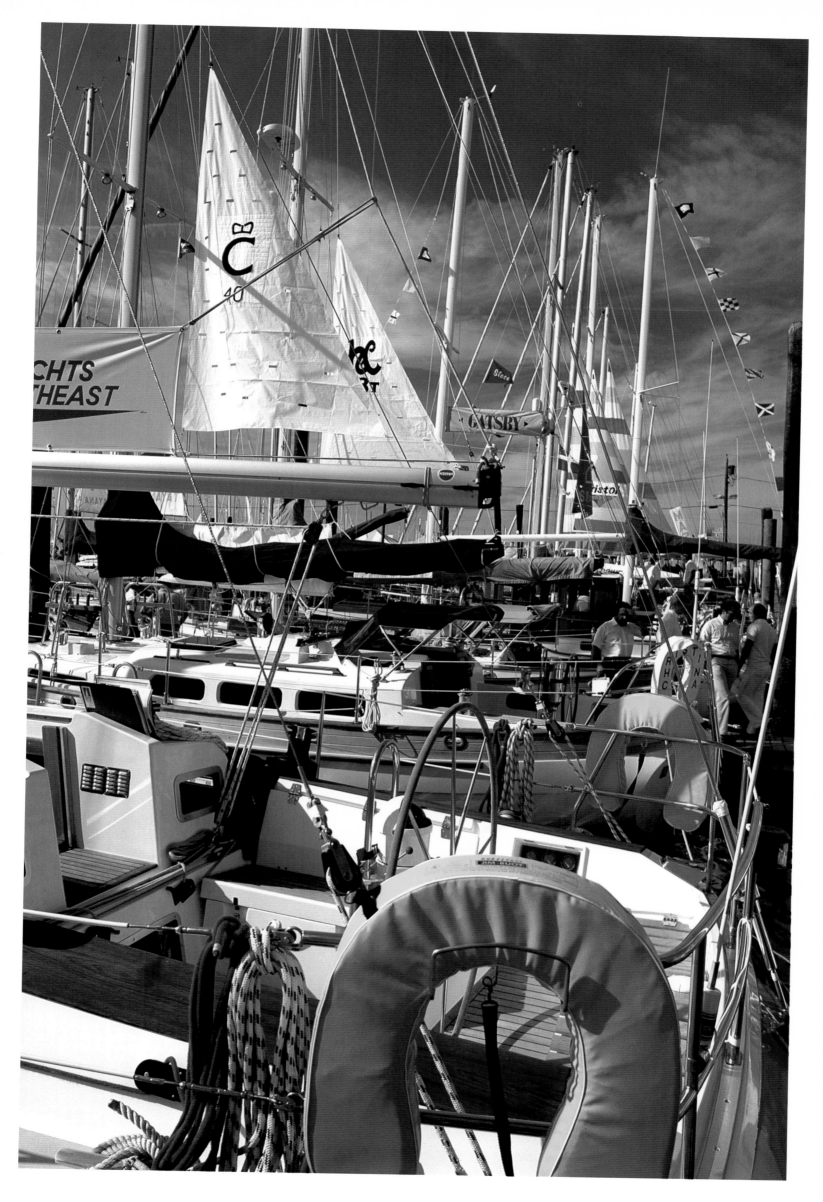

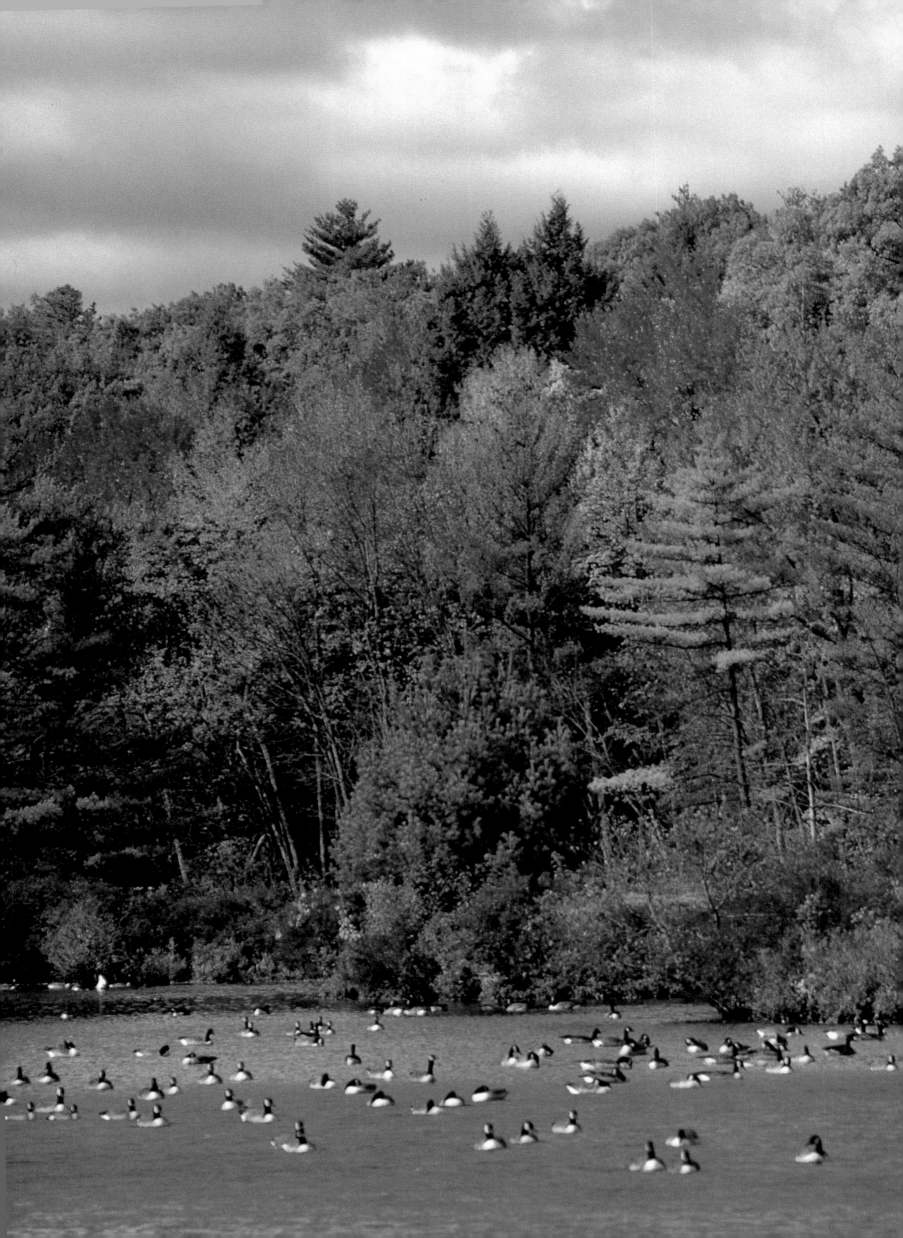

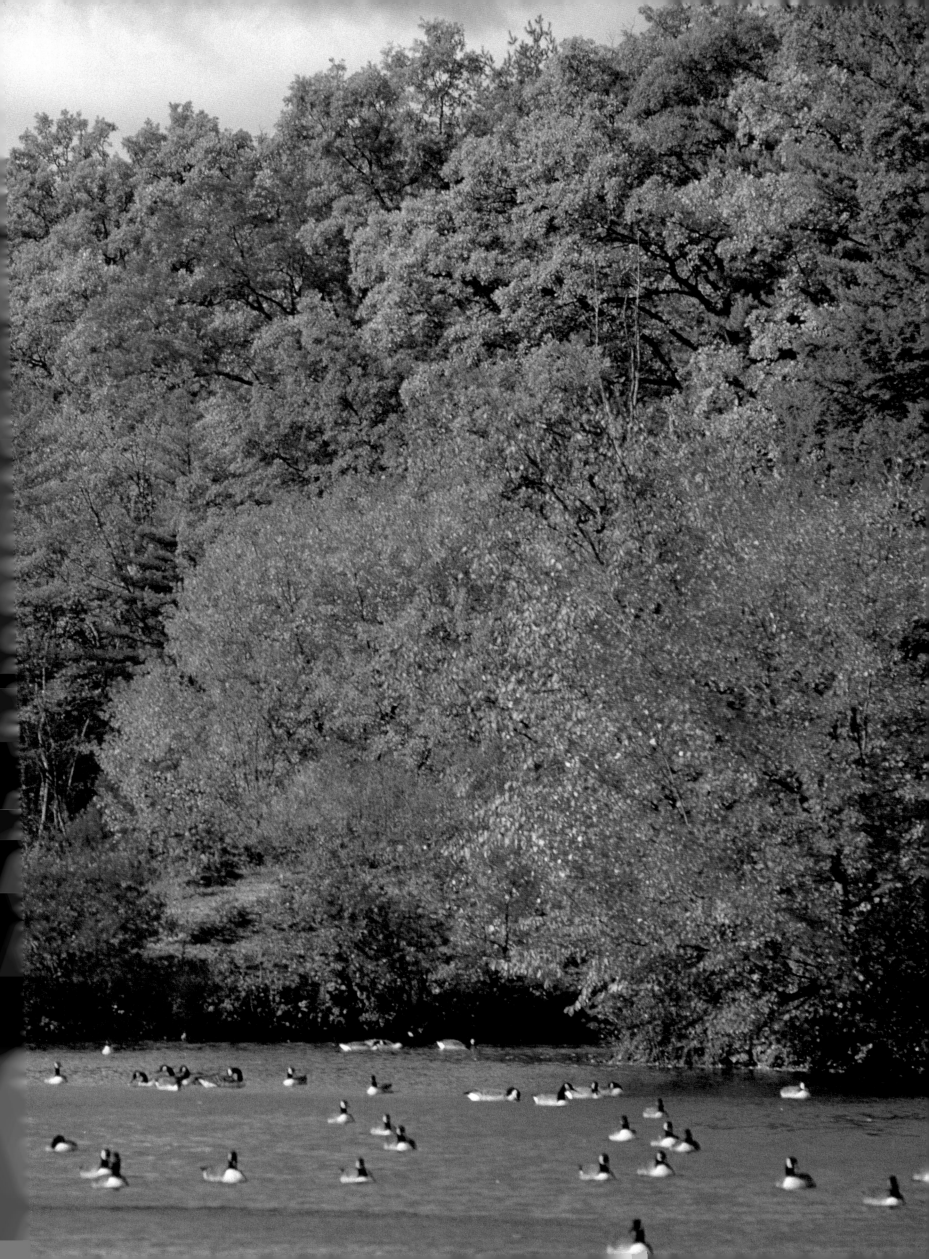

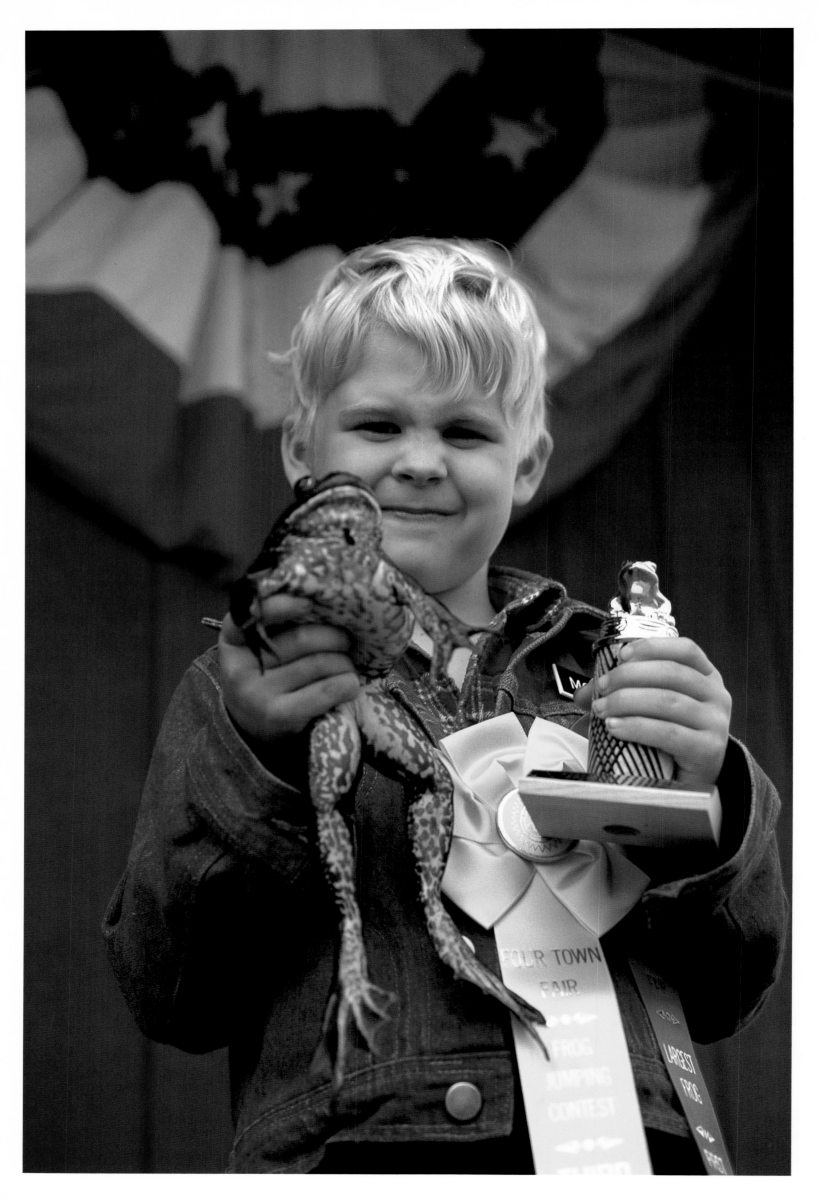

■ *Left:* A day to be remembered—having the largest frog at the Four Town Fair in Somers! Among the more than sixty fairs in the state, the Four Town Fair, begun in 1838, is the oldest. ■ *Above:* The maple is one of fall's most glorious trees. Often planted to shade rural roads, some trees are about two hundred years old.

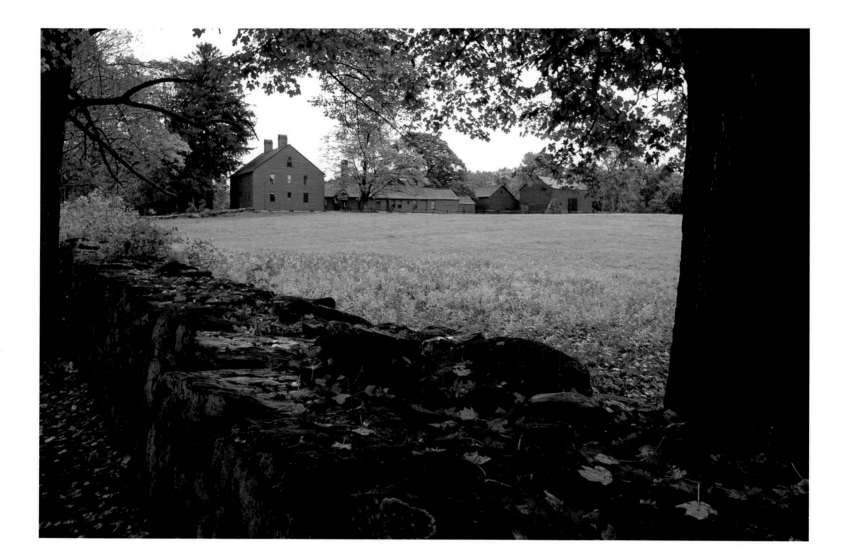

■ *Above:* Nathan Hale, Connecticut's most famous Revolutionary War hero, was born on this site near Coventry in 1755. ■ *Right:* Rebuilt in 1909, Old Lyme's Congregational Church is a faithful reproduction of the earlier 1817 Meeting House, which was adapted from drawings by Sir Christopher Wren. Located at the mouth of the Connecticut River, the town was home to over sixty sea captains and was a center of shipbuilding and shipping during the nineteenth century.

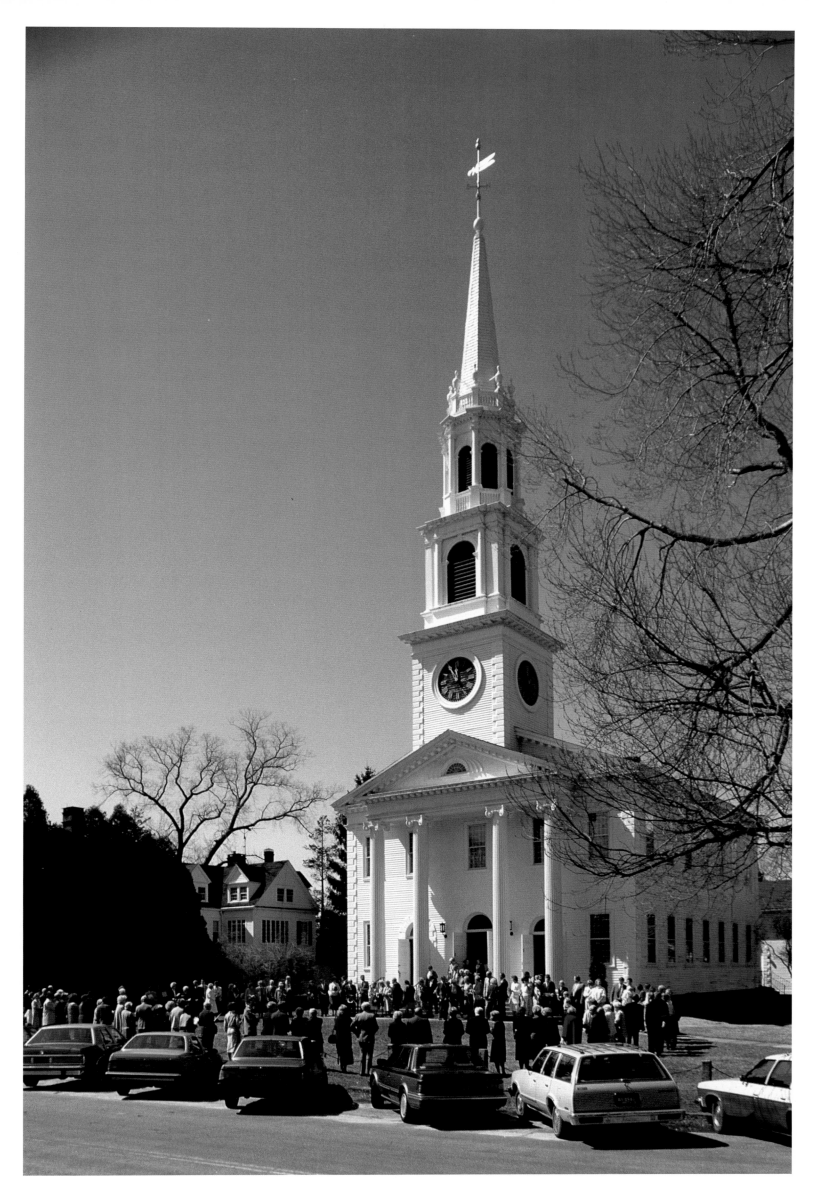

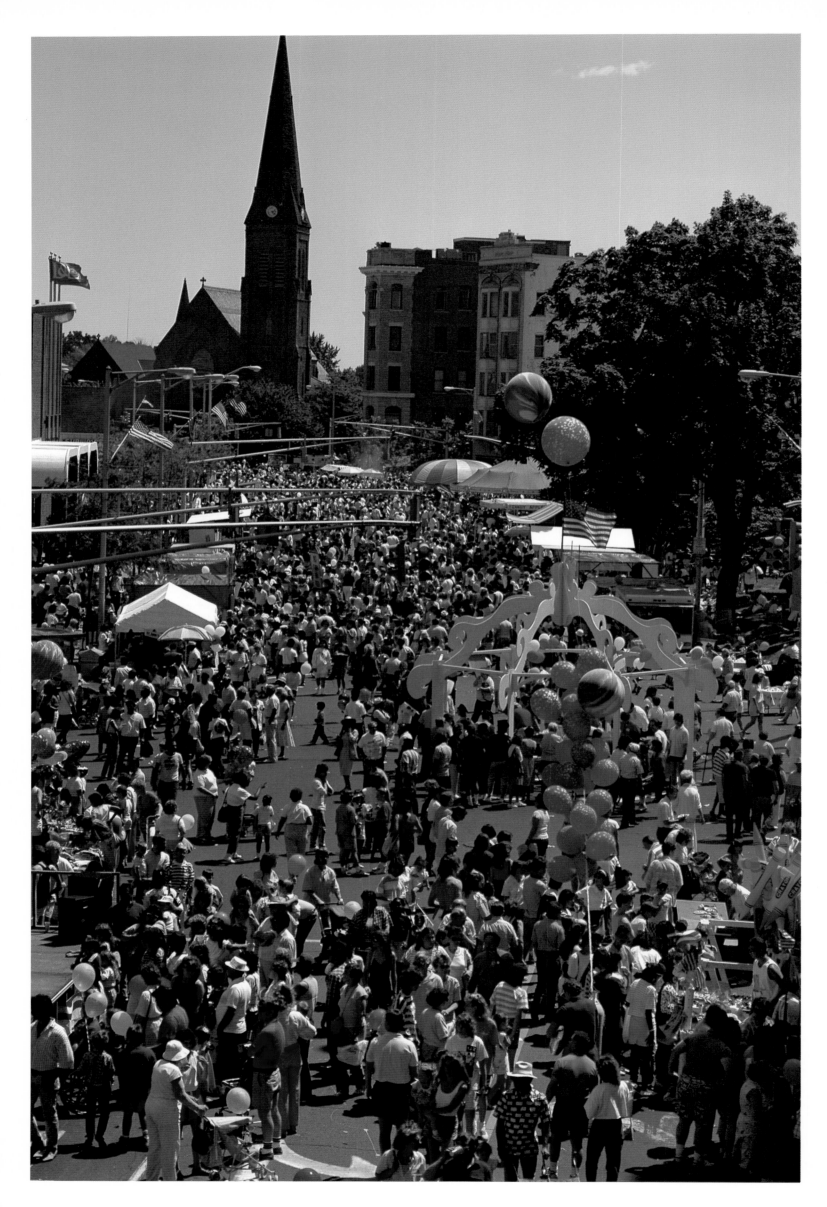

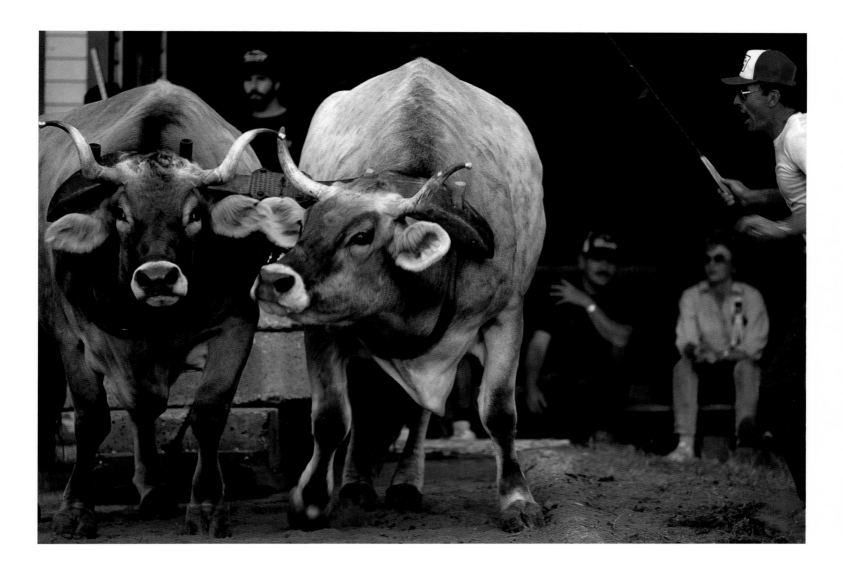

■ *Left:* The annual Main Street USA Festival in New Britain attracts food booths that represent cuisine from around the world. Participating are more than twenty-five countries as diverse as Viet Nam and Poland. While Connecticut is the third-smallest state in area, it ranks twenty-eighth in total population in the United States. ■ *Above:* Oxen drawing is a major country fair event. The strongest teams may pull over eleven thousand pounds of cement weights on a stone boat.

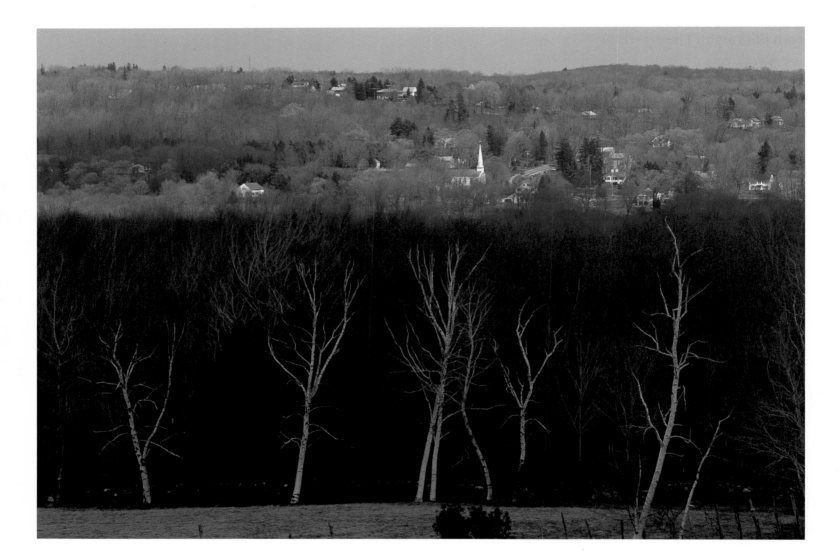

■ *Above:* The town of Harwinton, founded in 1732, was named by combining syllables of three other towns—Hartford, Windsor, and Farmington. ■ *Right:* Established in 1903, Hartford's Elizabeth Park, a popular wedding spot, is the nation's first municipally owned rose garden, with over nine hundred varieties.

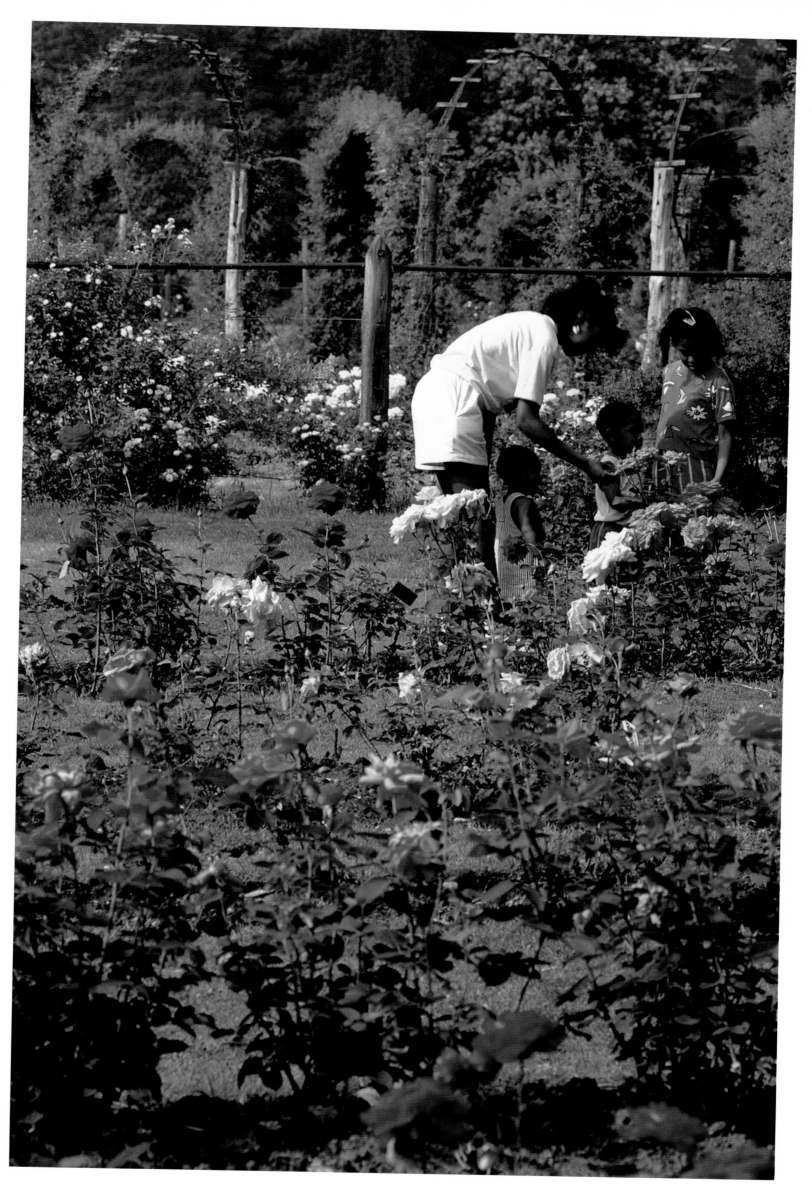

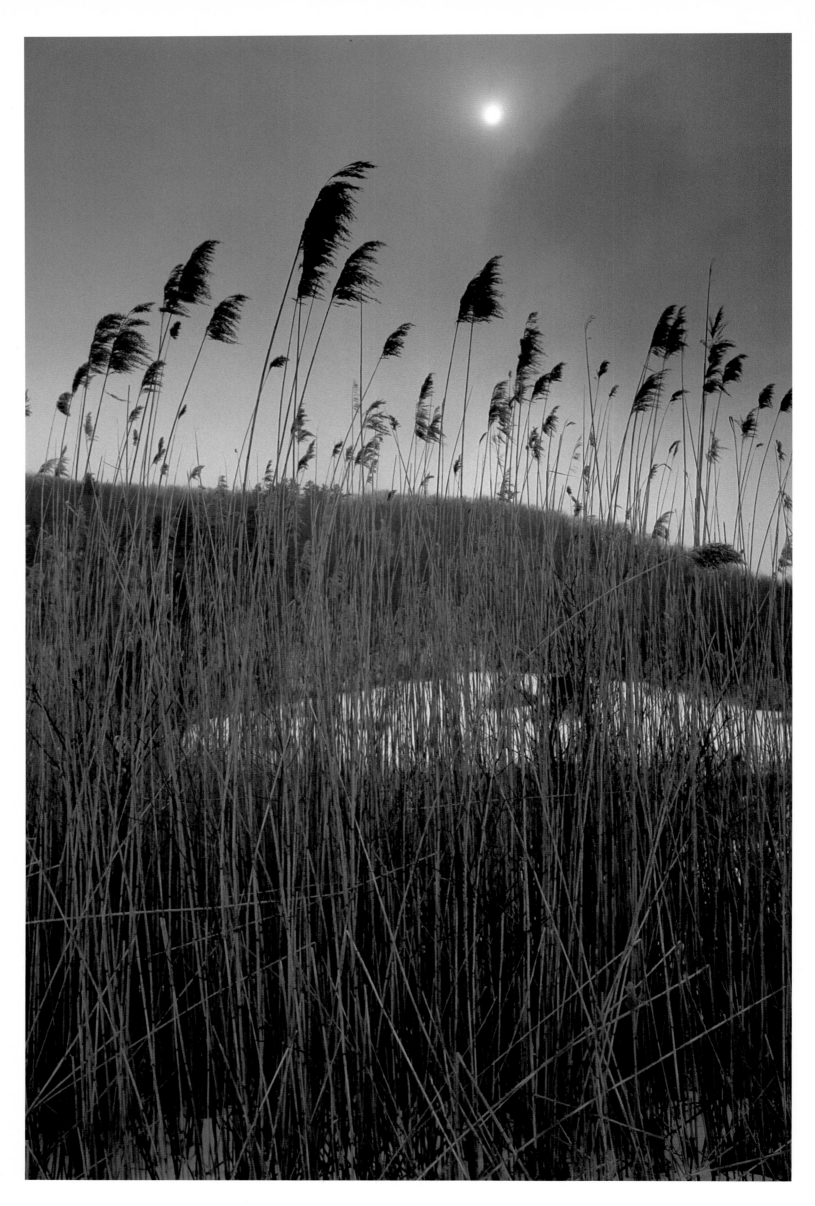

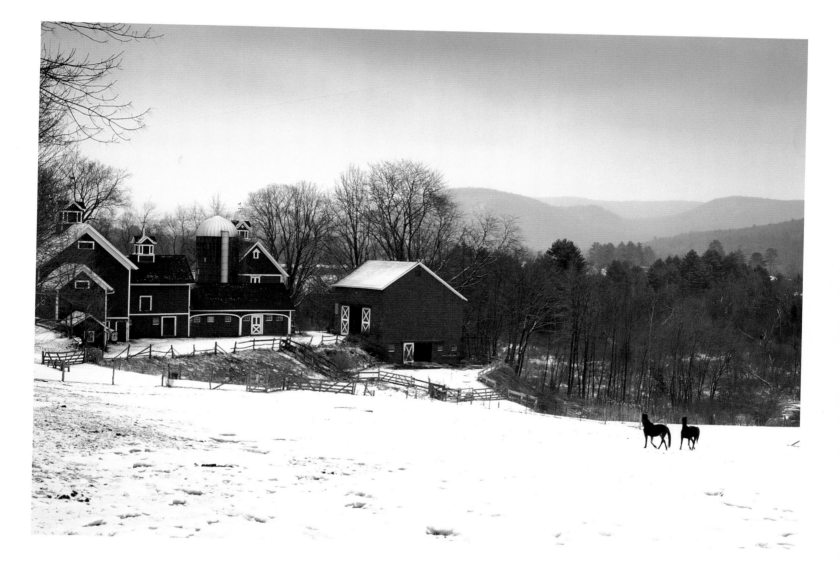

■ *Left:* Picturesque, non-native reed grasses appear frequently in wetlands that have been disturbed by man. Though beautiful, they upset the ecology of these marshy areas. ■ *Above:* In 1883, the owner of a major smelting industry in the state's northwest corner built these barns as a racehorse breeding farm for a son.

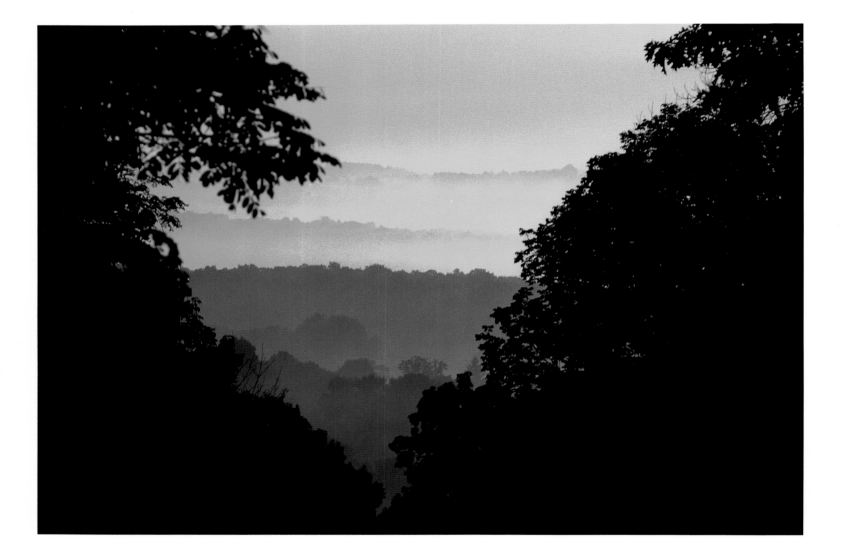

■ *Above:* North of the Litchfield County town of Woodbury, settled in 1672, the terrain across the Nonewaug River Valley is rugged, with steep ridges which stand out sharply in the early morning fall mist. ■ *Right:* Early every summer, thousands of newly hatched waterbirds on Chimon Island, part of the Stewart B. McKinney Wildlife Refuge, are banded by trained ornithologists. This refuge, which is located on islands off the coast of Norwalk, is one of the state's newest.

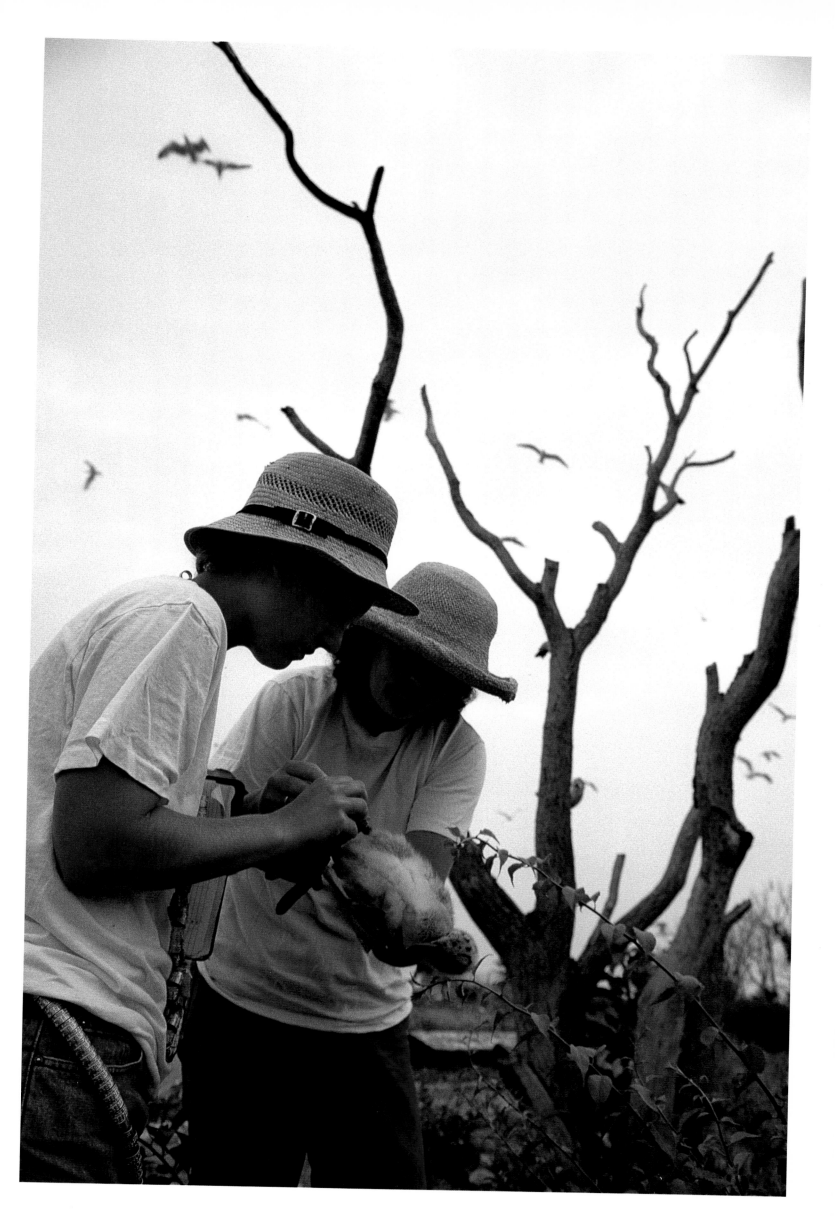

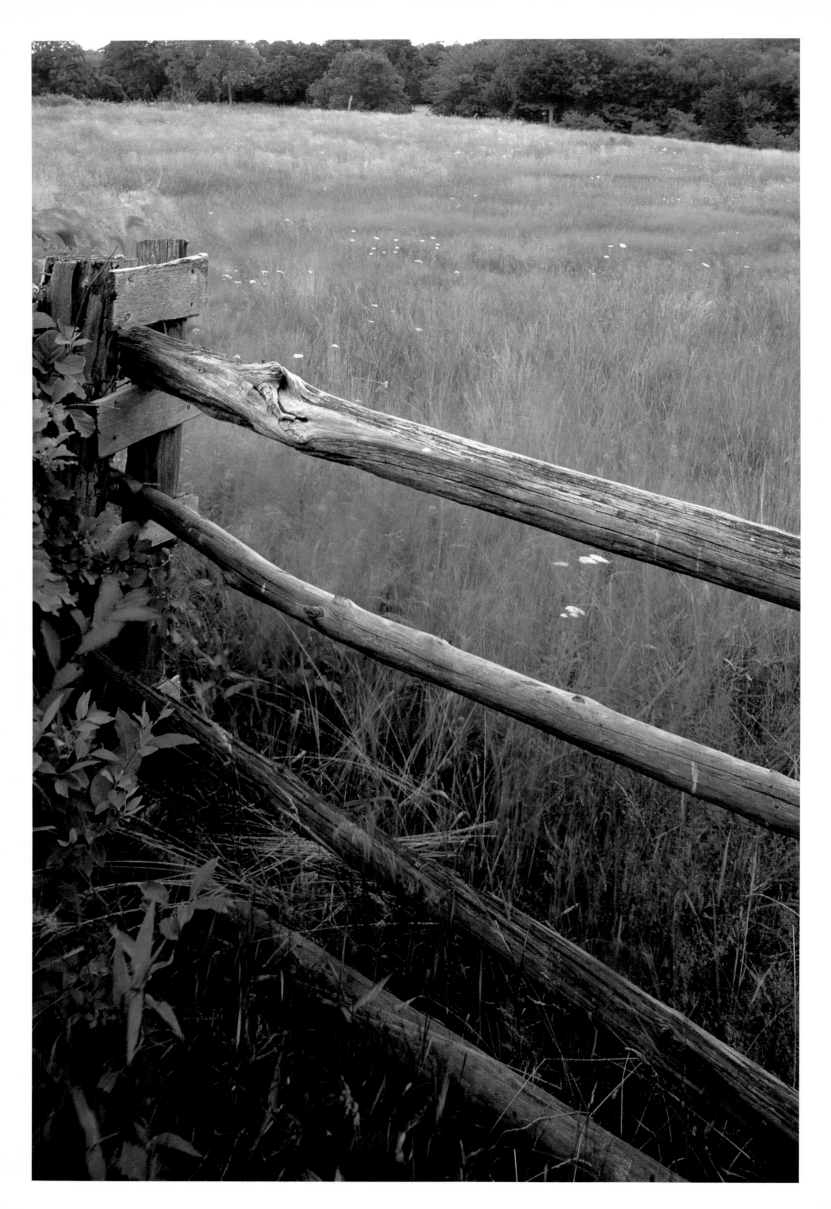

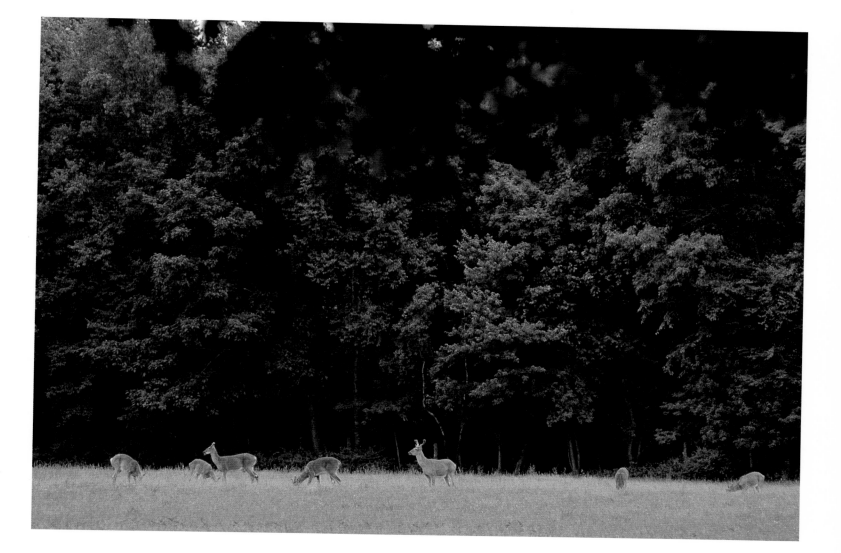

■ *Left:* Meadows, an endangered feature of the Connecticut landscape, are either falling prey to pavement and subdivisions or are reverting back to the forest for lack of care. ■ *Above:* White-tailed deer are finding fewer browsing areas as the human population continues to expand into their woodland habitat. ■ *Overleaf:* This farm near Old Lyme, along with many others in the state, will be preserved for agricultural use under the state's Agricultural Preservation Program.

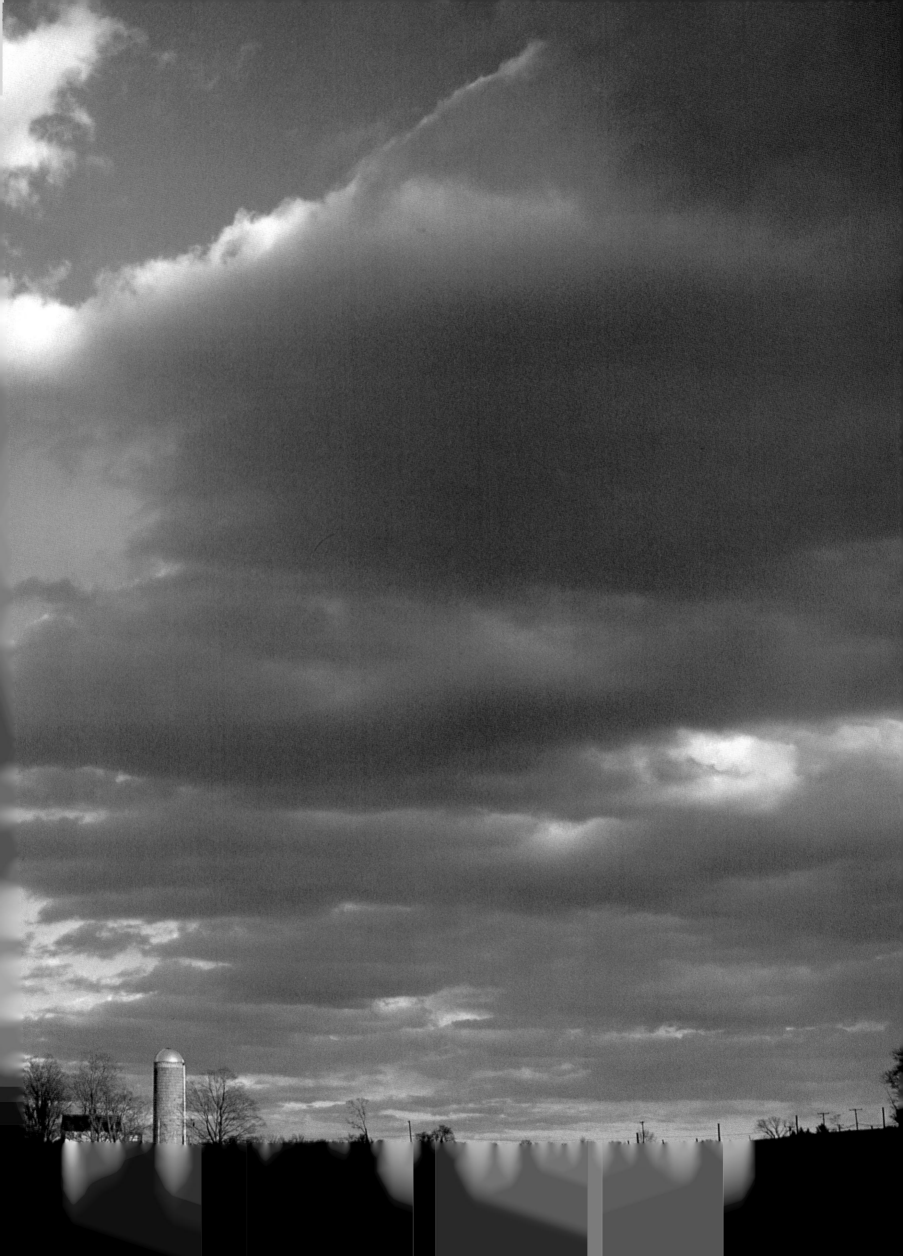

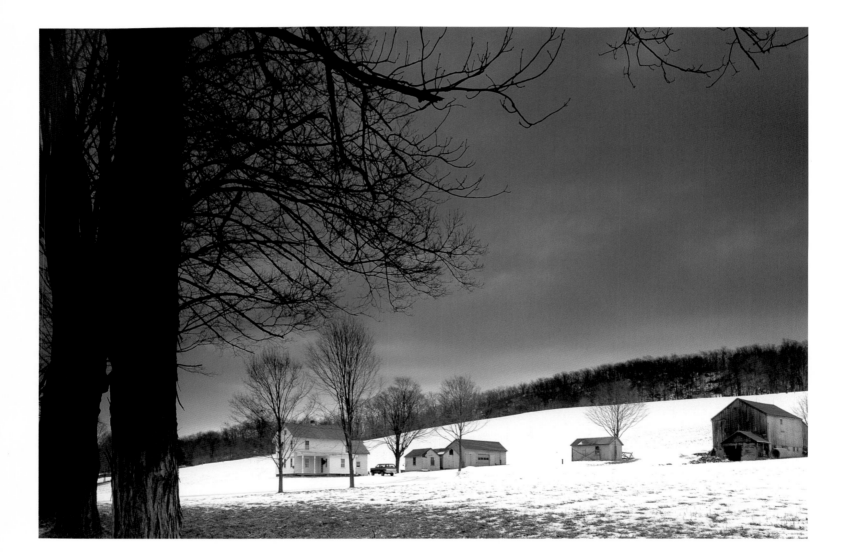

■ *Above:* Small farms are still the backbone of Connecticut agriculture. While many areas are far too rocky for anything other than pasture, others are very fertile. In fact, milk production per cow beats the national average. Corn production per acre is 30 percent above the national average, beating Kansas and Iowa.
■ *Right:* Built in 1770 as a Congregational Meeting House on the village green in Brooklyn, this building is a classic example of eighteenth-century architecture.

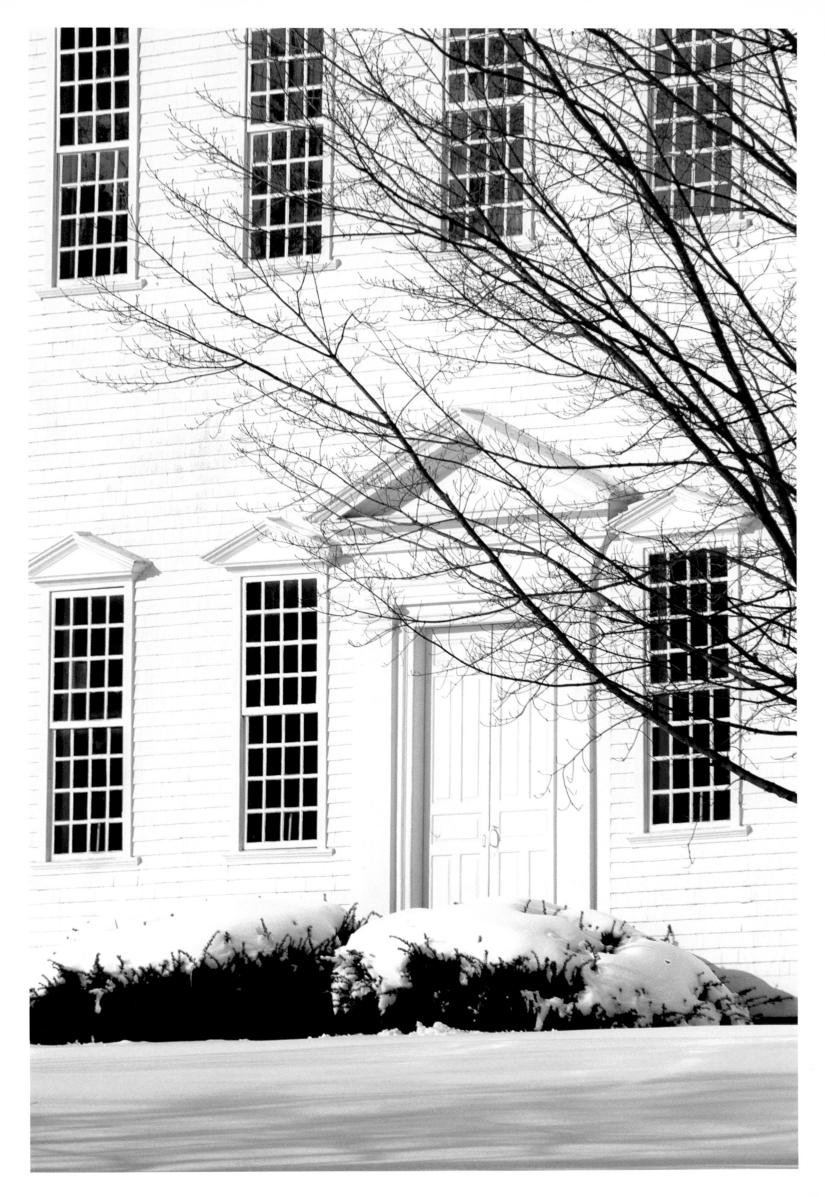

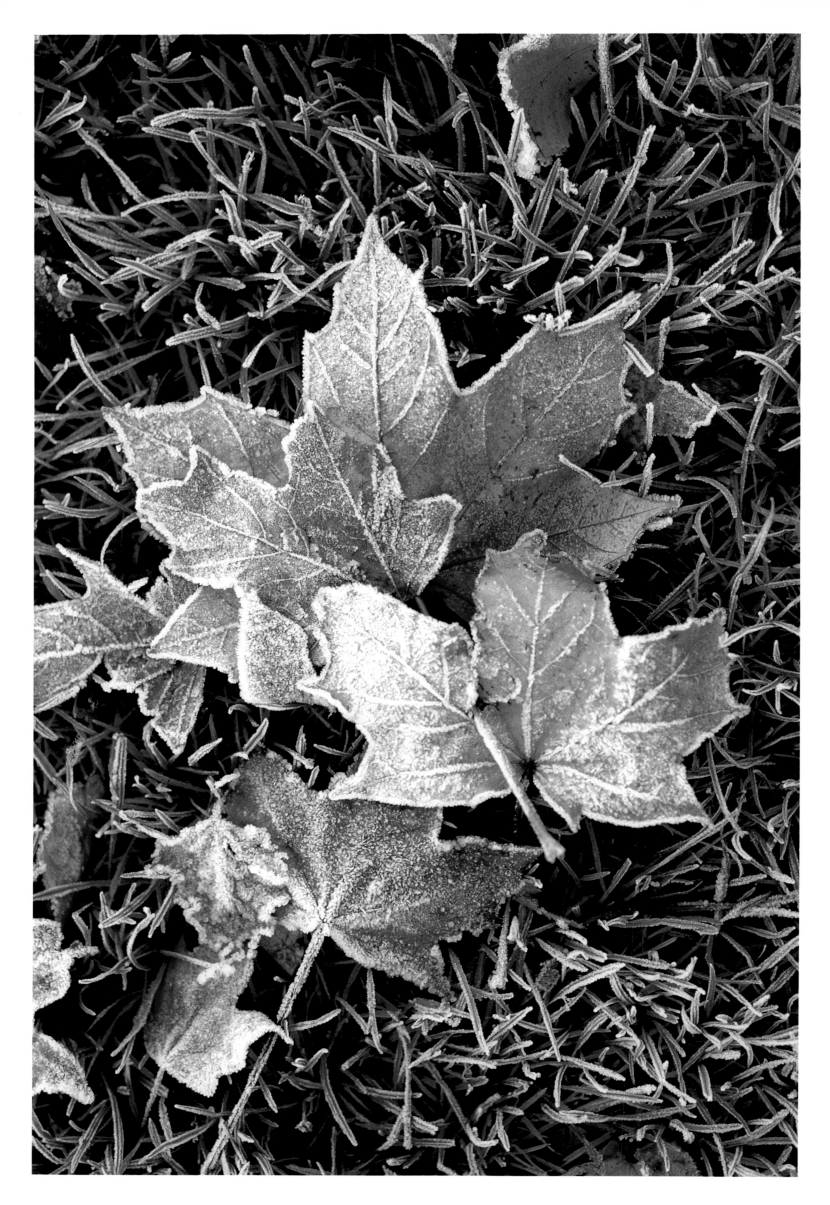

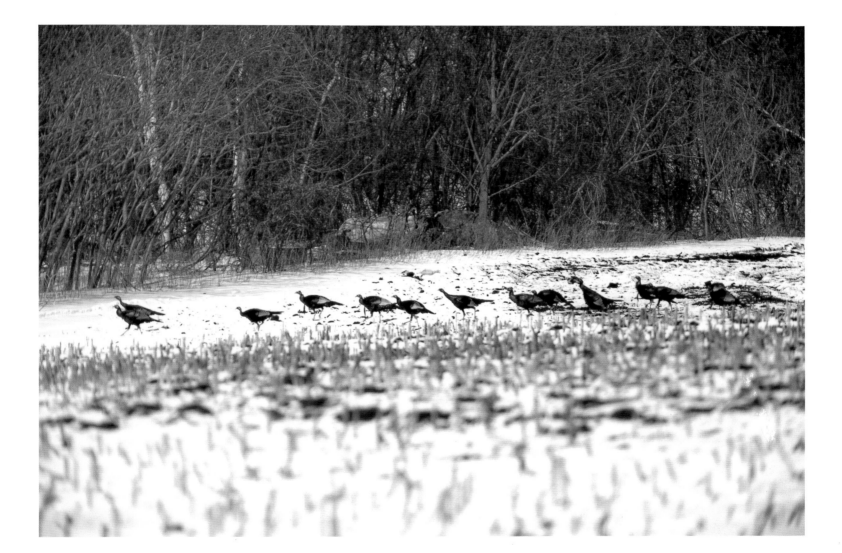

■ *Left:* On average, the last and first days of frost come in early May and mid-October. Since the frost hits hardest in Connecticut's lower valleys and kills the delicate fruit blossoms in the spring, farmers have learned to plant their orchards on the tops and slopes of higher hills. ■ *Above:* Wild turkey, once extinct in Connecticut woodlands, have now been successfully reintroduced in many parts of the state. It is estimated that some six thousand are now in the forest.

■ *Above:* Trees have always been important in Connecticut, in both a practical and a decorative way. In 1777, the first trimmed and lighted Christmas tree in America was created in Windsor Locks by a former Hessian soldier, Hendrick Rodemore. ■ *Right:* Stonington's Old Stone Lighthouse, built in 1823, was the first of many erected along the country's coastlines by the young federal government. It is now a museum of the town's early history and the whaling industry.

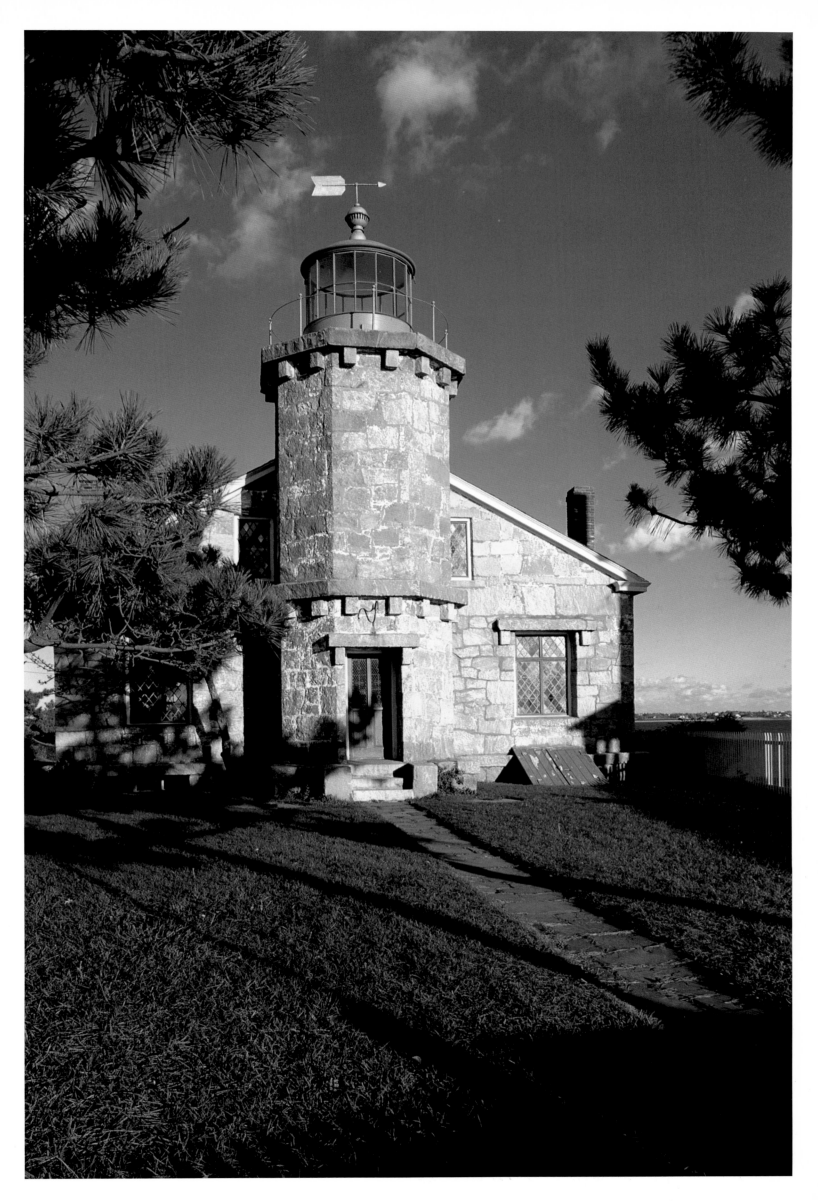

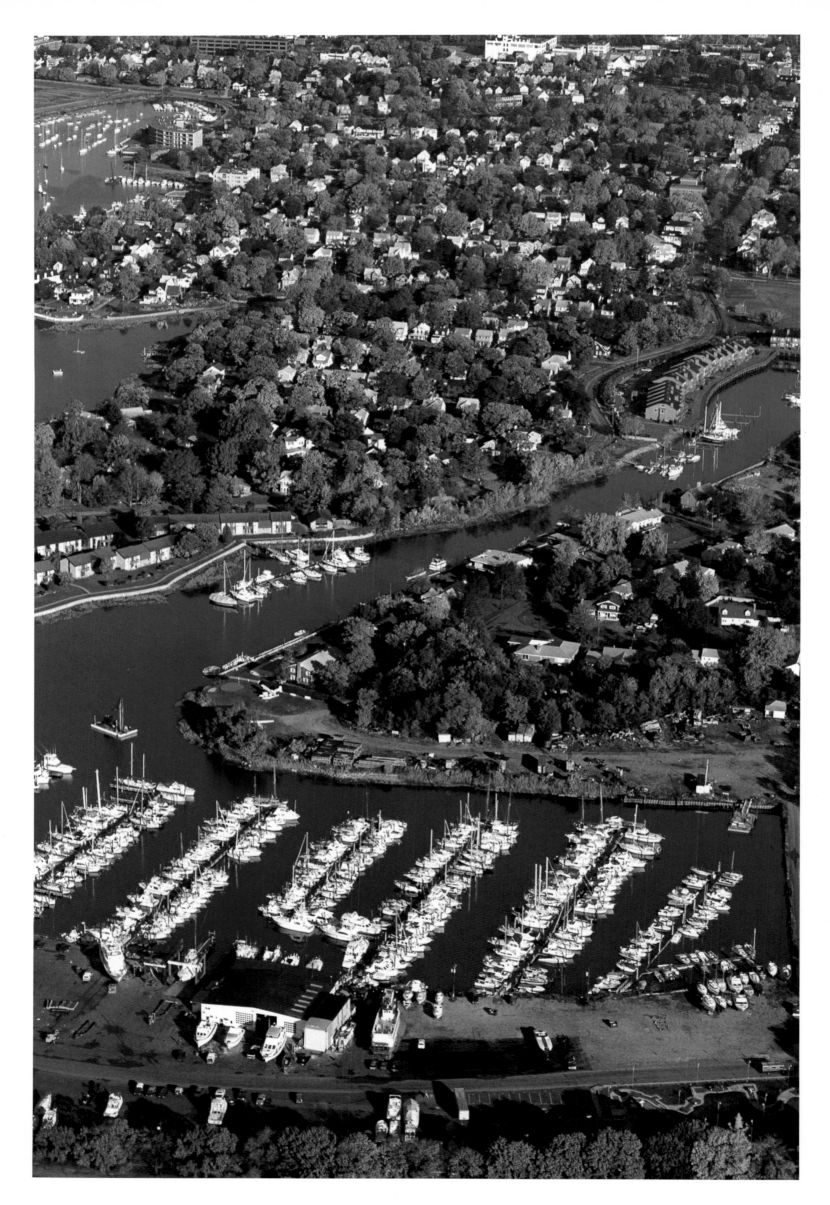

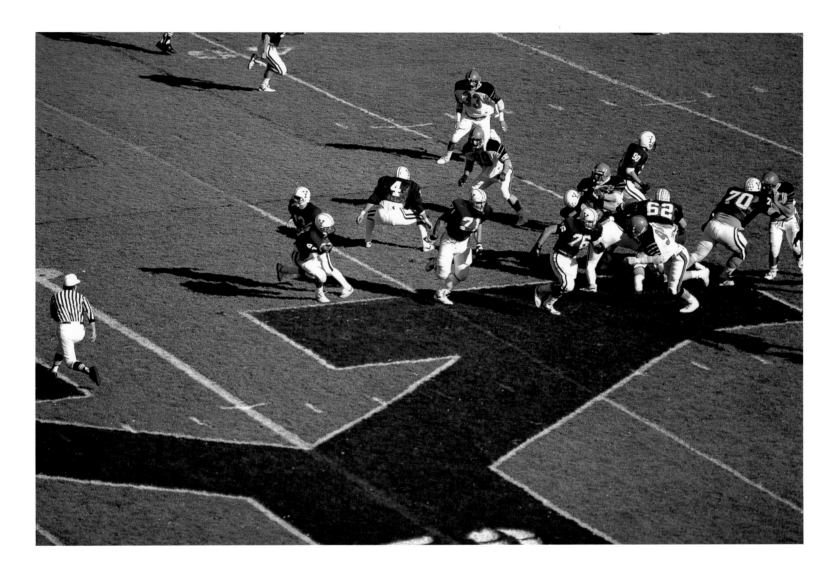

■ *Left:* Perfectly suited for today's marinas and submarine building, the state's indented shore provided harbor in colonial days for pirateering and piracy.
■ *Above:* Intercollegiate football is closely followed in Connecticut, as the state has no professional team. The Yale-Princeton football rivalry began in 1873.

■ *Above:* In colonial times, the state's population was almost wholly English. Today, Connecticut has one of the highest percentages of foreign-born citizens in the United States. ■ *Right:* Rocky Neck State Park has a mile-long beach. It is one of three state beaches along Connecticut's estimated 278 miles of coastline.

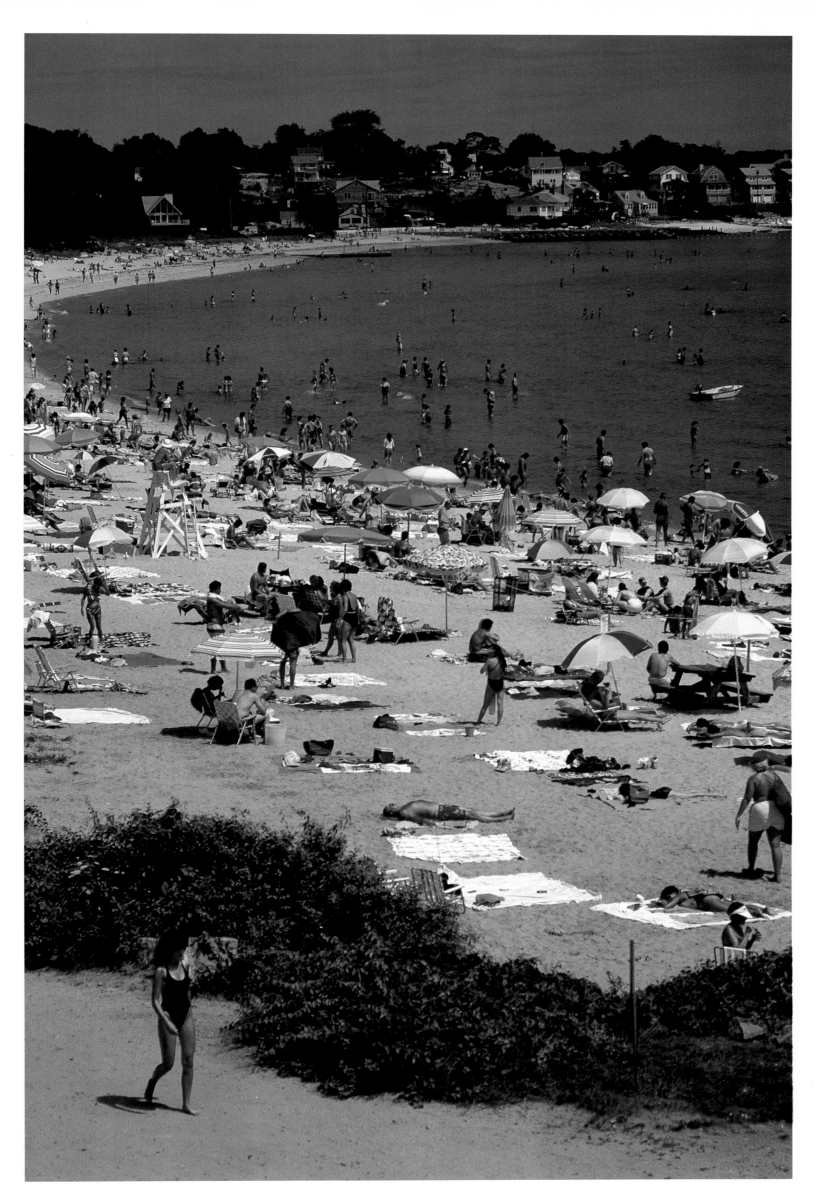

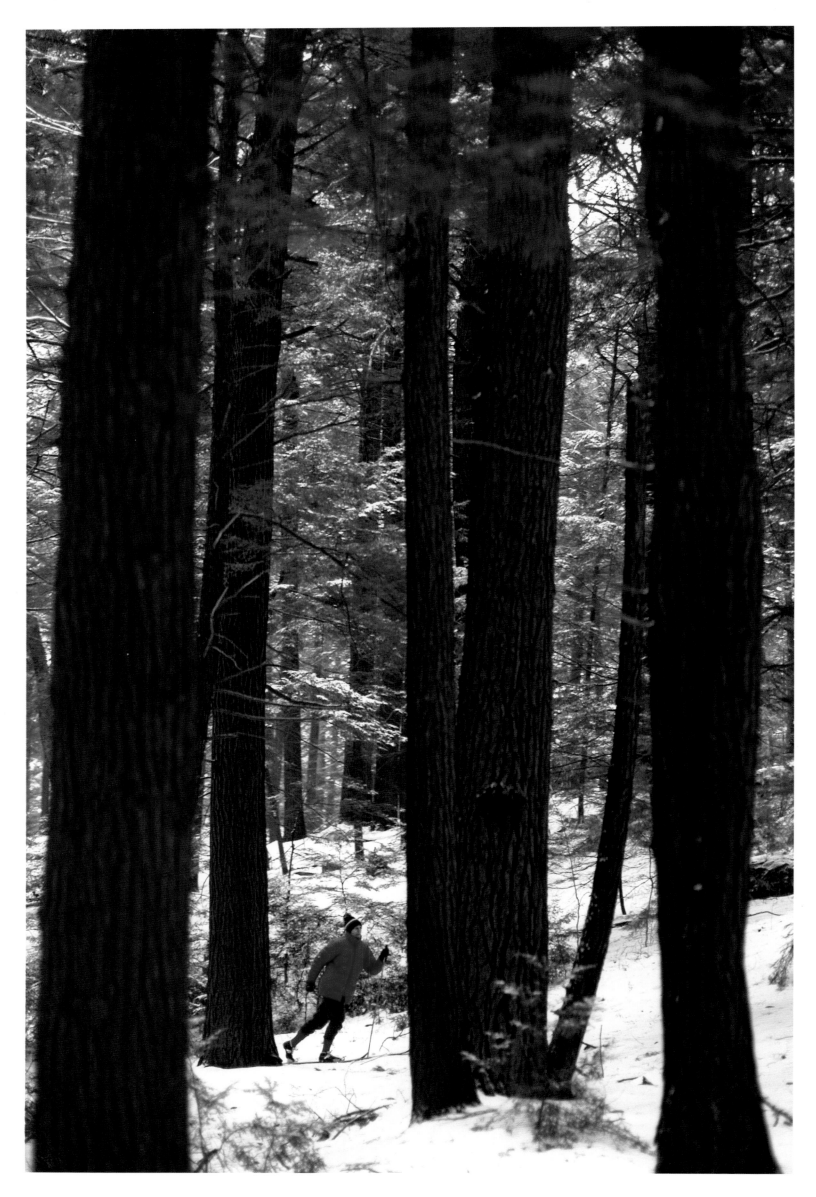

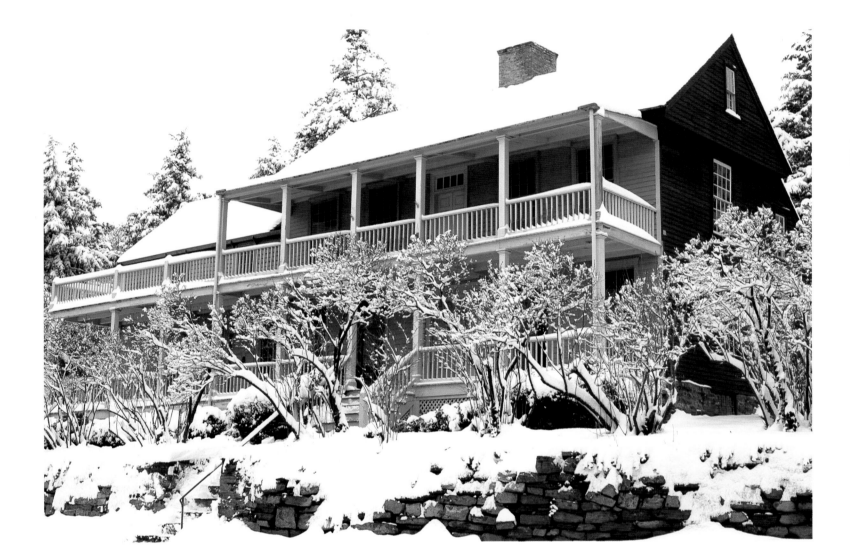

■ *Left:* Once the timber industry's mainstay, white pines make up the Cathedral Pines, a Nature Conservancy Preserve in Cornwall. In colonial days, the king's admiralty owned any tree over twenty-four inches in diameter. ■ *Above:* The Bush-Holly House in Cos Cob, built in 1732, is known as "the house that never stopped living." First a farmhouse and later an inn where early American Impressionist painters gathered, today it houses the Greenwich Historical Society.

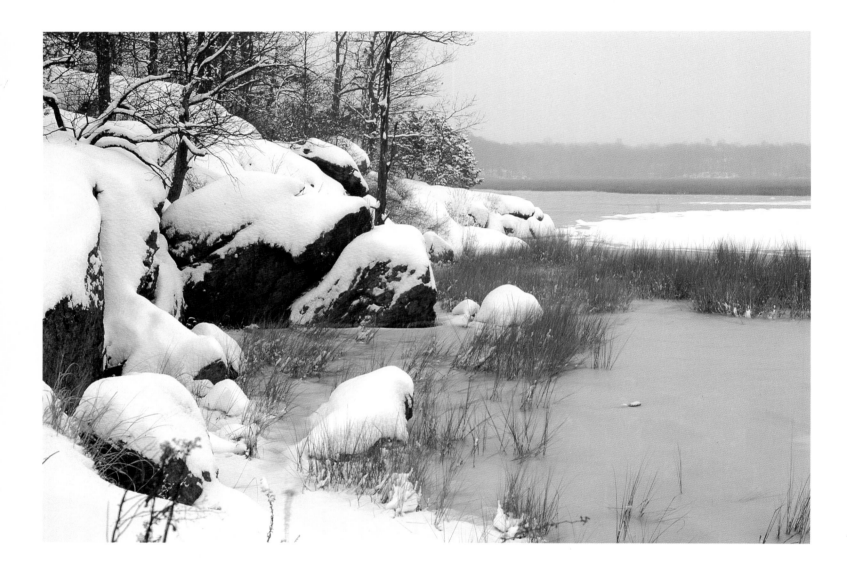

■ *Above:* In Guilford, as elsewhere along the state's shore, rocky granite headlands protrude into Long Island Sound. Stone from these outcrops was often quarried and sent to New York City for cobble stones and building materials. ■ *Right:* Standing in Greenwich, this statue commemorates some of the fifty-five thousand Connecticut men who fought in the Civil War. ■ *Following page:* Bridgeport, the state's largest city, spreads inland from Long Island Sound.

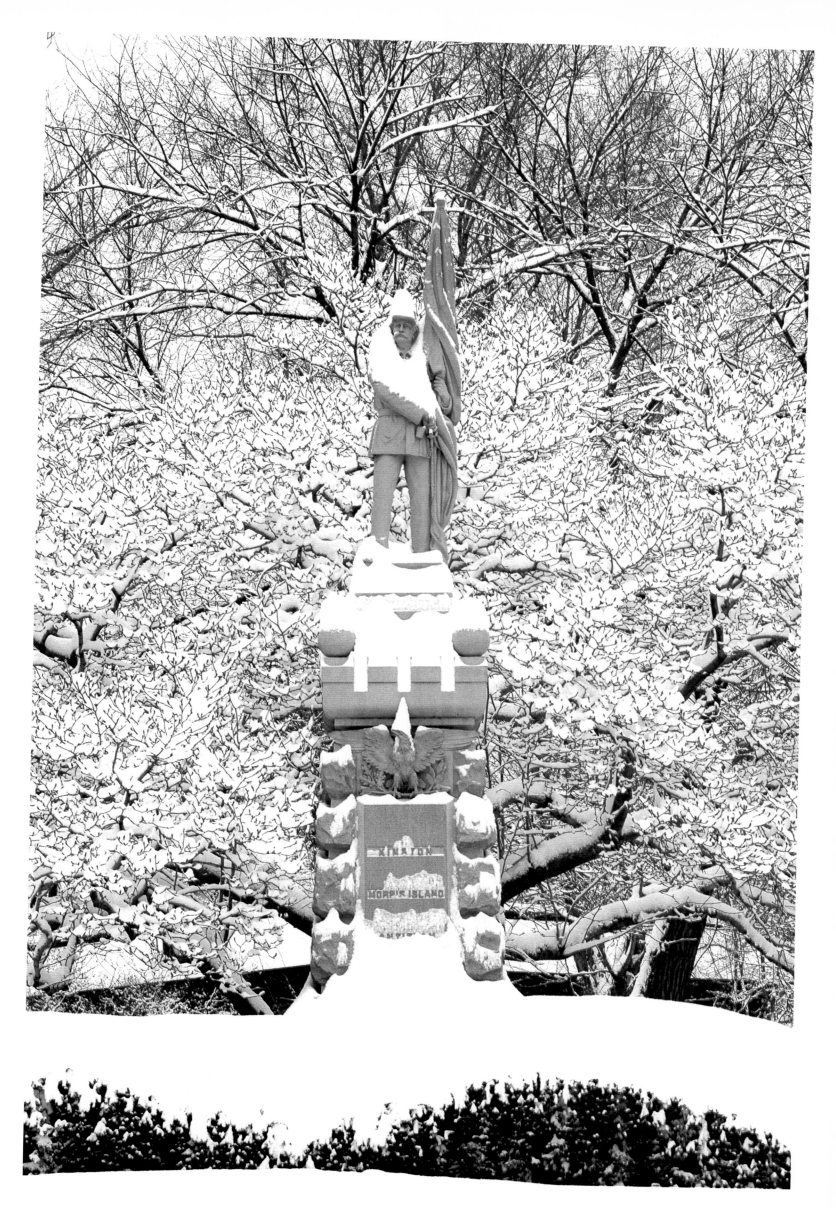

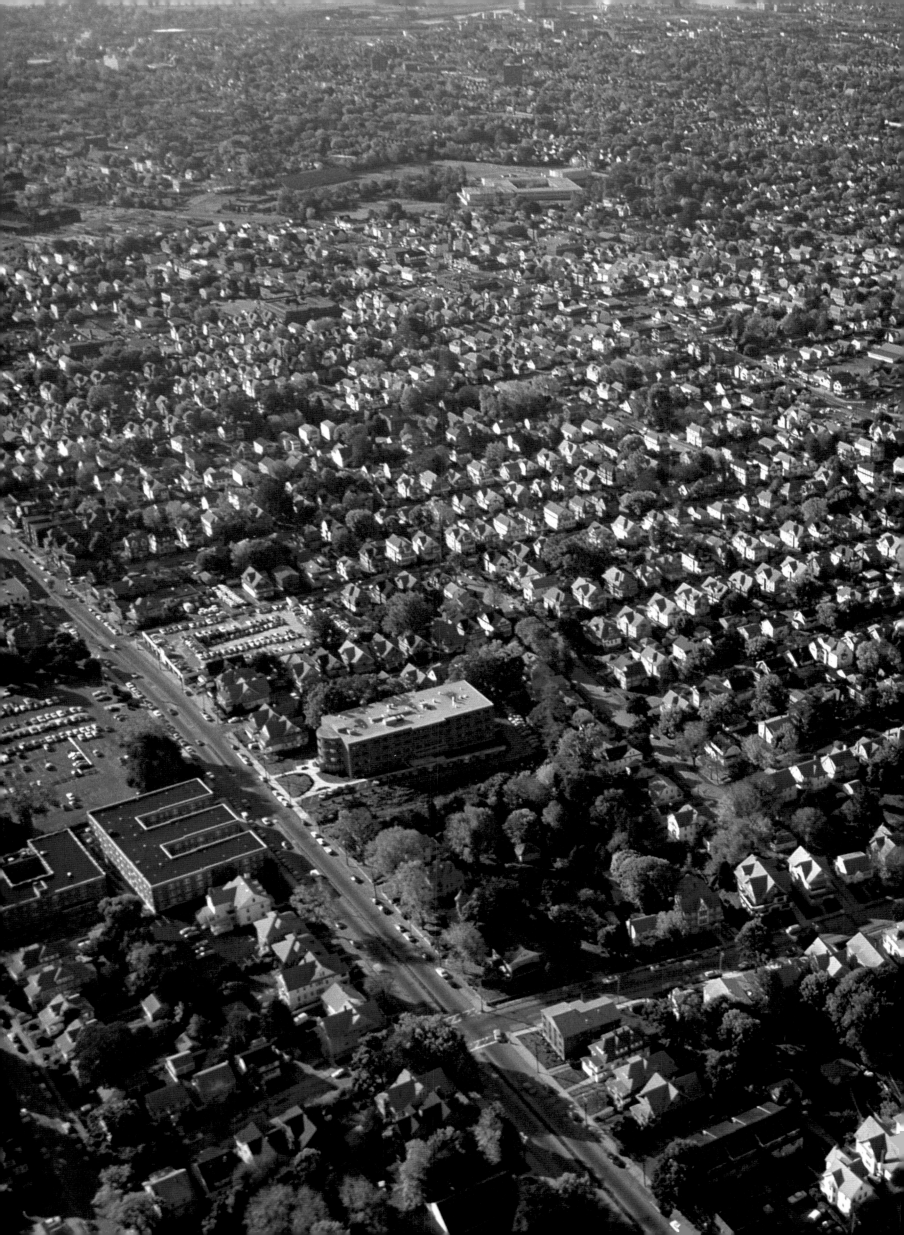

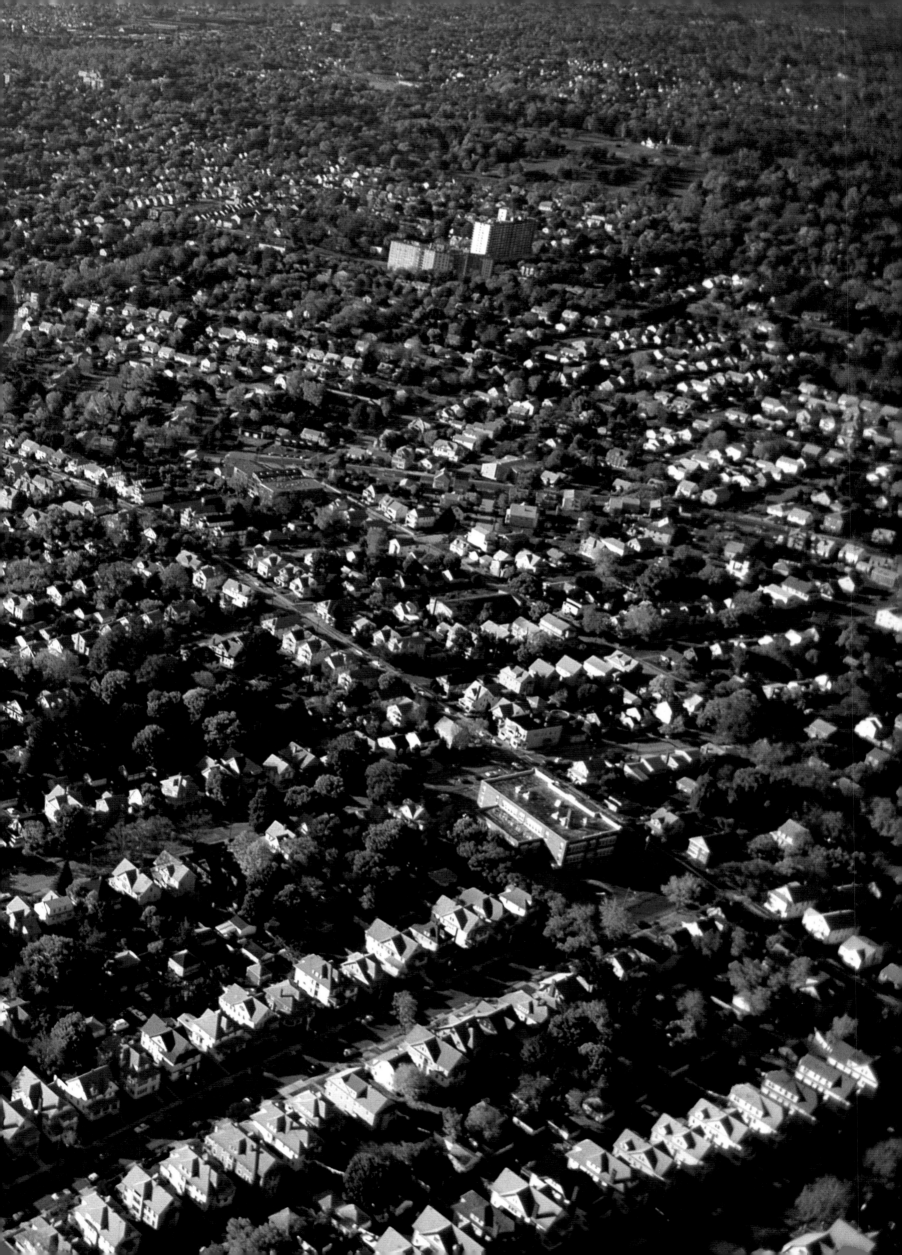

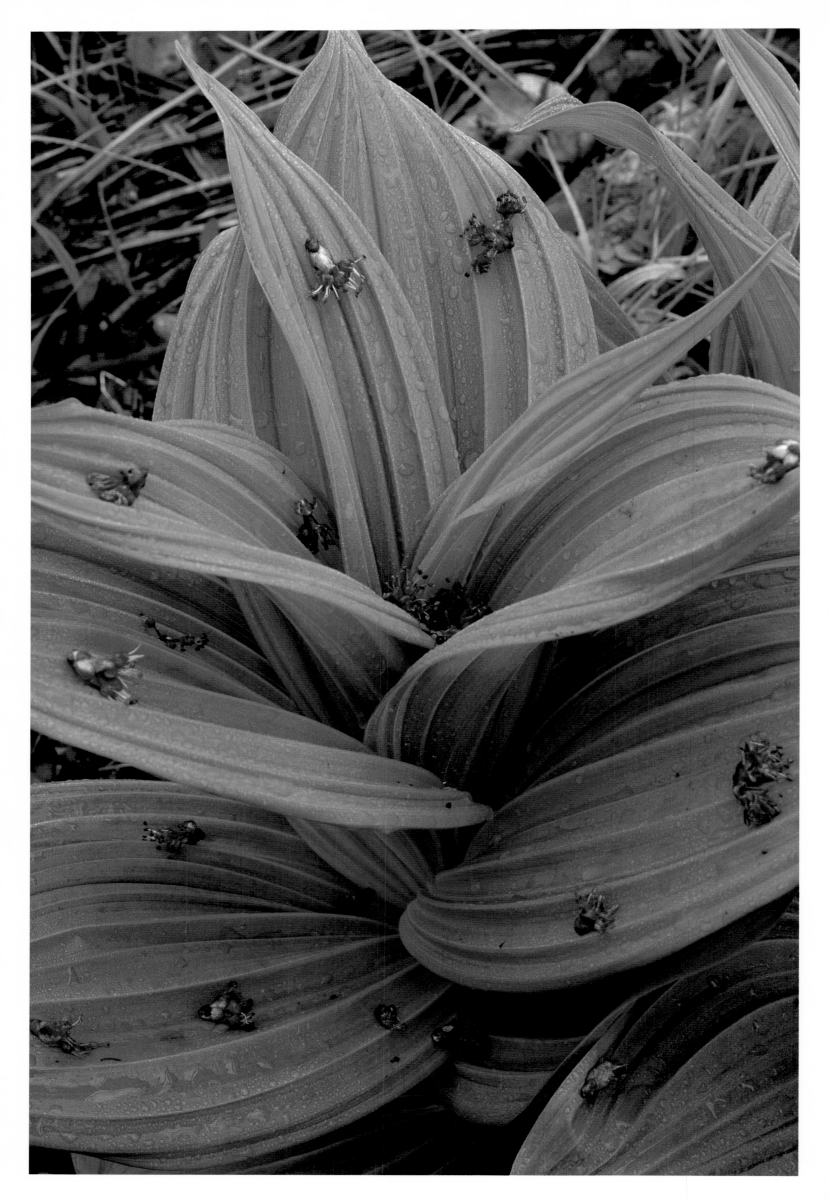

■ *Left:* In early spring, false hellebore, here sprinkled with swamp maple flowers, is among the first wetland plants to appear. ■ *Above:* In the rolling hills of Litchfield County, the only sign of the hand of man is the steeple of New Preston's Congregational Church, built in 1824. Around the time the church was built, Connecticut was said to have had more sheep than people. These wooded hills were then cleared grazing lands, criss-crossed by many miles of stone walls.

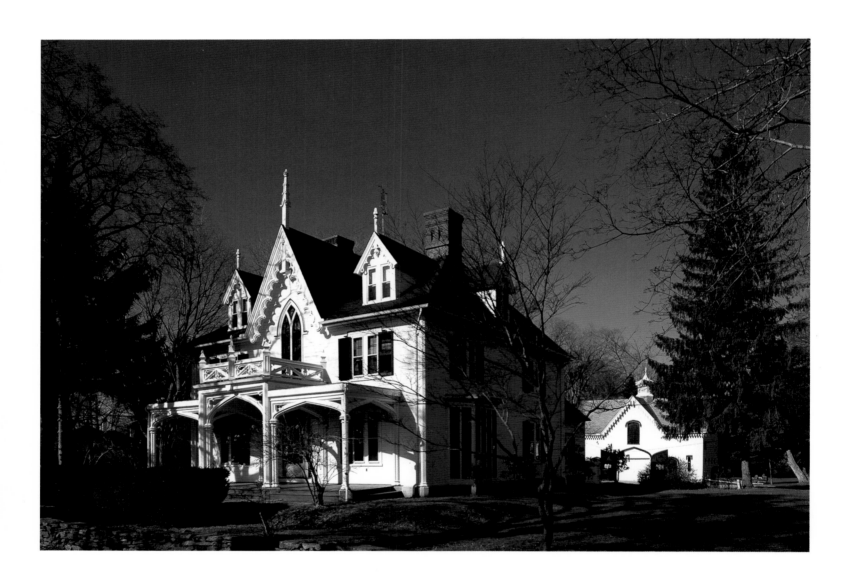

■ *Above:* In Thompson stands the William Mason house built in 1845. On the French River, Mason founded one of the largest cotton mills ever built in the state.
■ *Right:* In 1701, the Congregational Meetinghouse was built in Washington, a typical hilltop farming community before the development of the valley towns.

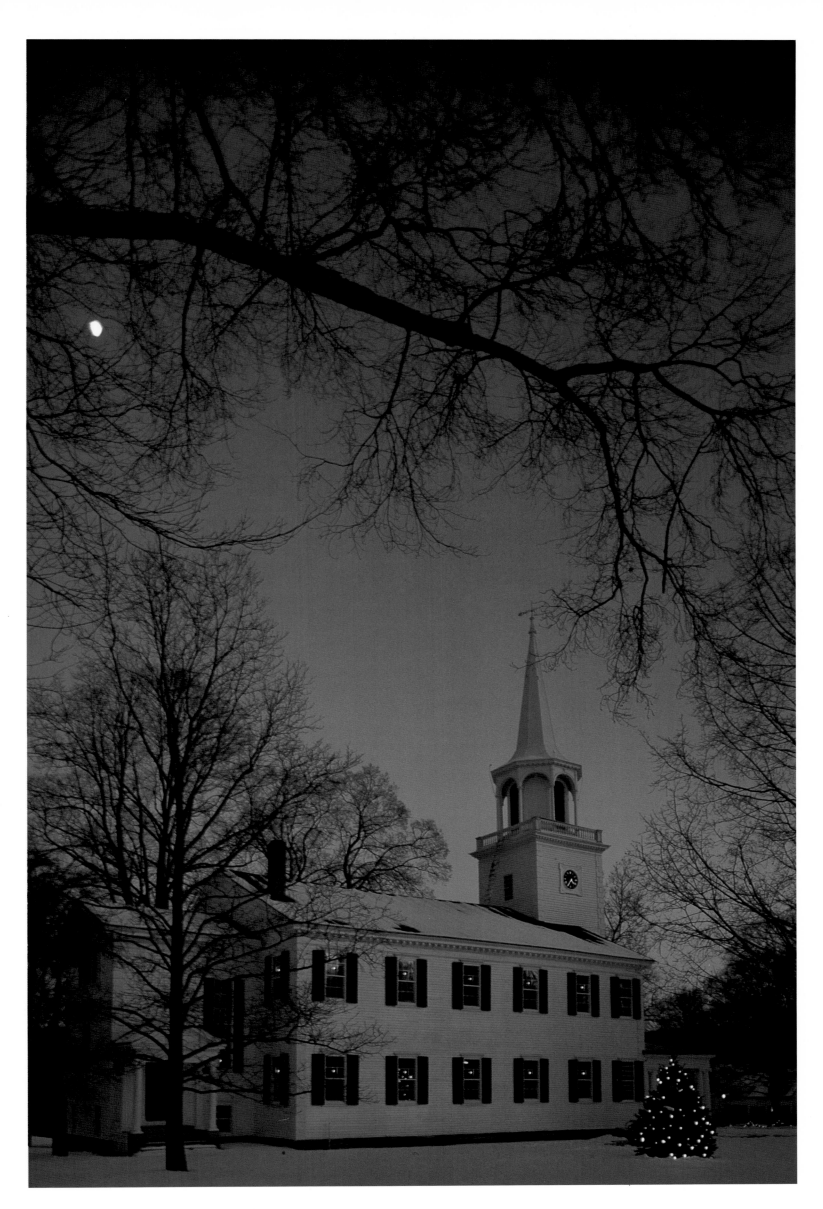

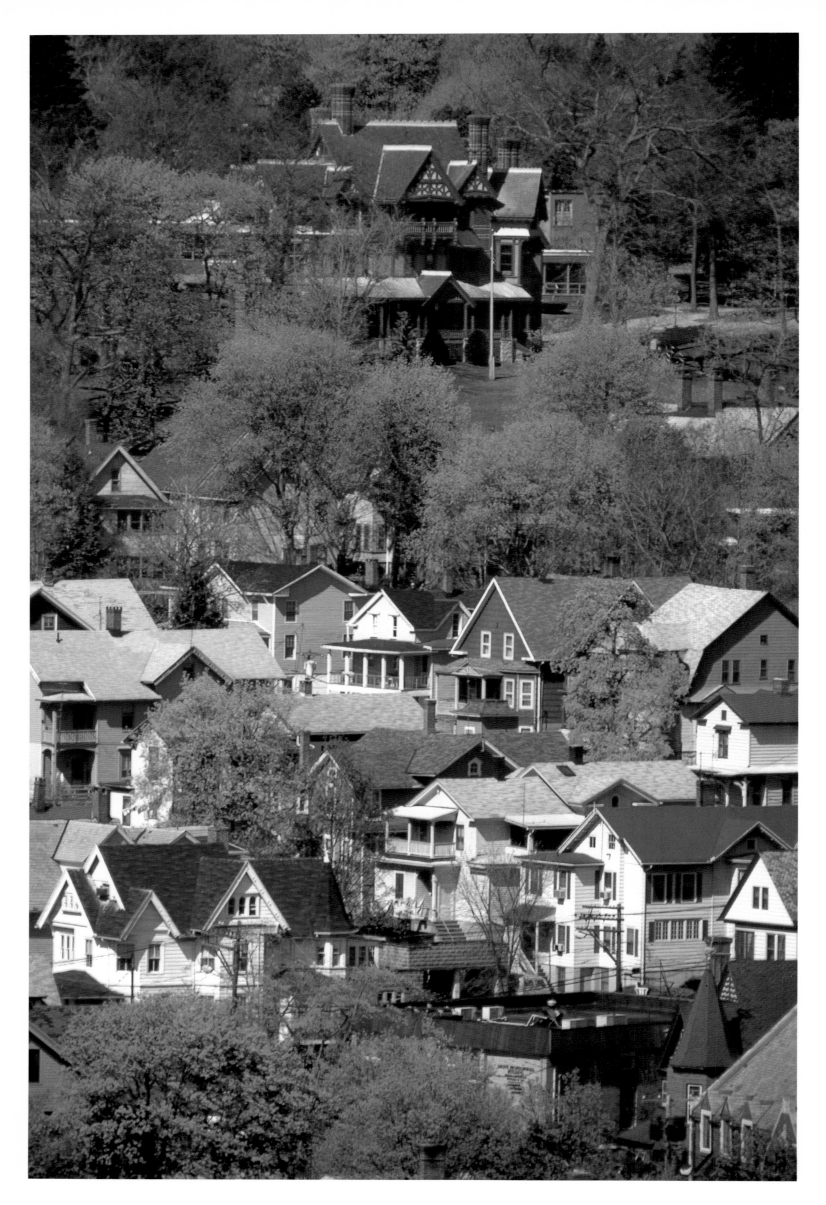

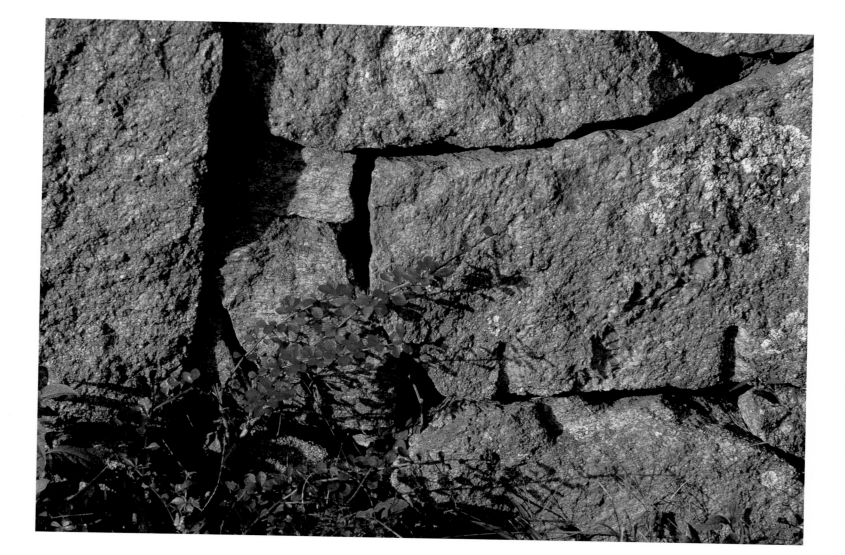

■ *Left:* One of the great houses in Waterbury's Historic Hillside district is the Benedict-Miller House, which was built in 1879 by one of the brass barons when the town was known as the "Brass Capital of the World." ■ *Above:* Showing the marks of stonecutting drills, the rocks in this stone wall provide protection for a Japanese barberry plant. Fully one-third of Connecticut's flora is not native, having been introduced either from other areas of the country or from abroad.

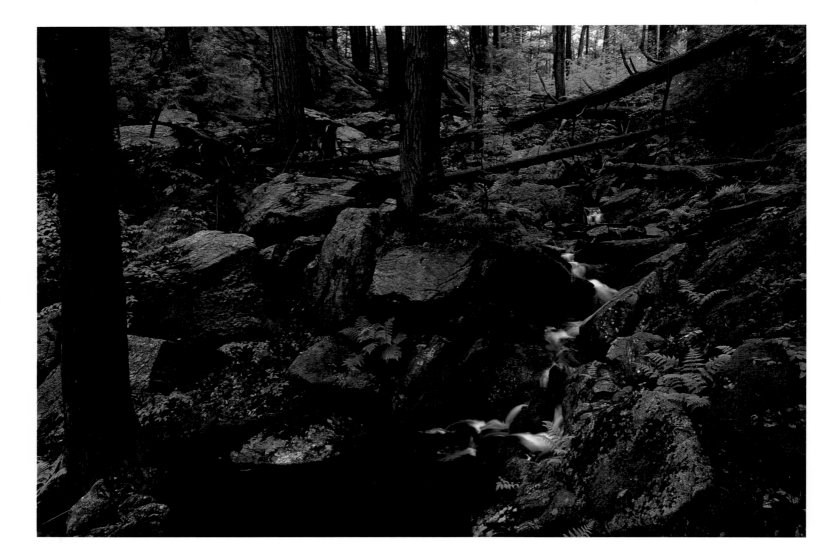

■ *Above:* Connecticut landscapes, like the state itself, are concise, small and well-ordered. It is a manageable state. It could fit into Texas fifty-three times. This stream has another two hundred yards to go before meeting the Connecticut River as it flows past Hurd State Park. ■ *Right:* Heublein Tower sits atop Talcott Mountain, just west of Hartford. This ridge of traprock has various names as it runs the width of the state from the Massachusetts border to Branford on the coast.

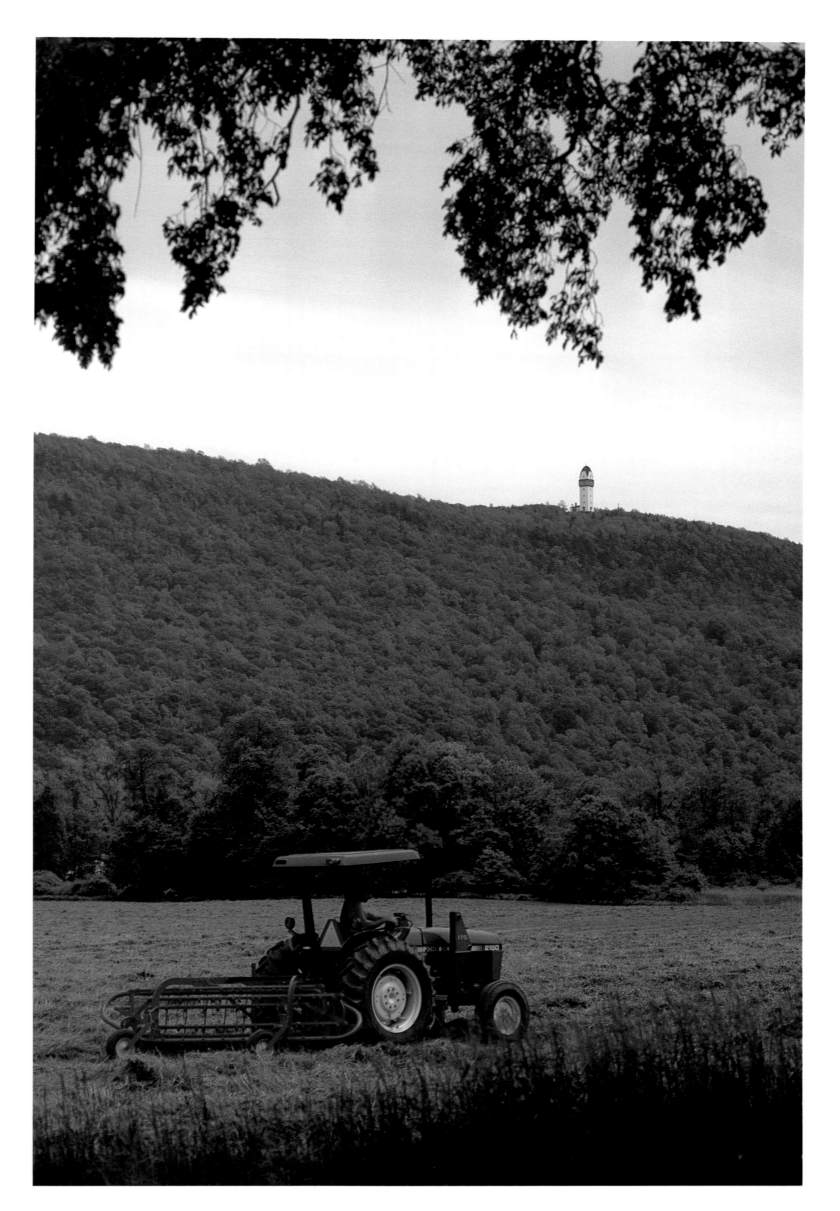

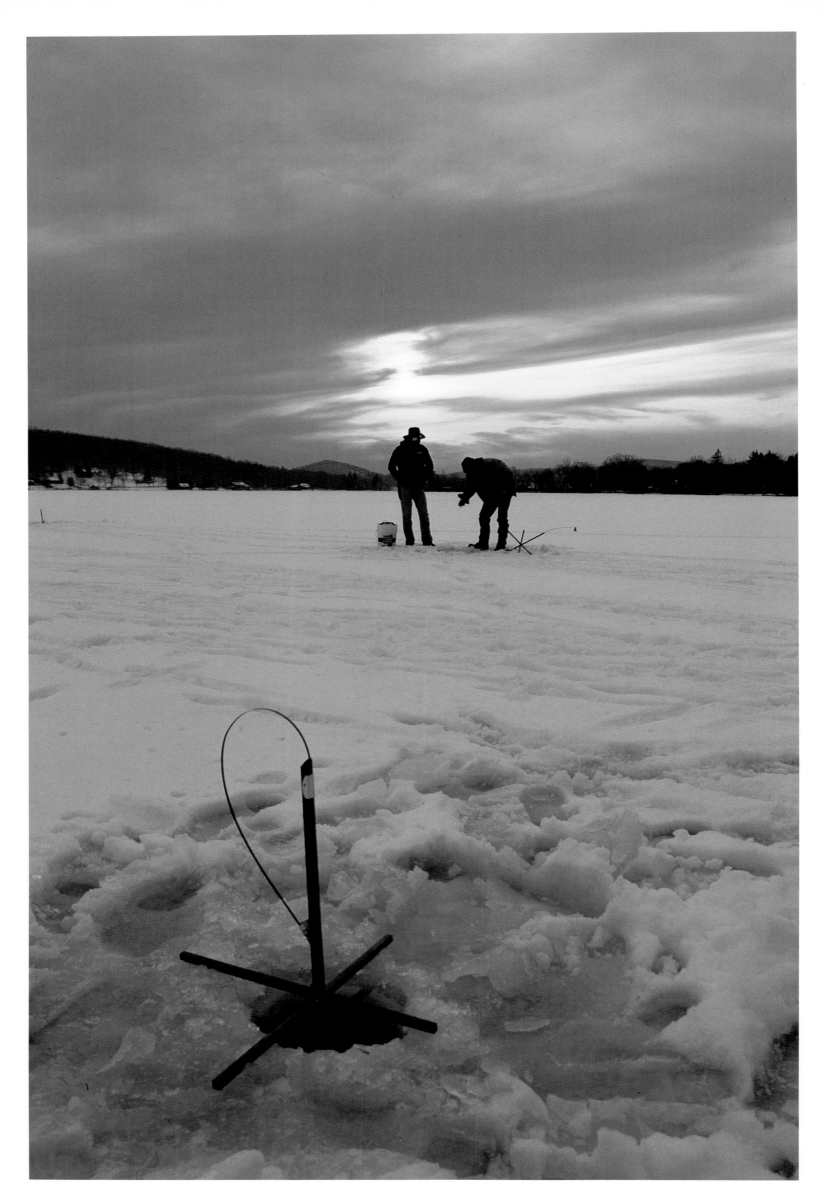

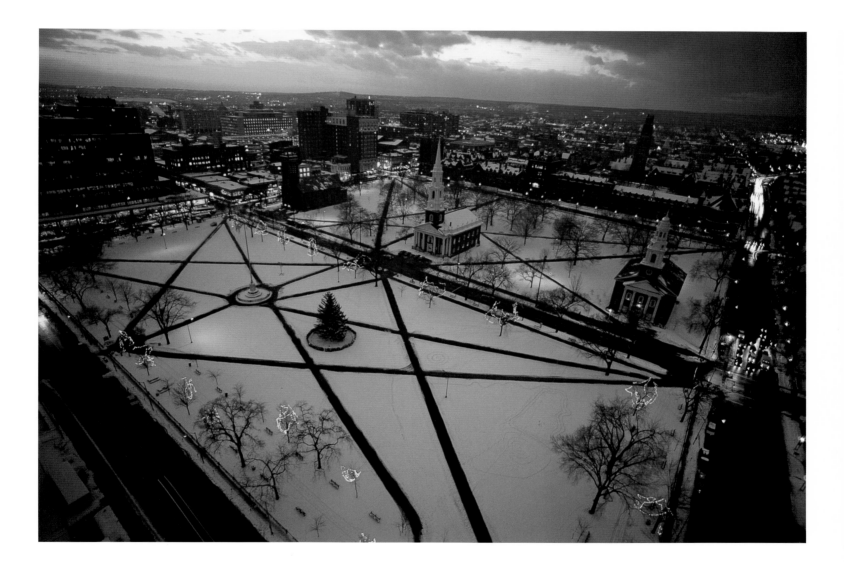

■ *Left:* Fishing is one of the state's most popular sports. Over two hundred thousand licenses are issued annually. ■ *Above:* Regarded as the first instance of city planning in America, New Haven was laid out in 1639 around the green. Three churches stand on the Green and behind them, part of Yale University.

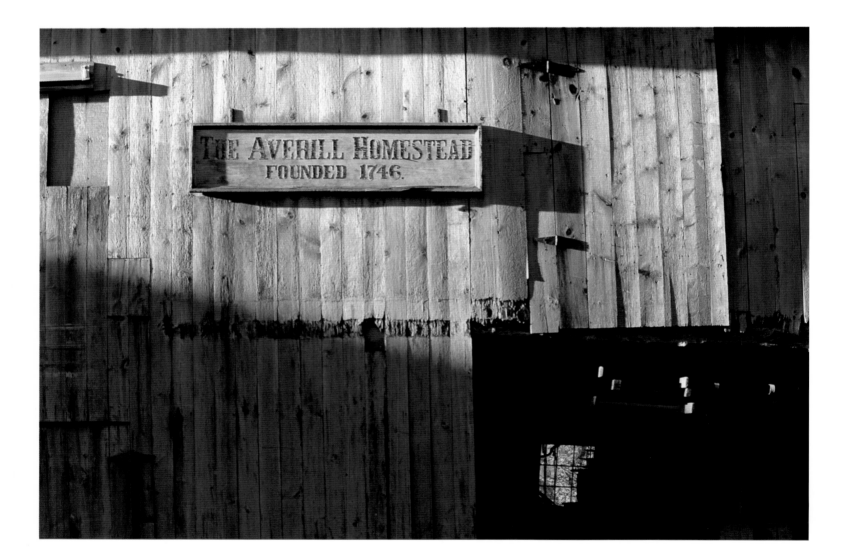

■ *Above:* This farm in Washington has been in the same family since it was bought from the Indians for five hundred pounds sterling in 1746. Originally supporting a variety of crops—wheat, corn, oats, rapeseed, hemp—now, under the management of the family's ninth generation, the land produces fruit. ■ *Right:* In a state where twenty thousand acres per year are developed for industry and housing, vistas such as this over Lake Waramaug become increasingly precious.

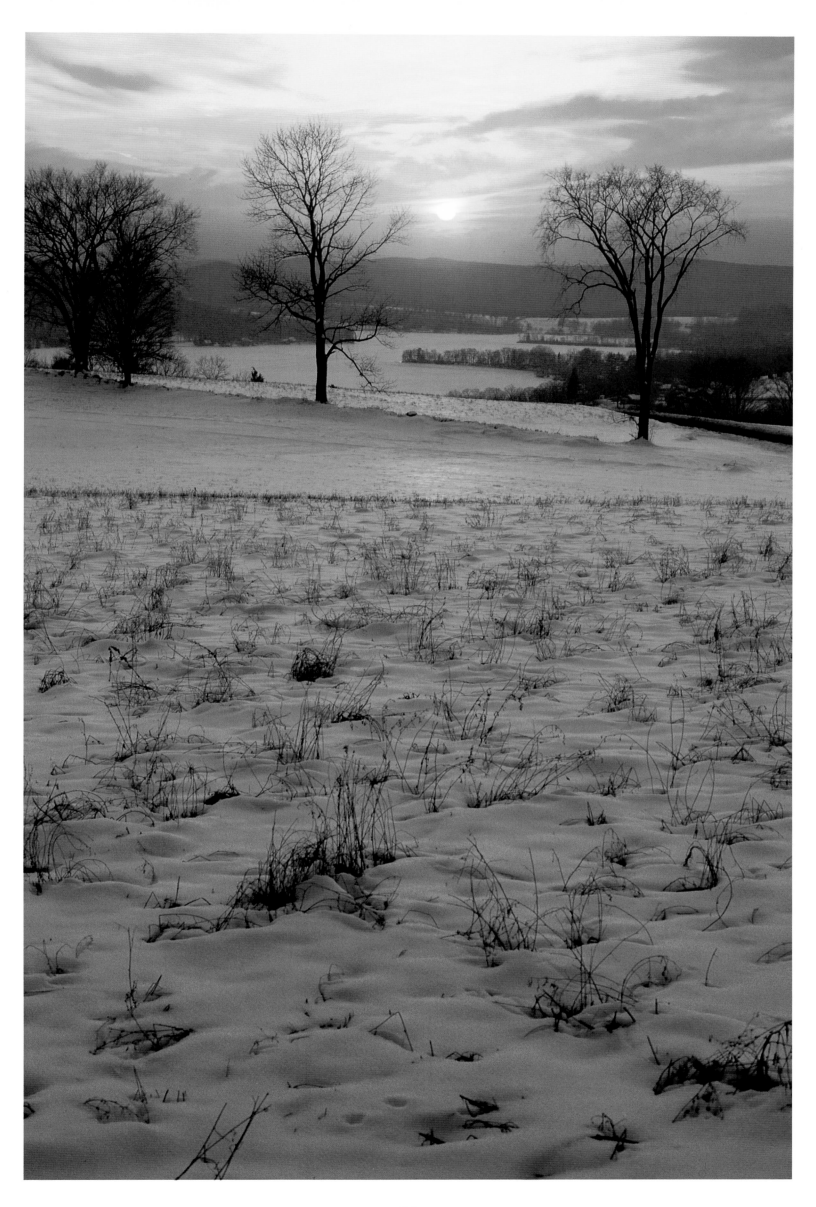

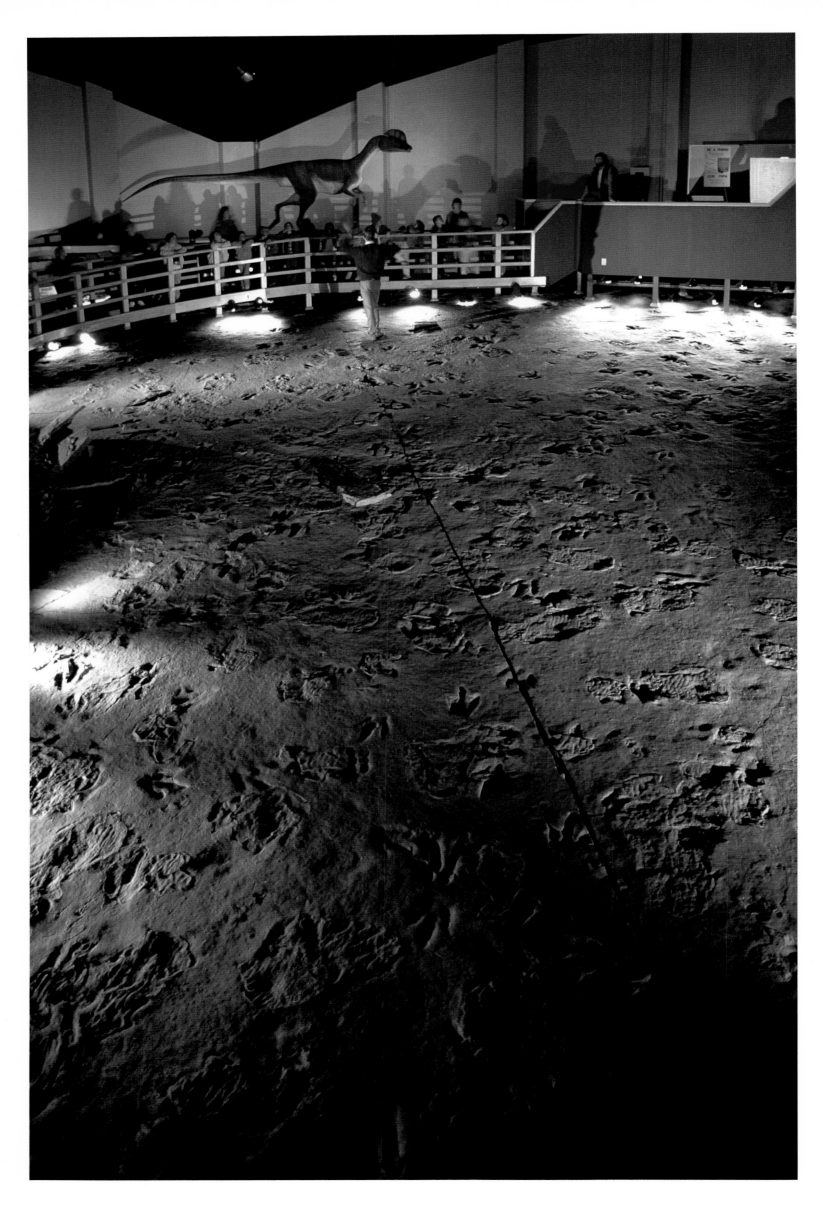

■ *Left:* A class of grade schoolers listen to the story of how these thousands of dinosaur footprints came to be preserved in the Connecticut Valley mud some 185 million years ago. ■ *Above:* Built in 1760 by Elisha Sheldon, this Litchfield house, which became Sheldon's Tavern under the supervision of his son, can honestly claim, "George Washington slept here." ■ *Overleaf:* An early morning summer fog lifts from a Connecticut River marina at the foot of Essex's main street.

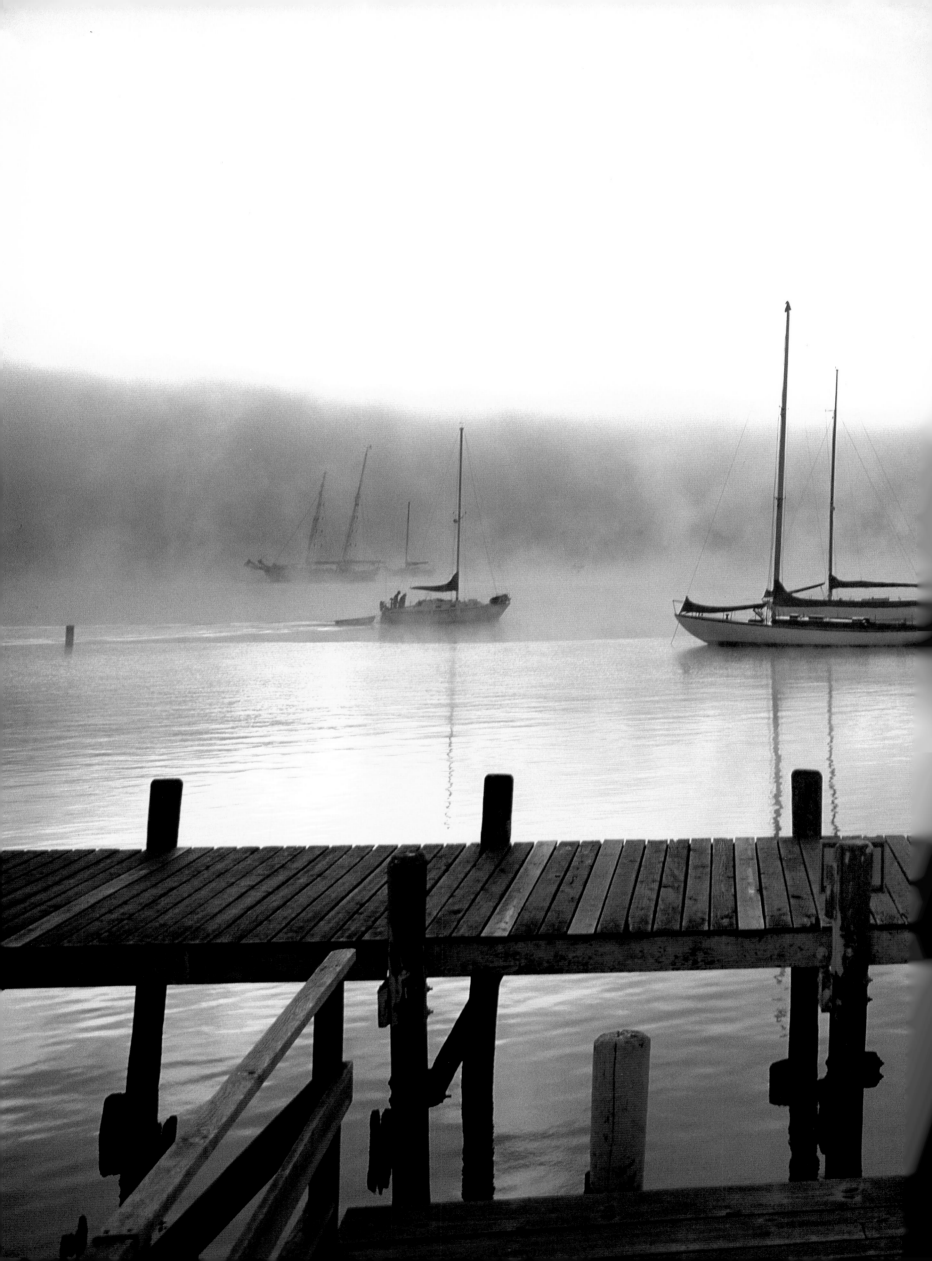

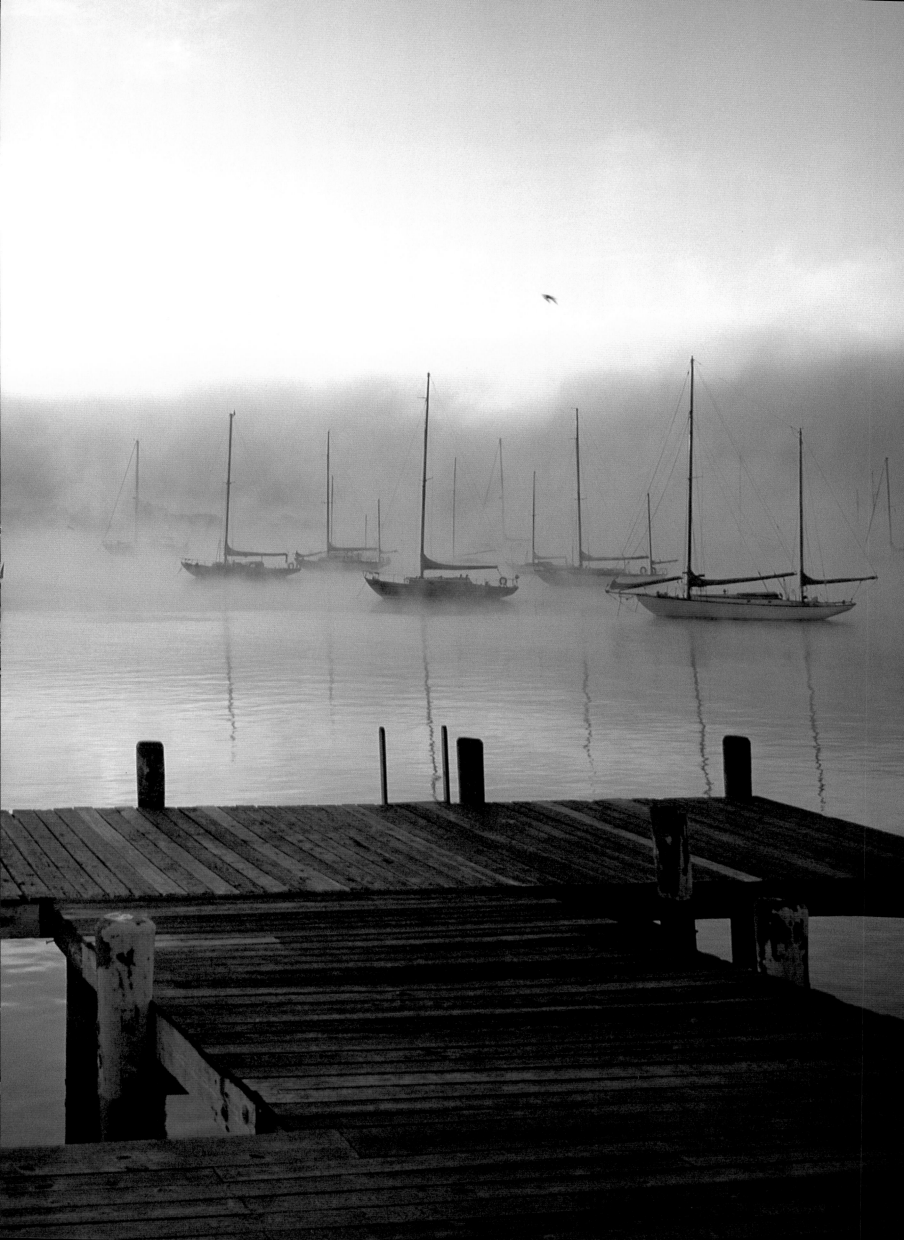

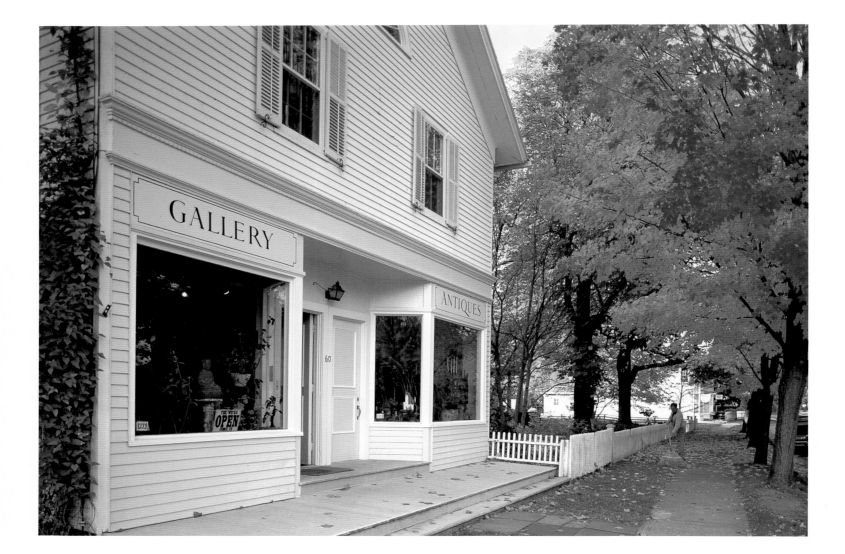

■ *Above:* The quiet Main Street of Old Lyme is lined with antique stores and art galleries, which evoke memories of the town's prosperous nineteenth-century whaling days and its once-thriving art colony. ■ *Right:* Mountain laurel, or calico bush, which has been named Connecticut's state flower, blossoms in early June.

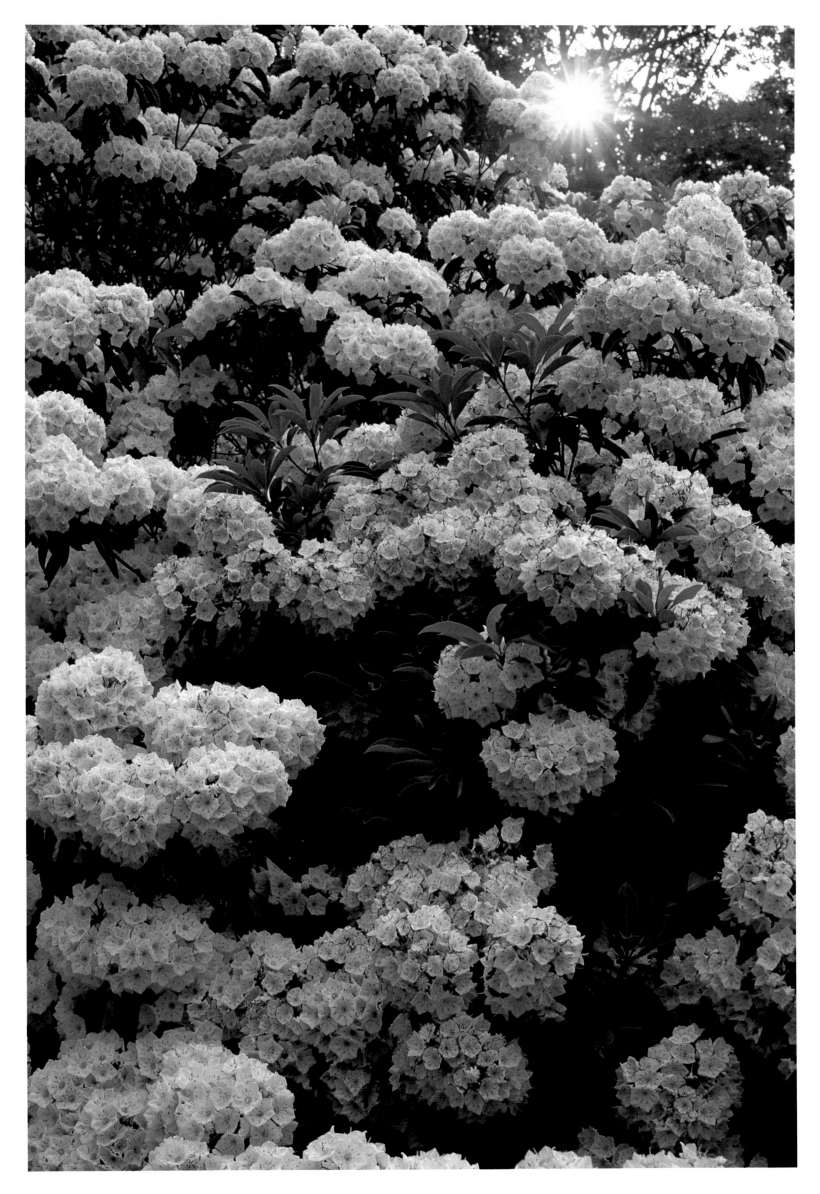

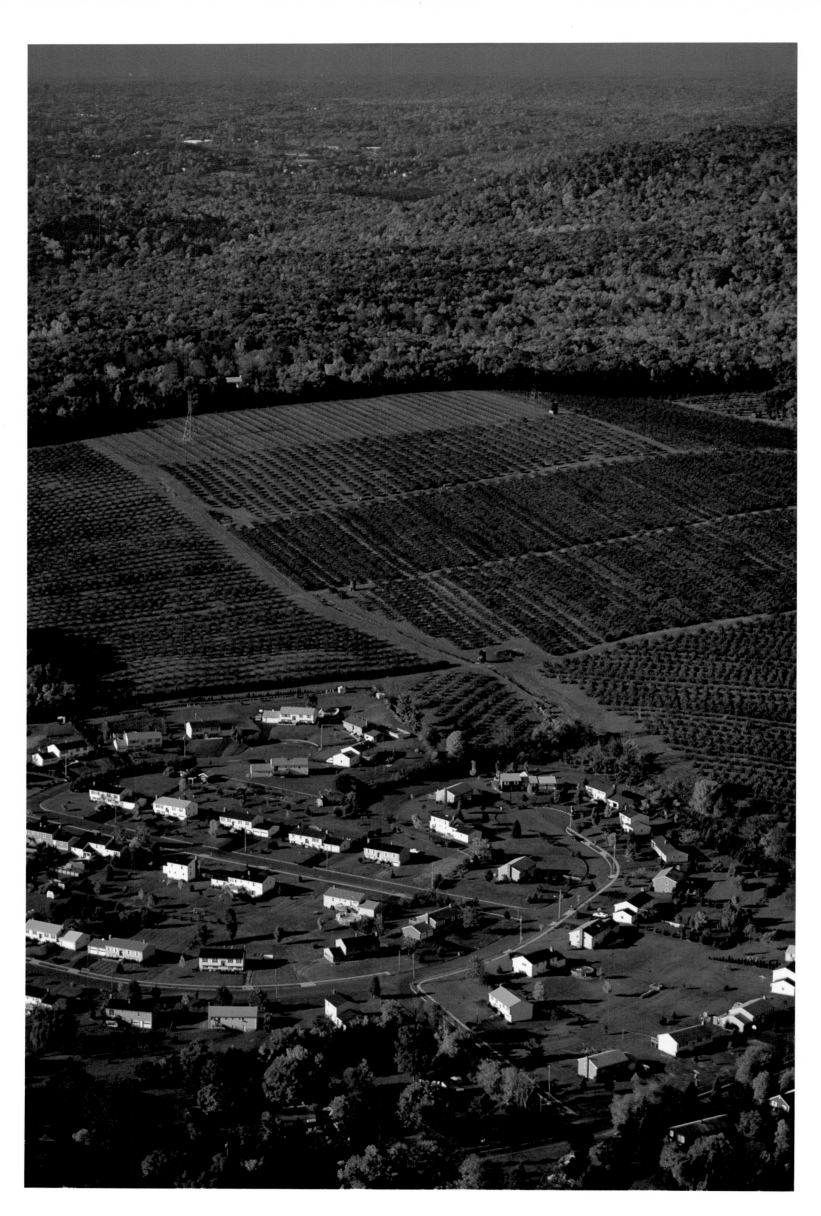

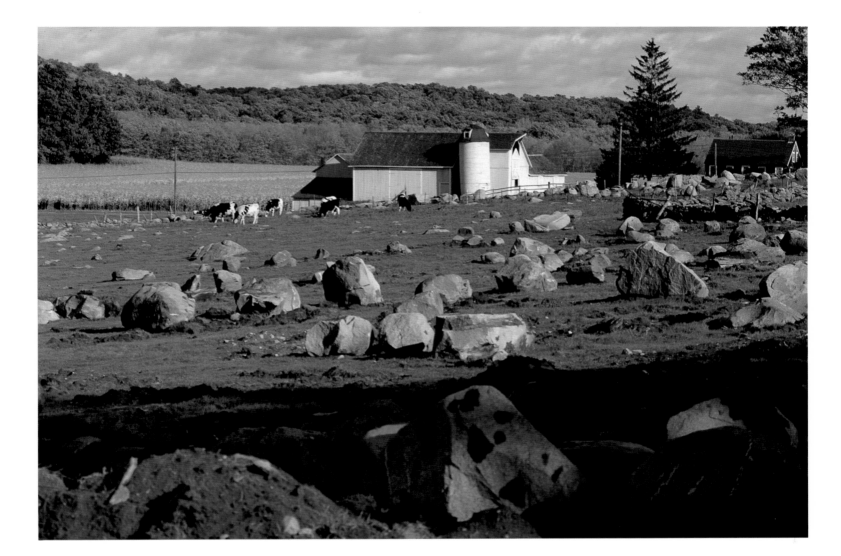

■ *Left:* In south central Connecticut near Wallingford, as in so many other parts of the state, housing is encroaching on lands traditionally used for agriculture.
■ *Above:* Overheard near the hamlet of Hamburg-passer-by: "You got a lot of rocks in your field, haven't you?" Farmer: "Yup, most two rocks for each dirt."

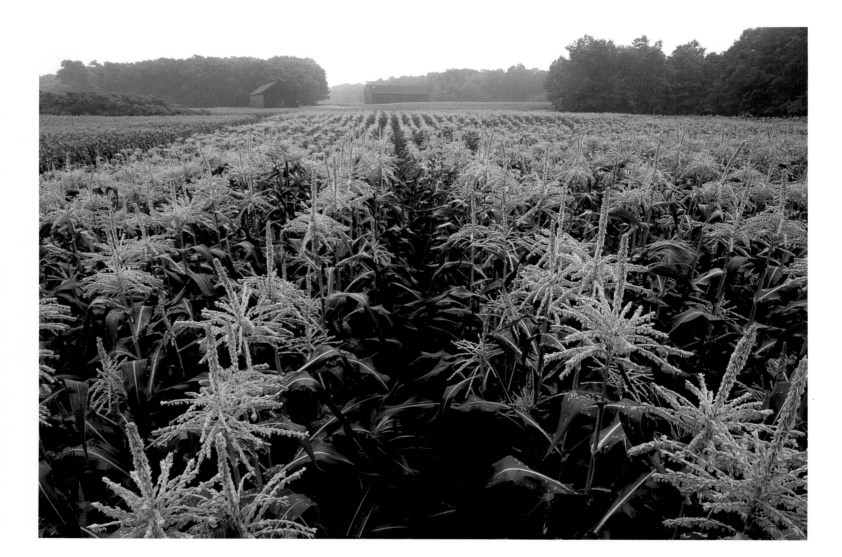

■ *Above:* In the Connecticut River Valley north of Hartford, sweet corn now grows where broad leaf tobbaco was once planted. Sweet corn follows hay and silage corn in the number of acres planted in the state. ■ *Right:* Of Connecticut's twenty-five thousand miles of stone walls, many are now on land reclaimed by forest.

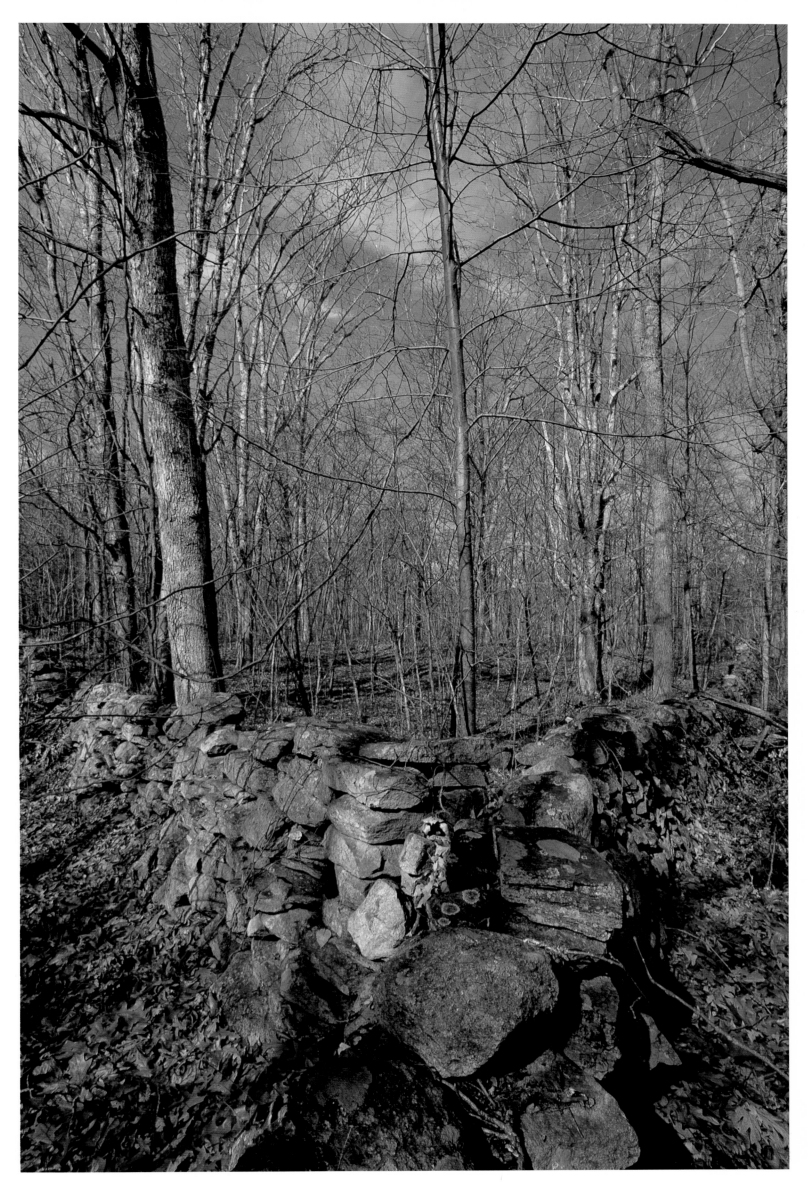

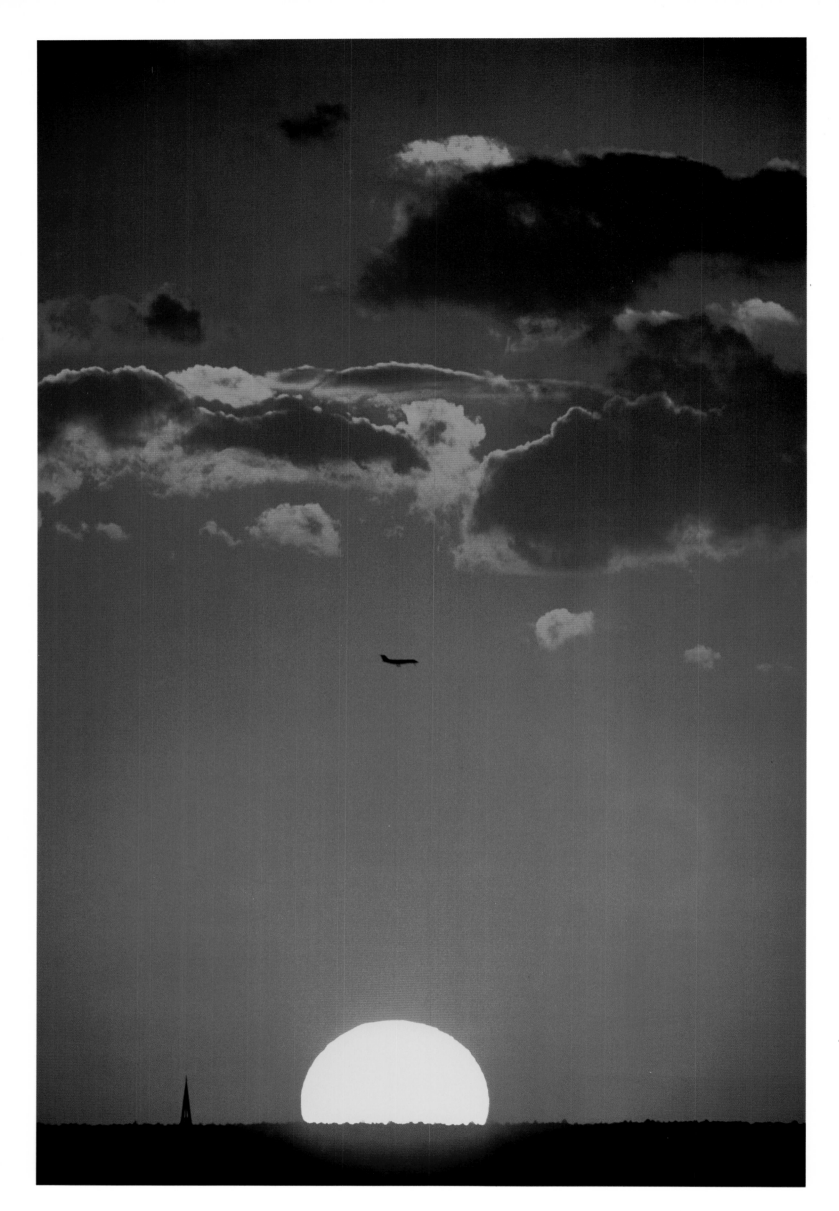

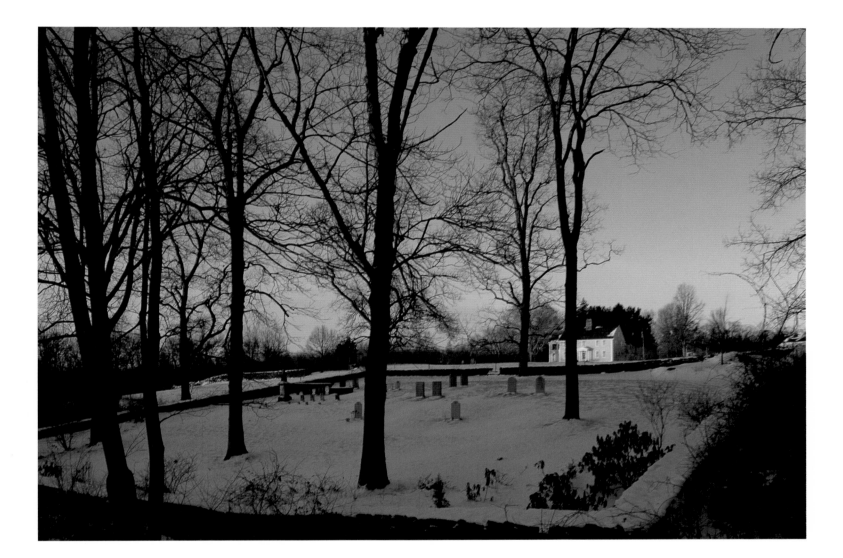

■ *Left:* From Stamford, the spire of a Greenwich church pierces the horizon as a plane circles for landing at Westchester Airport on the Connecticut-New York state line. ■ *Above:* Like many colonial buildings, this 1792 farmhouse faces east, overlooking fields and the cemetery where its original owner is buried.

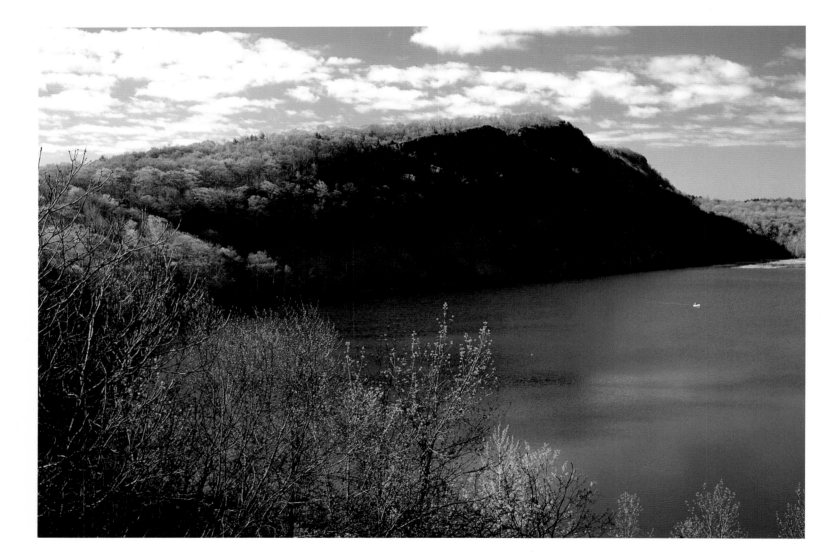

■ *Above:* Near Middlefield in the Central Valley, the westfacing scarp of a traprock ridge towers above Black Lake. These ridges act as corridors of green space, providing habitat for wildlife in the thickly populated Central Valley. ■ *Right:* Devil's Hopyard State Park, one of fifty-two developed state parks, derives its name from a legend recounting how the devil played his violin at the top of the falls to direct the East Haddam witches brewing up their black magic potions.

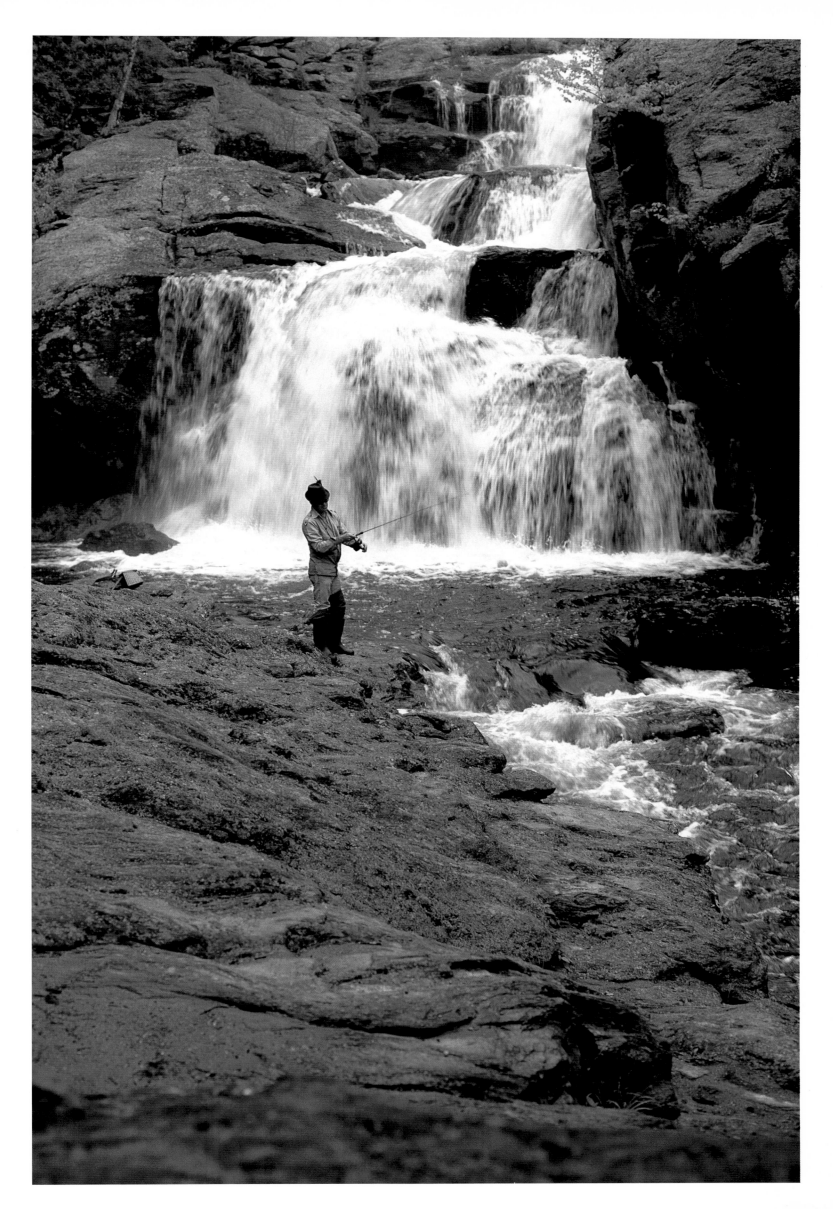

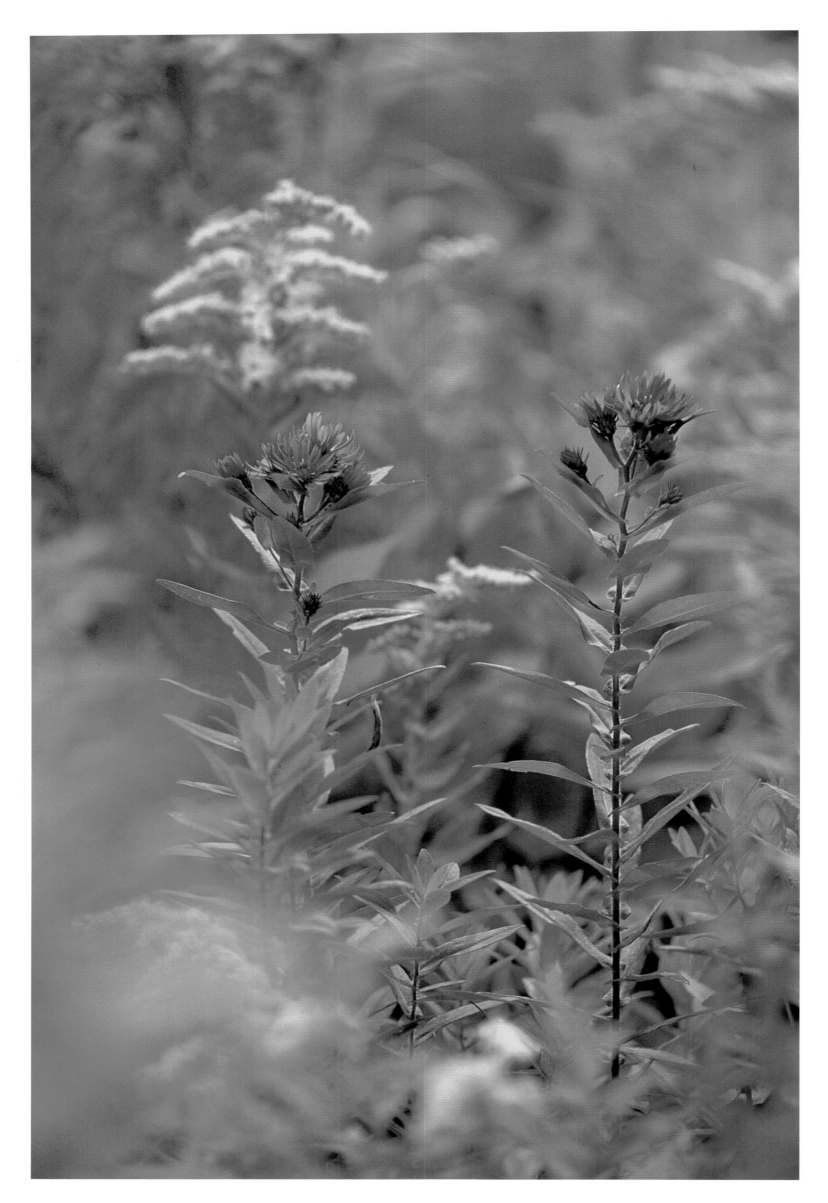

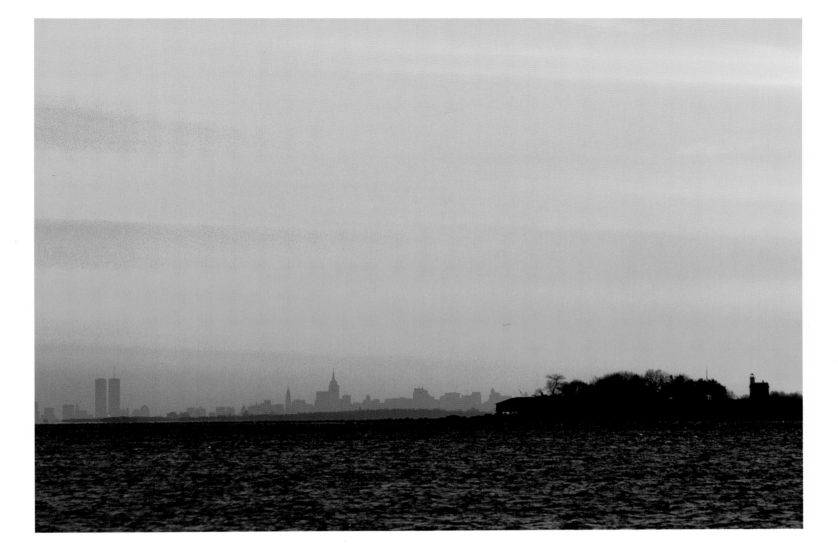

■ *Left:* Fall wildflowers, such as the goldenrod and aster, often appear in fallow fields that are beginning the process of reverting back to forest. ■ *Above:* Great Captain's Island, with its 1868 lighthouse, is part of the Greenwich Park System. New York City is visible approximately thirty miles away in the distance.

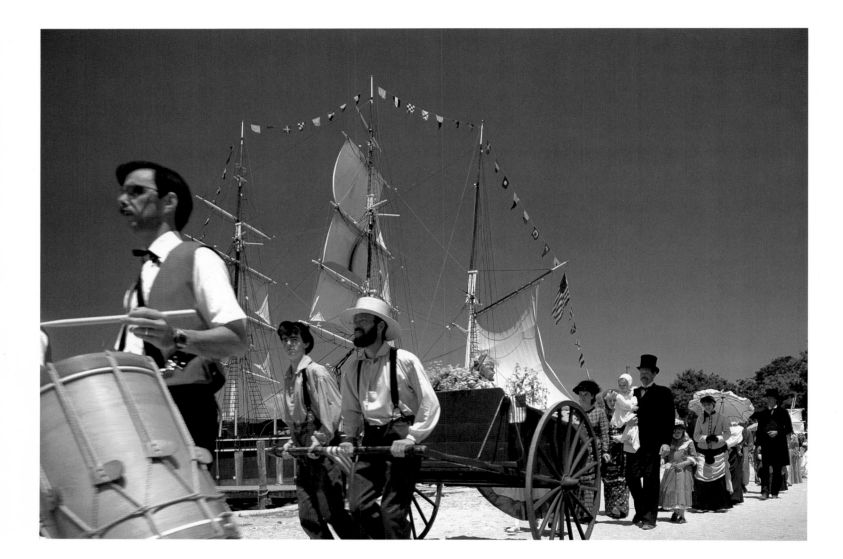

■ *Above:* Recreating an 1870s Independence Day parade, marchers at Mystic Seaport pass the *Charles W. Morgan,* the last wooden American whaling ship.
■ *Right:* In dawn's first light, the nation's oldest continuously published newspaper, *The Hartford Courant,* is delivered to a quiet street of Victorian houses.
■ *Following page:* The 172-acre Squantz Pond State Park, located in western Connecticut just north of Danbury, offers a wide variety of water sports.

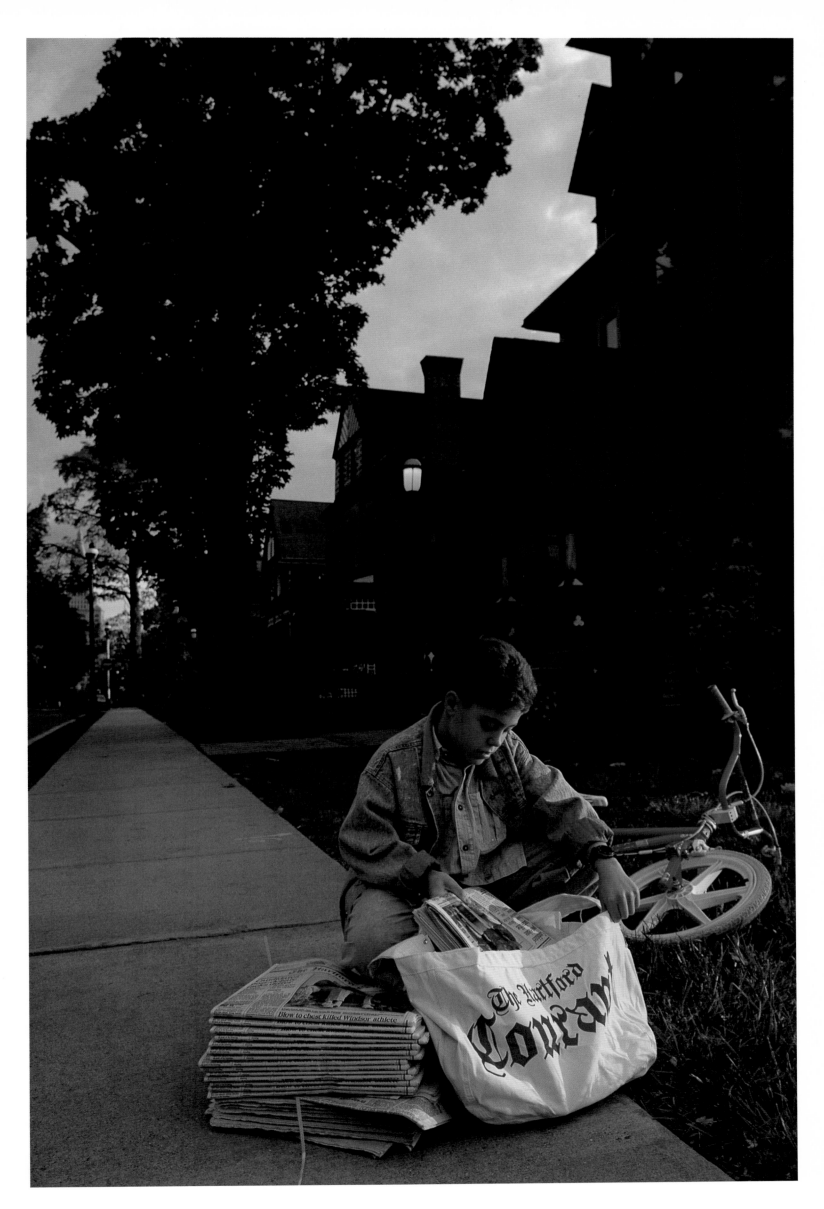

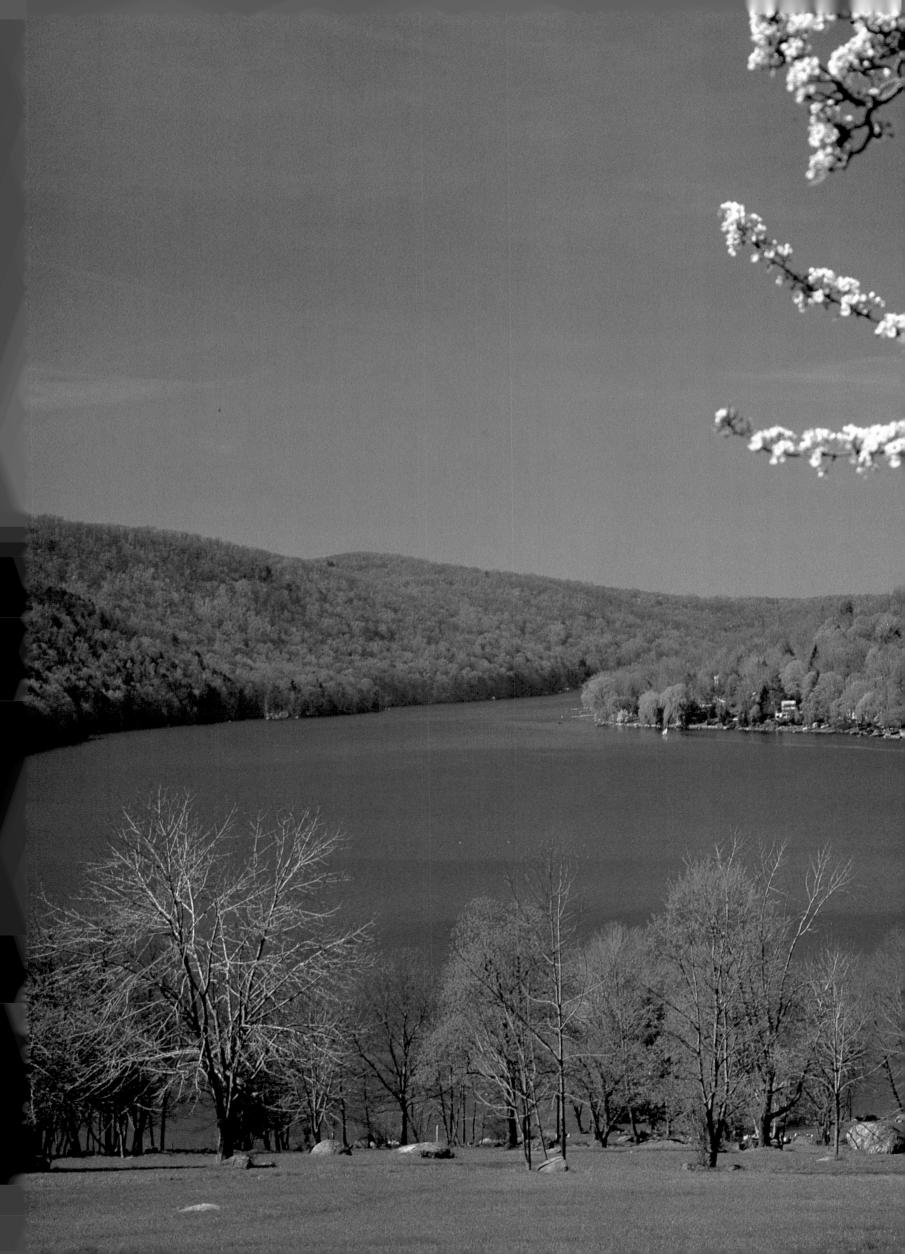

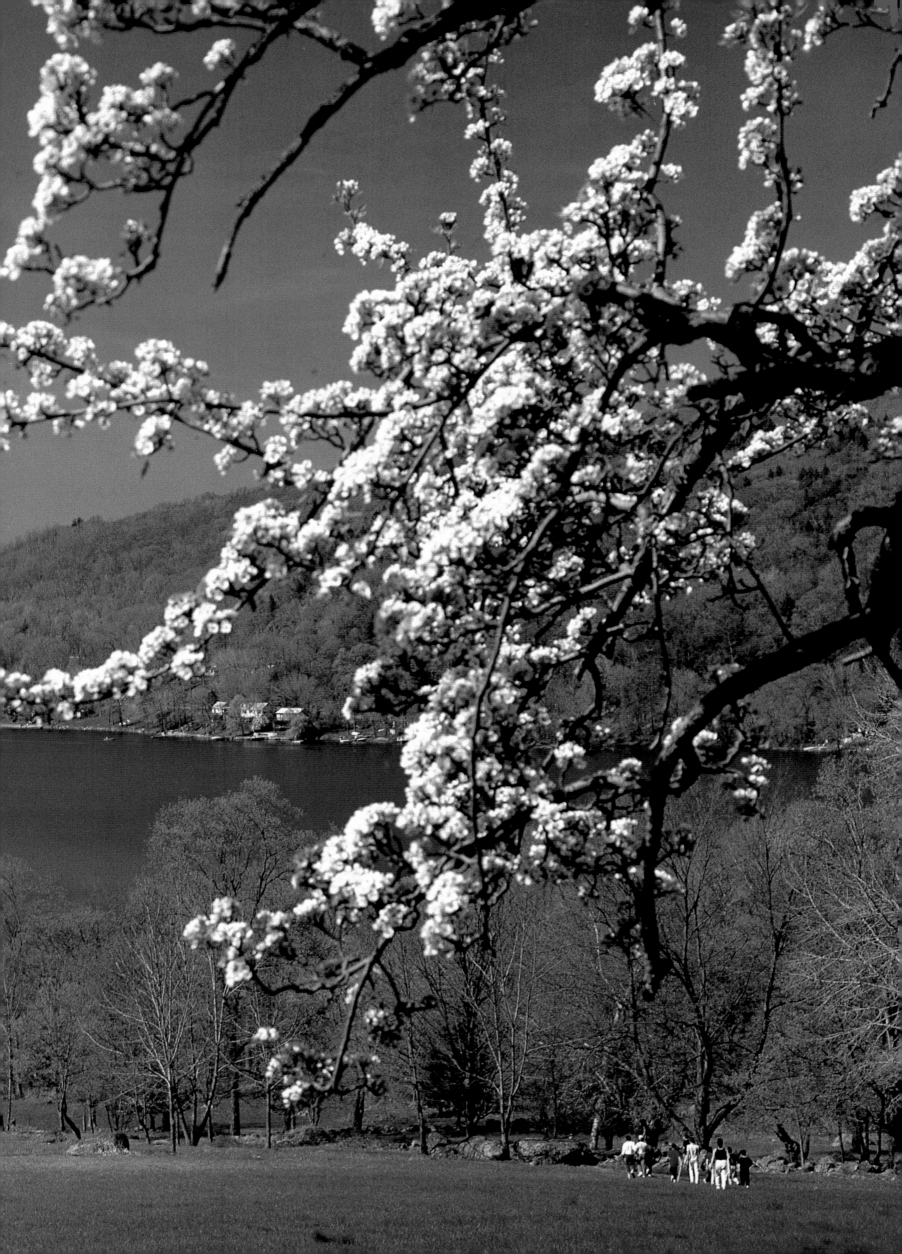

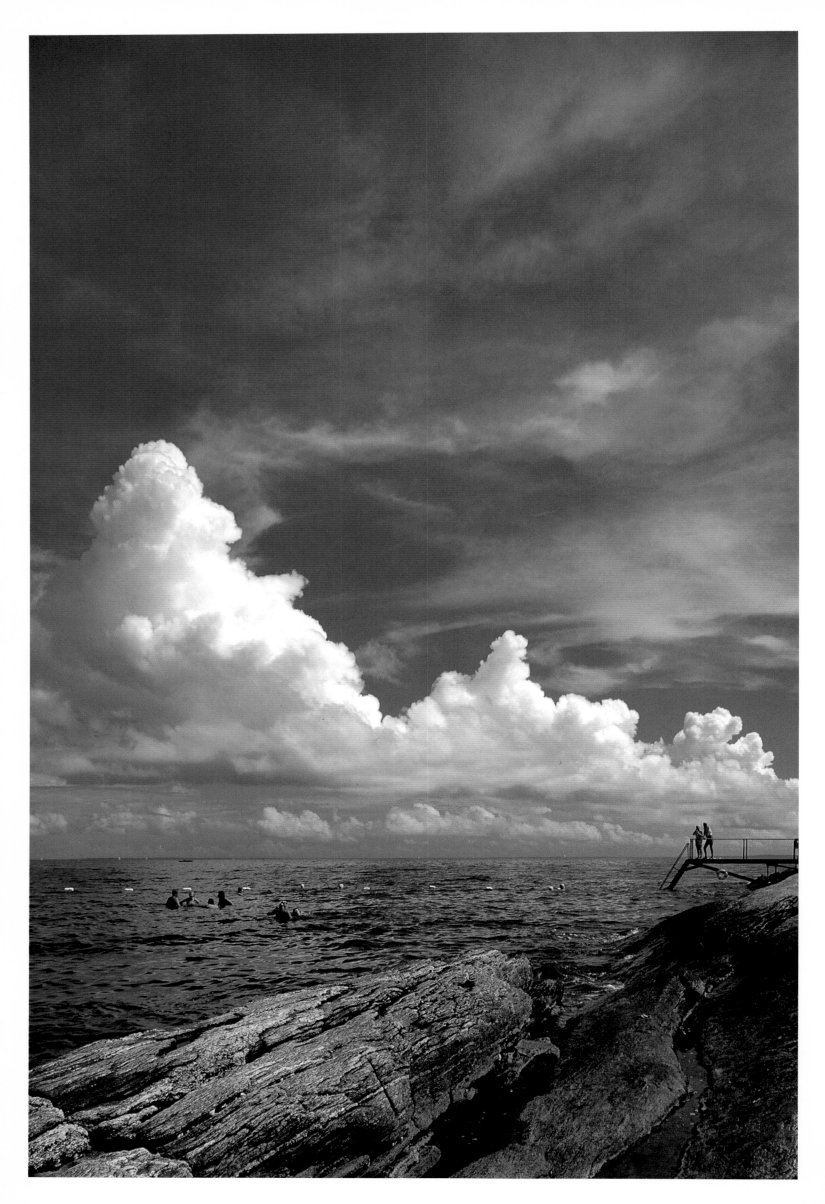

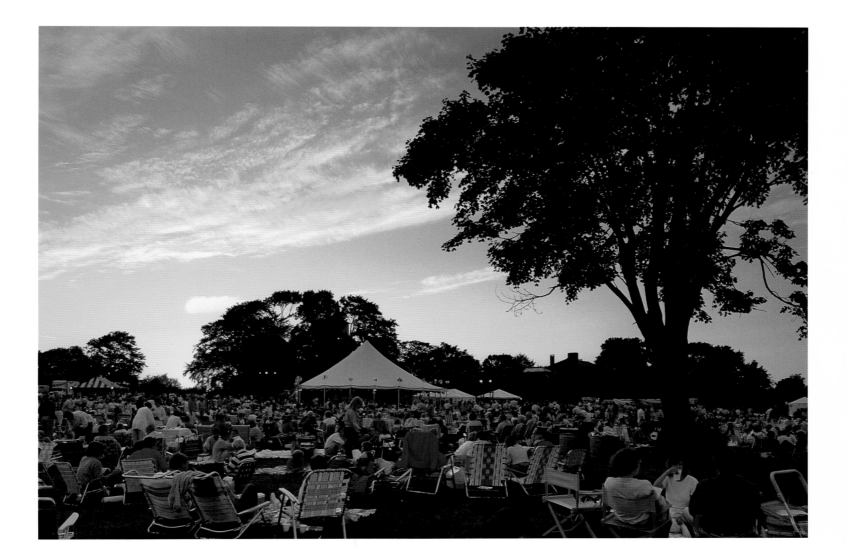

■ *Left:* In the past century, Connecticut's shoreline along the Long Island Sound has experienced a rise in sea level of between twelve and sixteen inches. ■ *Above:* On the spacious formal grounds at Harkness Memorial State Park, the programs of the Summer Music Festival attract thousands from the New London area.

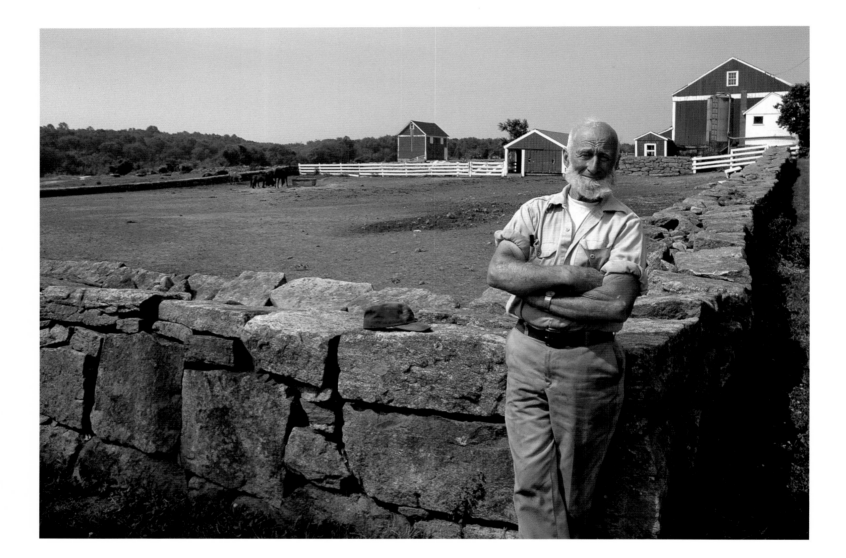

■ *Above:* Sam Harding, one of the few remaining dairy farmers near the mouth of the Connecticut River, leans against walls with three-foot-deep foundations. In 1944, there were twenty-two thousand farms covering 1.5 million acres. Today, fewer than three thousand farms work less than four hundred thousand acres.
■ *Right:* Near Old Lyme, a hayfield on the shore of the Sound rests in the August sun. Long Island's landmass, ten miles to the south, breaks the distant horizon.

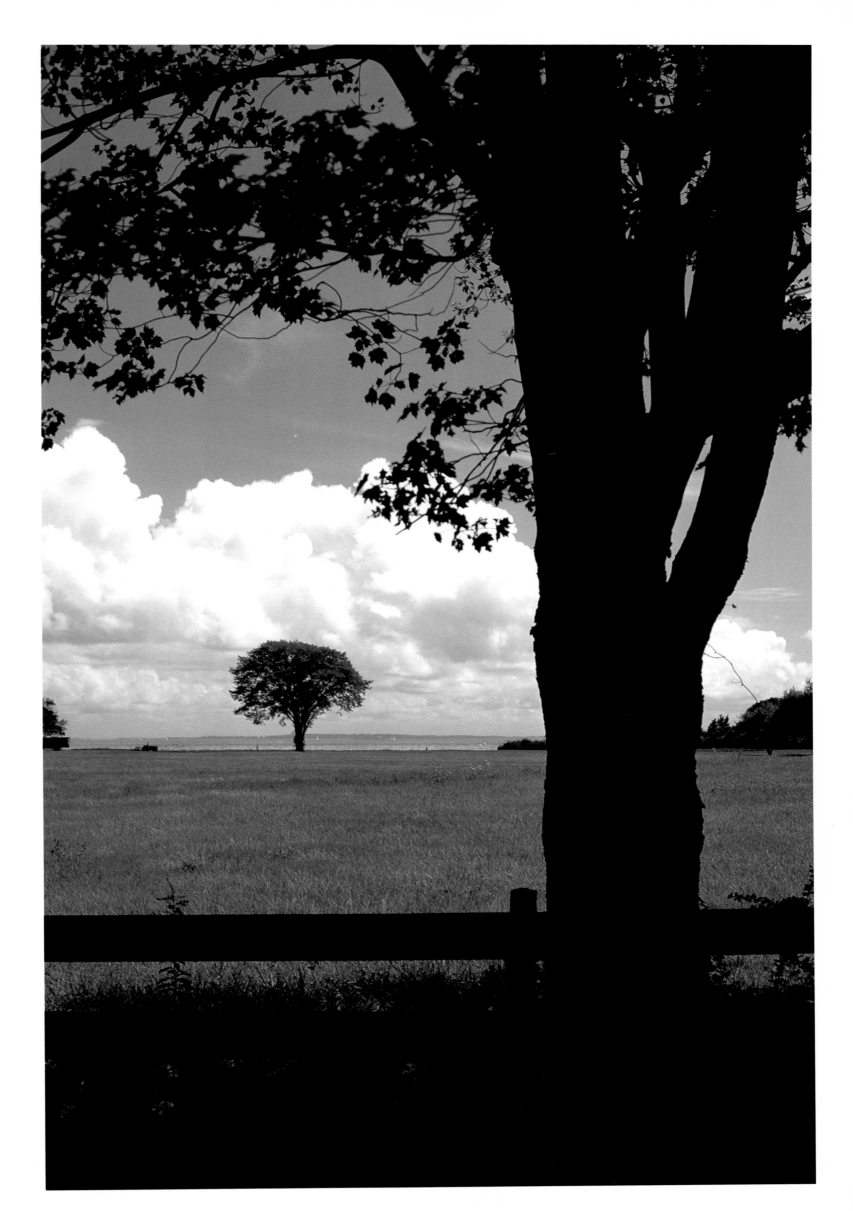

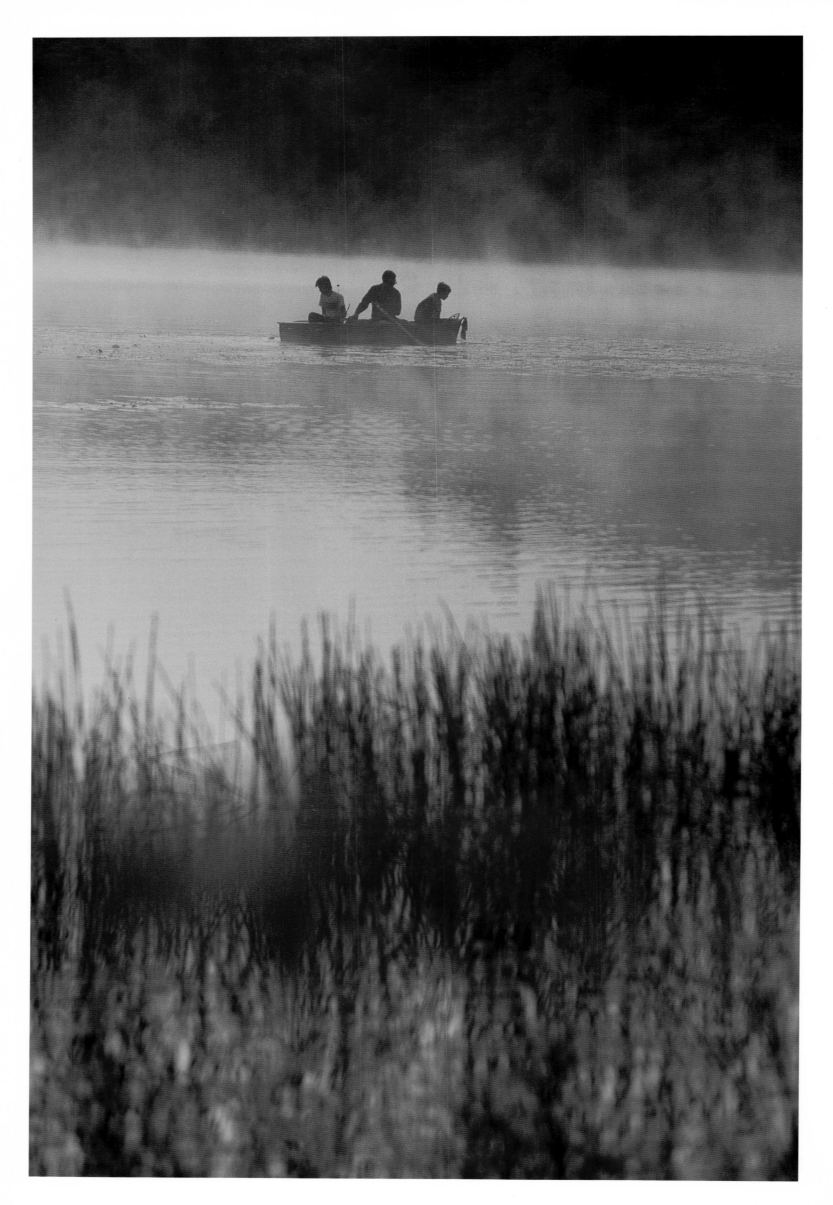

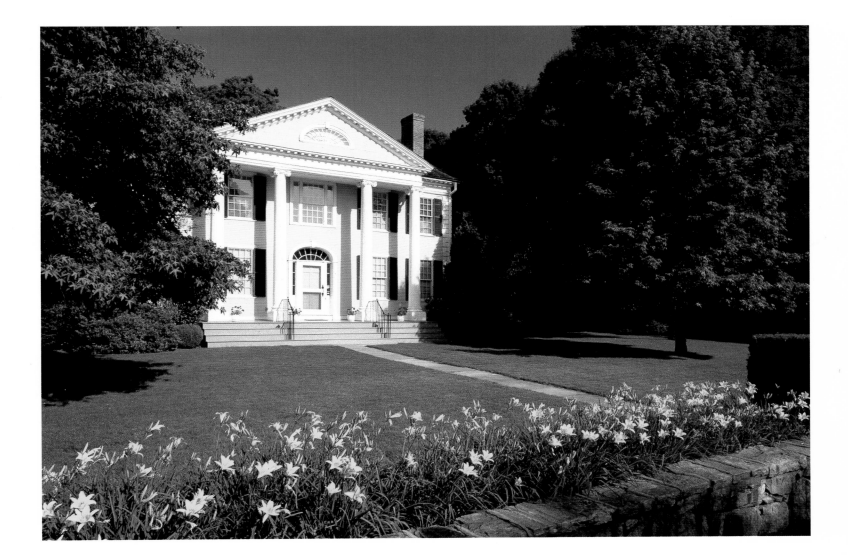

■ *Left:* Uncas Pond near Old Lyme is stocked by the state each year with some thirty-six thousand trout. Not stocked are bass, sunfish, or yellow perch, since they reproduce well without the assistance of man. ■ *Above:* Now the Florence Griswold Museum in Old Lyme, this building was once Miss Florence's boarding house, where well-known artists gathered nearly a hundred years ago. The art colony they created played a key role in the rise of American Impressionism.

ACKNOWLEDGMENTS

By William Hubbell

What a joy it has been to work on this book! I have met wonderful people, seen beautiful sights, worked harder and longer than on anything I can remember—and had more fun than ever expected.

When I learned Texas could hold fifty-three Connecticuts, I was just grateful our state was not larger. In driving and hiking some thirty thousand miles within its boundaries in the past year and a half, I have come to appreciate the beauties of our state, as well as to respect the balance between growth and preservation.

Although Connecticut is a small state, no pictorial representation could be so bold as to say it was all-inclusive. Editor Douglas A. Pfeiffer, book designer Bob Reynolds, and I have made a major effort to distill thousands of images down to the 156 presented here. We trust the representations ring true and, as a collection, properly depict the Commonwealth. I also called on as wise and articulate a Yankee as I could find, Roger Eddy, to give an added scope and perspective with his wonderful essay on the state.

One of a photographer's joys is the opportunity to select the beauty around him, freeze it in time, and then share it. For me, each day of shooting, often beginning at 4:30 a.m., was like a treasure hunt. First I checked the weather, for that was all-important. Then I headed off. My job was to combine research, logic, luck, and— most importantly—the instinct to find that special beauty.

Among those who helped so much, my deep gratitude goes to Sid Quarrier, Charle Cafiero, Ted Spiegel, Bill Faude, Les Corey, Chief Big Eagle, Sarah Casey, Janet Serra, and my pilots Ted Crosby, Chip Raymond, and Gerry Trembly. I owe a special debt to Donna Callighan, my office manager, whose superb organization of images and captions kept us functioning at peak efficiency.

At lastly, my love and very special thanks go to my family who gave such loving encouragement and understanding. They will welcome, now the book is done, the fact that all family plans will not be held in limbo by my continually saying, "Well, it depends on the weather."